D1242457

MANET
A VISIONARY IMPRESSIONIST

HENRI LALLEMAND

SMITHMARK

DEDICATION
THIS BOOK IS DEDICATED TO NETHANEL AND DINA KALUJNY.

This edition published in 1994 by SMITHMARK Publishers Inc.,
16 East 32nd Street, New York, NY 10016

SMITHMARK books are available for bulk purchase for sales promotion and premium use.
For details write or call the manager of special sales,
SMITHMARK Publishers Inc.,
16 East 32nd Street, New York, NY 10016; (212) 532-6600.

This book was designed and produced by
Todtri Productions Limited
P.O. Box 20058
New York, NY 10023-1482

Printed and Bound in Singapore

10 9 8 7 6 5 4 3 2 1

Library of Congress Catalog Card Number 94-66829

ISBN 0-8317-5776-0

Author: Henri Lallemand

Producer: Robert M. Tod
Book Designer: Mark Weinberg
Production Coordinator: Heather Weigel
Photo Editor: Ede Rothaus
Editors: Mary Forsell, Joanna Wissinger, & Don Kennison
DTP Associates: Jackie Skroczky, Adam Yellin
Typesetting: Mark Weinberg Design, NYC

CONTENTS

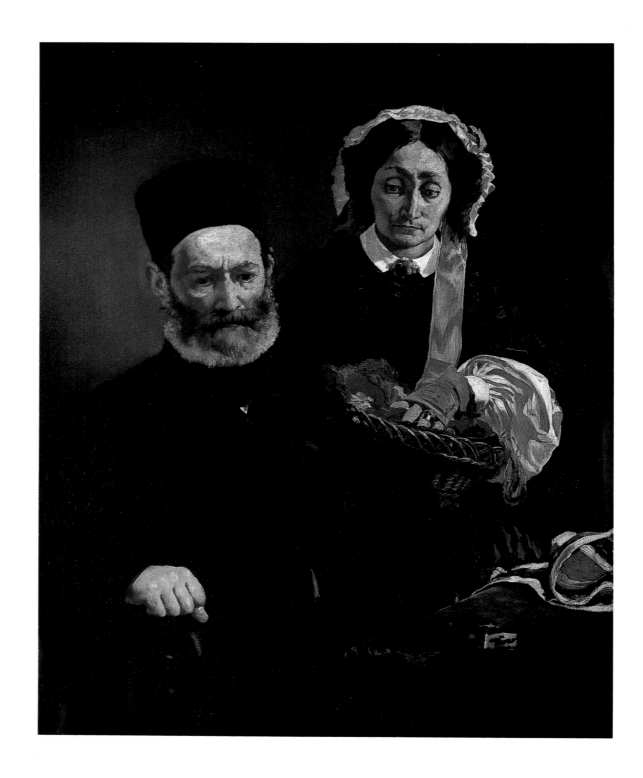

Portrait of M. and Mme. Auguste Manet

1860; *oil on canvas*; 44 x 35 3/4 in. (111.5 x 91 cm.). Paris, Musée d'Orsay.

With this double portrait of his parents, Manet created a new type of painting that represents the austere bourgeoisie of the Second Empire. Auguste Manet, a judge and high government official, was sixty-three years old at that time, his wife Eugénie-Désirée, daughter of a diplomatic emissary to Stockholm, was fourty-eight. This depiction is of a severe intimacy not without some tension. The work was presented at the Salon of 1861.

INTRODUCTION

anet's position in the history of modern art, his aloofness, his independence from his peers, and his achievements as a painter single him out from other artists of his time. In fact, Manet remains one of the most enigmatic and least classifiable artists in the entire history of painting.

Certainly, the history of Impressionism could not be written without including Édouard Manet (1832–1883). In his time he was often considered the leader of this avant-garde movement. But his work is in fact the least representative of all Impressionist artists, especially when compared to Claude Monet, Pierre-Auguste Renoir, Camille Pissarro, or Alfred Sisley. His reputation as the first truly Modern painter, however, can be agreed upon without hesitation.

His seriousness as an artist was often questioned by his peers. Manet actually preferred the company of women over discussions about aesthetics or other artistic matters with fellow artists and he rejected the role as the leader of the "Manet gang" altogether. Upon his death, Edgar Degas defined his position with the illuminating remark: "He was greater than we thought."

Portrait of Antonin Proust
1855–1856; *oil on canvas;*
22 x 17 3/4 in. (56 x 45 cm.).
Prague, Národni Galerie.
Manet and Proust knew each other from childhood. In the 1850s both were pupils at the studio of Thomas Couture, and it was during that time that Manet painted this portrait of his friend. Eventually, Proust pursued the career of a journalist, critic, and politician serving under various governments. His memoirs remain a valuble source of information about Manet's life.

Manet's Personality

Most agreed, however, that Manet was a fascinating personality, whose worldliness and enlightened liberalism attracted great spirits such as poets Charles Baudelaire and Stéphane Mallarmé. Manet loved his native city, Paris ("It's not possible to live anywhere else," he once said), and had a strong liking for the urban culture of its 'Grande Bourgeoisie.' Manet's wit was sharp and quick, at times even cutting, and his skepticism and raillery were feared by his contemporaries. Always courteous, he moved freely in circles of the upper society; his irreverence and free spirit, although mingled with respect for traditional values, set him apart from the mainstream.

Contemporaries often felt compelled to describe him. Antonin Proust, one of his closest friends from childhood and who was to become Manet's first important biographer, said of the painter: "Of medium height, well muscled ... He was obviously a thoroughbred. Beneath a broad forehead, the frank, straight line of the nose. The eyes small, the glance lively. ... There were few men so attractive." Émile

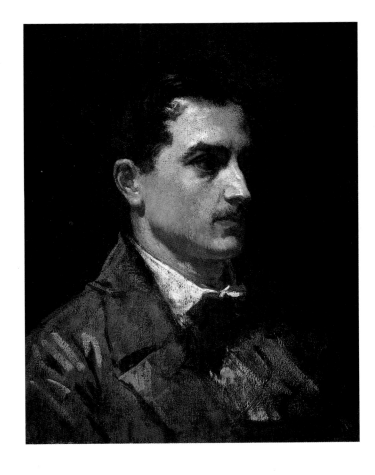

Music in the Tuileries Gardens
detail. 1862;
National Gallery, London.
Partially cut off by the picture frame on the left stands Manet himself next to Albert de Balleroy, with whom he had shared a studio. The seated man is the writer and critic Zacharie Astruc. In the foreground, the two ladies in bonnets are Mme. Lejosne, at whose house Manet met Baudelaire and Bazille, and Mme. Loubens or Mme. Offenbach in a veil. Behind them, near a tree trunk, are Baudelaire in profile and, at his left, Fantin-Latour.

Zola wrote about Manet, then thirty-five years of age: "The hair and beard are light chestnut brown; the eyes, narrow and deep set, have a boyish liveliness and fire; the mouth very characteristic, thin, mobile, a trifle mocking in the corners." And Georges Jeanniot remembered several years later that "one evening in October 1878, I was walking down the rue Pigalle, when I saw coming toward me a man of youthful appearance, most distinguished, turned out with elegant simplicity. Light hair, a fine silky beard ... gray eyes, nose straight with flaring nostrils; hands gloved, step quick and springy. It was Manet." The painter Berthe Morisot, who had married Manet's brother Eugène, remembers him as being gay and spirited, "direct [and] exuberant about everything." In short, Manet was a real gentleman.

Manet was always quite assured about his position and eminence as a painter, although occasionally his confidence alternated with self-doubt. When critics harshly attacked his *Olympia*, exhibited at the Salon of 1865 ("... this silly, phlegmatic creature..."), he wrote to Baudelaire, who was then temporarily living in Brussels: "I wish I had you here, my dear Baudelaire, abuses rain upon me like hail ... obviously, someone is in the wrong..." In his response to this lament, Baudelaire reminded Manet of the examples of author François-Auguste-René de Chateaubriand and composer Richard Wagner, both of whom had been oblivious to assaults from the public, and closed with the well-known though ambiguous statement: "You are but the first in the decline of your art." Pride mingled with vanity was the poet's strongest weapon. Luckily, he expressed also his personal opinion about Manet: "Painters always crave immediately for success; but indeed, Manet's faculties are so brilliant and so fragile that it would be a pity if he became discouraged. He will never quite make good the deficiencies in his temperament. But he has a temperament, that's what counts." And, "Manet's talent is strong and will endure. But his character is weak. He seems to me to be prostrated and stunned by the blow."

Manet could at times indeed be impetuous in his behavior as the matter of the duel with Edmond Duranty in 1870 shows. Offended by comments about his paintings, which Duranty had published in a newspaper, Manet walked up to him at a café and slapped him. However, he was also quick in forgiving, and the two men eventually became friends.

Manet's Heritage

Manet's pride was part of his upbringing and cultural heritage. Born in Paris on January 23, 1832, his father, Auguste Manet, was a high official in the Ministry of Justice, his mother, Eugénie-Désirée, née Fournier, daughter of a diplomat stationed in Stockholm. His parents' rela-

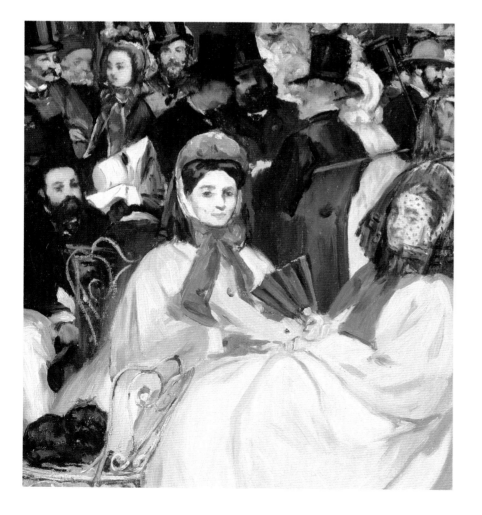

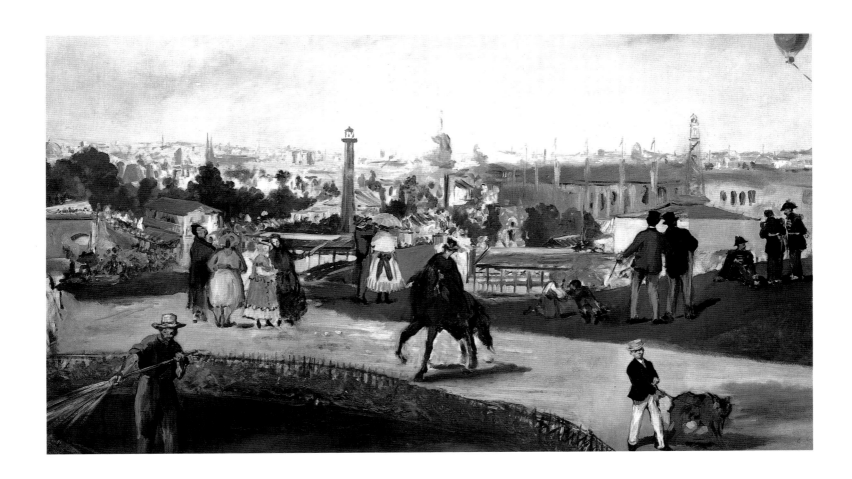

tive wealth and independence provided Manet with a much more favorable position from the start than those of Monet or Renoir, both of whom came from rather modest social backgrounds and who for a long time had to struggle for survival. Édouard had two younger brothers, Eugène and Gustave, who occasionally served him as models. During his studies at the Collège Rollin, Manet met Antonin Proust (1832–1905), who was the same age. Together the two boys visited often the Louvre and eventually became lifelong friends as is documented in several portrait paintings. Proust's published memoirs are still a valuable source about the painter's life. Himself a painter of modest talent, Proust became eventually involved in politics and held briefly the position of minister of fine arts between November 1881 and January 1882. Despite his short tenure, he managed to have Manet appointed Chevalier de la Légion d'honneur, a distinction Manet was only too willing to accept, since it meant to him the official recognition of his accomplishments as a painter.

In December 1848 Manet, just sixteen years old, embarked on a training ship leaving for Rio de Janeiro. He had a talent for doing caricatures of members of the crew and upon his return to Paris the following summer, he pursued an artistic career with his family's consent. Together with Antonin Proust he joined the studio of Thomas Couture, a painter much in favor since his success in 1847 with *Romans of the Decadence*. Although his style was rather academic and traditional, Couture attracted many young artists, since his teaching methods were based on innovative principles. Despite numerous quarrels, Manet remained there for six years, until February 1856. Occasionally the Couture studio made walking tours, as in 1853, when they went to Normandy in order to do studies from nature. But often Manet's hopes were

View of the Exposition Universelle
1867; *oil on canvas;*
42 1/2 x 77 1/8 in.
(108 x 196 cm.).
Oslo, Norway,
Nasjonalgalleriet.
During the Exposition Universelle of 1867 Manet exhibited fifty of his canvases in his own private pavilion adjacent to the exhibition grounds. It was then that he painted his first view of Paris in a general panorama of the world's fair. The theatrical view is taken from the newly arranged Trocadero. In the right-hand corner Manet introduced the famous balloon of his friend Nadar, who took photographs of Paris from the air.

disappointed: "I don't know why I'm here. Everything we see is ridiculous. The light is wrong; the shadows are wrong. When I arrive at the studio, it seems to me I'm entering a tomb. I realize you can't have a model disrobing in the street. But there are fields, and, at least in summer, studies from the nude could be done in the country, since the nude is, it appears, the first and the last word in art." Eventually, at the "Salon des Refusés" in 1863, Manet showed his *Déjeuner sur l'herbe*, where an unclad female figure appears in an outdoor scene, just like the one he had described over a decade earlier.

A study trip to Italy in the fall of 1853 took him to Rome and Florence, where he copied Old Master Paintings, among them Titian's *Venus of Urbino* in the Uffizi. Together with his friend Proust he paid a visit to Eugène Delacroix in Paris.

Manet on His Own

After leaving Couture's studio in February of 1856, Manet continued to study and explore the works of the masters. In the Louvre he copied portraits by Peter Paul Rubens and he visited Italy once more. In Paris he shared a studio on the rue Lavoisier with the animal painter Albert de Balleroy, whose portrait appears next to Manet's own in *Music in the Tuileries Garden*. His fist major public work was *The Absinthe Drinker*, which was rejected by the Salon, despite

Reading

1868–1873c.; *oil on canvas*; 24 x 29 1/4 in. (60.5 x 73.5 cm.).
Paris, Musée d'Orsay.
Probably painted in two separate stages, this work shows the artist's wife, Suzanne, at the age of about thirty-five. Their son, Léon, who is reading to his mother, was most likely added at a later date. The woman is rendered in a harmony of whites, her face delicately textured against the summer sunlight filling the room. Her firm hands,—she was a distinguished piano player,—are prominently placed on the sofa and armrest.

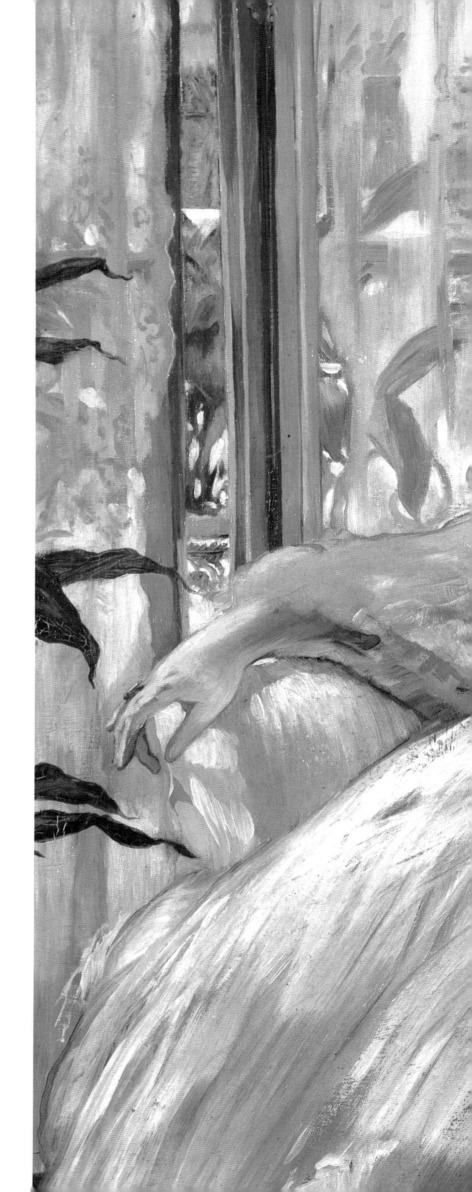

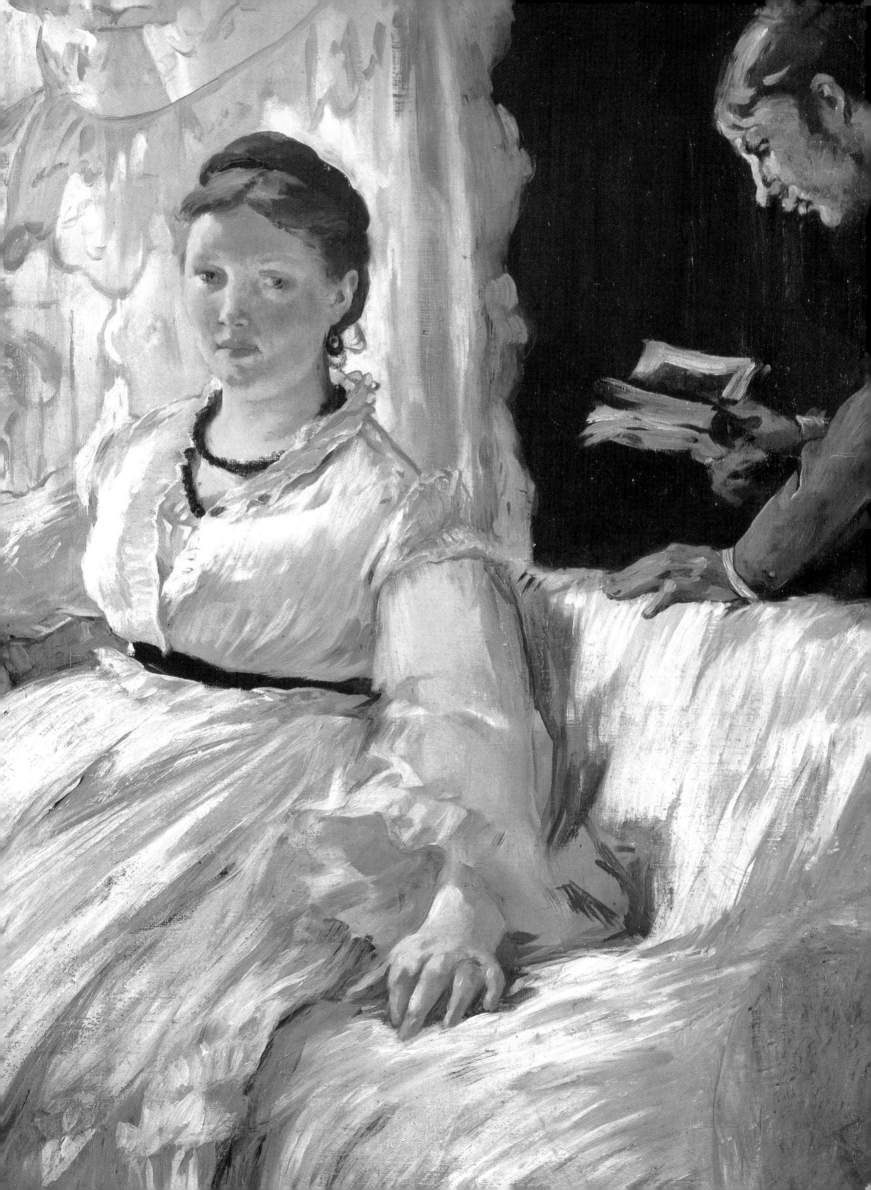

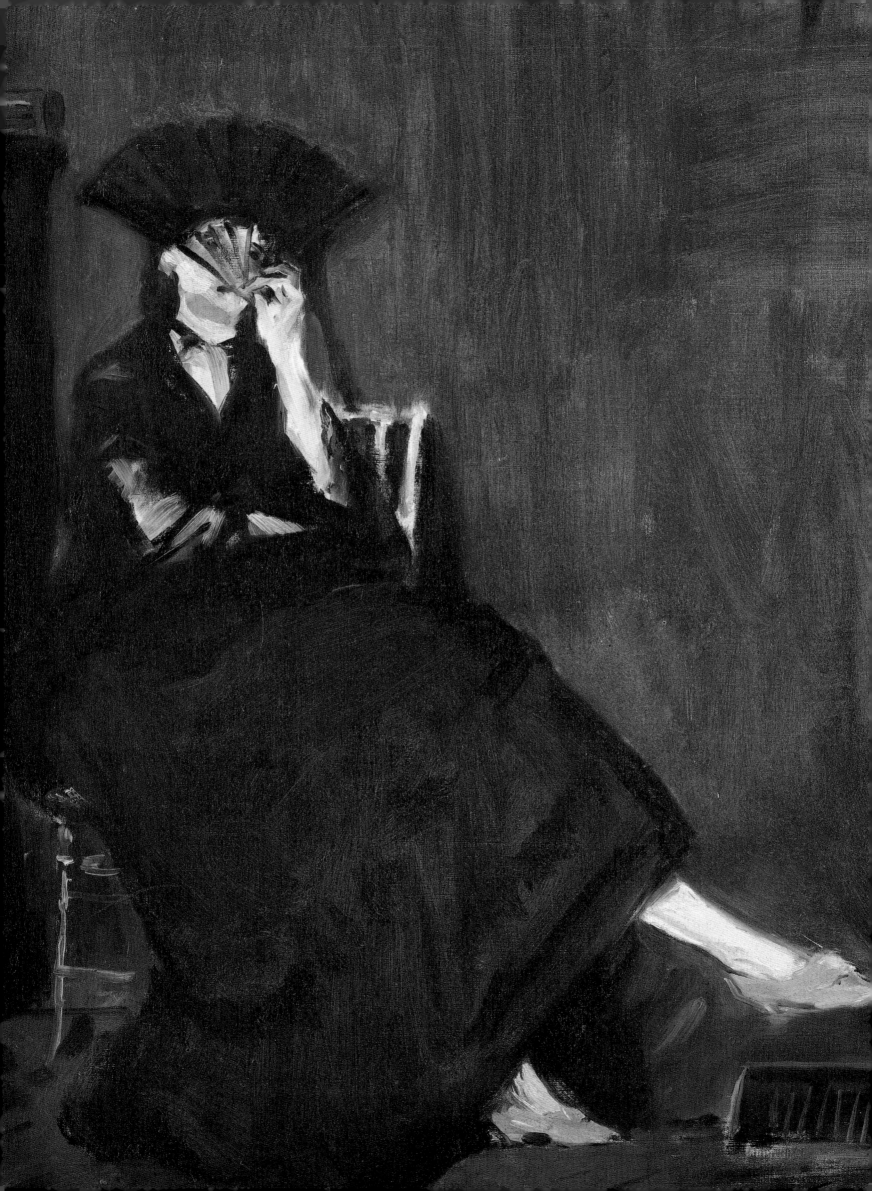

Delacroix's favorable opinion. The rejection note arrived at his place in the presence of Charles Baudelaire: "Ah, [Couture] had me turned down," Manet declared. "What he must have said about it, in front of the other high priests of his ilk. But what consoles me is that Delacroix found it good. For, I have been told, Delacroix did find it good. He's a different customer from Couture, Delacroix. I don't like his technique. But he's a gentleman who knows what he wants and makes it clear. That's something."

Two years later, two of Manet's paintings were accepted at the Salon, *Portrait of M. and Mme. Auguste Manet*, a double portrait of his parents, and *The Spanish Singer*, which received an honorable mention. For several years, Manet did paintings with Spanish subjects, but he visited Spain only in August of 1865, after which he stopped painting Spanish themes.

Private Life

Manet's private life, especially during those years, is difficult to ascertain. Only a few facts are known. In 1849 he met Suzanne Leenhoff (1830–1906), a young Dutchwoman who gave piano lessons to him and his brother Eugène. On January 29, 1852, Léon-Édouard Koëlla, known as Leenhoff (1852–1927), was born, the illegitimate son of Suzanne Leenhoff. It has often been assumed that Manet himself was the father, although later the Manet family tried to keep up the pretense that Léon and Suzanne were brother and sister, and not mother and son. Manet portrayed Léon in several paintings; *Reading*, where he is standing near his mother, and in *The Luncheon in the Studio*, where the young man is at the center of the entire composition. Eventually, Manet and Suzanne Leenhoff married at Zaltbommel, in the Netherlands, on October 28, 1863, a year after the death of Auguste Manet. To live with an unmarried woman and her illegitimate child was not uncommon in artistic circles at the time. A few years later, Claude Monet went to live with Camille Doncieux and their son Jean, and Pierre-Auguste Renoir moved in with Aline Charigot during the early 1880s. But unlike his younger colleagues, Manet was in the favorable situation of being economically independent and he never had to worry about his finances as did Monet and Renoir.

Berthe Morisot with a Fan
1872; *oil on canvas*; 23 1/2 x 17 3/4 in. (60 x 45 cm.).
Paris, Musée d'Orsay.
The peculiar motif of Berthe Morisot coquettishly holding a fan before her face appears to be unique and might have been born out of a studio joke. However, the fan appears frequently as her attribute, as in The Balcony *and in* Portrait of Berthe Morisot (Le repos). *It almost reveals more of her face than it covers up. The black of her dress as well as the monochrome wall behind her evoke a Spanish atmosphere.*

Stem of Peonies and Pruning Shears
1864; *oil on canvas*;
22 3/8 x 18 1/4 in.
(56.8 x 46.2 cm.).
Paris, Musée d'Orsay.
The composition, unusual for a flower still-life, might have been derived from still-lifes of game in the manner of Chardin or Oudry, where dead animals often appear hanging upside down from a wall. The pruning shears with which the flowers have been cut are placed in front of them like a threatening weapon.

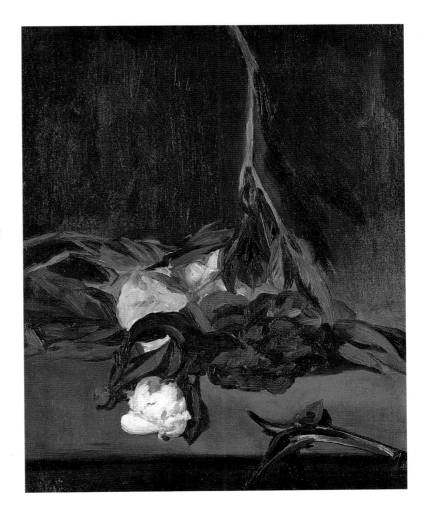

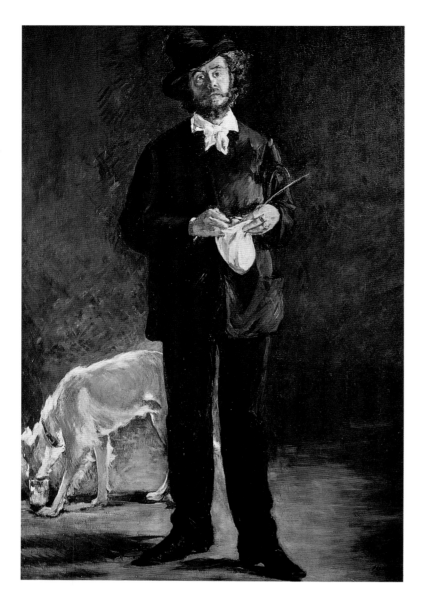

**The Artist
(Marcellin Desboutin)**

1875; *oil on canvas;*
75 5/8 x 50 3/8 in. (192 x 128 cm.).
São Paulo, Brazil, Museu de Arte.
*The painter and etcher
Marcellin Desboutin, who
modeled for this picture,
might have met Manet at
the meetings at the Café
Guerbois. The painting is in
many ways similar to* The
Tragic Actor, *but here the
brushwork is looser, the palette
brighter, and the overall effect
less severe. Manet emphasized
the sympathetic and dignified
character of Desboutin, of
whom he was particularly fond.*

Manet and Friends

Information about other aspects of Manet's private life is even more scarce. His friendships with Edgar Degas and Henri Fantin-Latour, both of whom Manet had encountered during visits to the Louvre, were often stormy. Baudelaire, who held him in great esteem, had died by 1867. Relationships with younger writers like Émile Zola and Stéphane Mallarmé were of a different kind. Mallarmé, who was on fairly close terms with the decade-older painter and who was perhaps attracted by Manet's distinguished association with Baudelaire, the writer whom Mallarmé most admired, does not reveal much in his writings about the nature of their encounters. In any event, Manet's portrait of Mallarmé turned out to be the most striking likeness of the poet who was also painted by Renoir, Edvard Munch, and Paul Gauguin, among others.

Manet's correspondence adds nothing essential to our knowledge of his personality. He was loyal to his friends and often generous, lending money readily to Baudelaire, Zola, and Monet, among others. He died too young (at age fifty-one) to be formally interviewed, as had Paul Cézanne or Pierre-Auguste Renoir, and he kept no journal. The books in his library were largely volumes published by his friends. Rather than an intellectual and speculative thinker, Manet was most brilliant at spirited conversation. Jacques-Émile Blanche, the portrait painter of Parisian celebrities at the turn of the century, judged Manet thus: "He was not a theoretician. His customary remarks about his art were good-humored prattle. He spoke of it as an 'amateur Communard' might speak of the Revolution." For Manet, discussions about art were idle debate, although he himself met regularly with artist friends at the cafés of Paris. It is not known how such gatherings proceeded. It appears though that Manet was often at the center of their debates, shaping the conversation with his sharp wit. "Art is a circle," he would often say. "You're either inside or outside, by accident of birth."

The Influence of History

Occasionally, external events entered this circle and found their way onto the canvas. In June 1864, a naval battle of the American Civil War was fought in the Channel off Cherbourg between the *Kearsage* and the *Alabama*, about which Manet was informed by detailed newspaper reports. The painting, *Battle of the 'Kearsage' and the 'Alabama'*, based on the incident, was exhibited the same year.

On June 19, 1867, while the Exposition Universelle was being held in Paris, the Emperor Maximilian of Mexico was executed along with two of his Mexican generals. The news spread quickly in France, and soon indignation was voiced against the role Napoleon III had played earlier in establishing Maximilian's reign and the ensuing withdrawal of French troops and support. The painting, *The Execution of Emperor Maximilian*, was intended and understood as a critical comment on these events. However, when it was made clear to Manet that the Salon of 1869 would reject the painting, he decided to submit *The Balcony* and *The Luncheon in the Studio* instead.

In *The Balcony*, painter Berthe Morisot made her first striking appearance on a Manet canvas. She had been introduced to Manet by Fantin-Latour in the Louvre, where she was copying a work by Rubens. Manet was fascinated by her charm and natural distinction and soon the Morisot and Manet families were much together. Berthe and her mother regularly attended Thursday evening parties at the Manets, where Suzanne Manet would perform on the piano for a circle of friends, then including Degas, Zola, and the Belgian painter Alfred Stevens, among others. When in December 1874 Berthe Morisot married Manet's younger brother Eugène, she became thus the painter's sister-in-law. He painted her likeness repeatedly over the following years and it has been freely hinted that her feelings for Manet were stronger than those of mere friendship, but this does not seem to be true. Manet did, however, greatly admire both her and her work, especially her landscapes, which were done in a bright palette with Impressionistic brushwork.

Manet and Impressionism

Manet's art defies any clear-cut categorization. It was always provocative and challenging and set apart from the eclectic and conservative taste of the Second Empire and the early Third Republic. His oeuvre was modern and singular. Today often considered an Impressionist, especially as he worked with Monet and Renoir in Argenteuil during the summer of 1874 after the first so-called Impressionist Exhibition, his work is easily distinguished from theirs. Manet was primarily a figure painter who was fascinated with subjects from modern urban life. He never painted a landscape for its own sake like Monet, for example, who

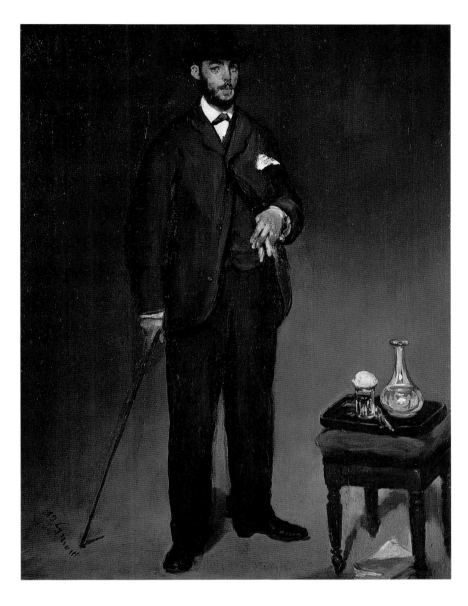

Portrait of Théodore Duret

1868; *oil on canvas;*
17 x 13 3/4 in. (43 x 35 cm.).
Paris, Musée du Petit-Palais.
Manet's friendship with art critic and collector Théodore Duret goes back to his visit to Madrid in 1865, where the two men met in a restaurant under amusing circumstances. Although Duret's comments about his friend's paintings were not always flattering, the artist entrusted his canvases to him during the siege of Paris in 1870 and named Duret executor of his estate.

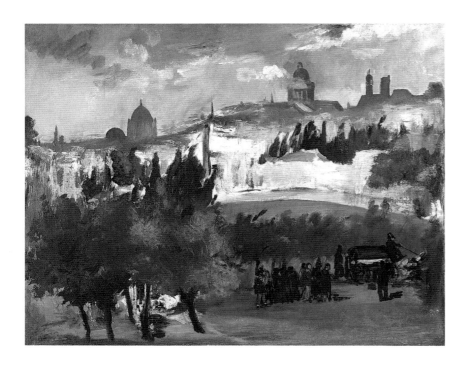

The Funeral

1867–1870c. ; *oil on canvas;*
28 5/8 x 35 5/8 in.
(72.7 x 90.5 cm.).
New York, Metropolitan
Museum of Art.
*The locale of this scene
has been identified as the
Butte Mouffetard at the
southeast edge of Paris.
In the background, the
silhouetted dome of
Val-de-Grace and the
Panthéon appear together
with the tower of St.
Étienne-du-Mont. It has
been convincingly argued
that the procession at the
bottom right represents
the cortege at Baudelaire's
interment,which occurred
on September 2, 1867.*

concentrated on outdoor subjects as perceived through the painter's eyes, transcribing his experience into visions of color and light. Nevertheless, references to Manet as being the leader of a new art movement, later known as Impressionism, began to circulate in the early 1870s. He was at times considered the head of a new school of painting or — by some critics — simply the embodiment of the "Manet gang." But nobody was less suited for that role by temperament than Manet. As a truly independent-minded individual, he was unwilling to play a prominent role in a group. He was neither pompous nor dogmatic, and his behavior remained at times enigmatic even to his contemporaries.

Manet never took part in any of the eight Impressionist exhibitions of his friends, although the variety of styles in those shows would easily have accommodated his works as well. But it appears that Manet was disinclined to see his paintings lost in that potpourri of avant-garde styles. He preferred to exhibit at the Salon, certain setbacks there notwithstanding. Degas interpreted Manet's absence from the Impressionist group shows as vanity: "Manet seems determined to keep aloof, he may well regret it ... I definitely think he is more vain than intelligent." It is difficult to ascertain if this judgment is true or not. Manet always supported and encouraged his colleagues. In 1877, for example, he recommended the work of "my friends Messrs. Monet, Sisley, Renoir, and Mme. Morisot" to the critic of *Le Figaro*, Albert Wolff.

Renegade and Conservative

Deep inside, Manet was a traditionalist, though a rebellious one. His goal was to reform the Salon and official French art through its own institutions rather than seeking change from outside through dubious means. In 1879 he submitted a plan for decorating the Municipal Council Hall in the new Hôtel de Ville (the old one was destroyed by fire during the Paris Commune) to the prefect of the Seine: "To paint a series of compositions representing, to use an expression now hackneyed but suited to my meaning, 'the belly of Paris,' with the several bodies politic moving in their elements, the public and commercial life of our day. I would have Paris Markets, Paris Railroads, Paris Ports, Paris Under Ground, Paris Racetracks and Gardens. For the ceiling, a gallery around which would range, in suitable activity, all those living men who, in the civic sphere, have contributed or are contributing to the greatness and the riches of Paris." Nothing became of this plan. However, it illustrates perfectly Manet's own position between tradition and the modern avant-garde. He must have welcomed the return of both Renoir and Monet to the Salons of 1879 and 1880, respectively, although they had thus become "renegades" in the eyes of their fellow artists.

In 1881 an important change took place in the status of the official Salon exhibitions. Abandoning the system of supervision by the state, any accepted artist was now entitled to participate in the election of the jury. Although this opportunity to get rid of its most reactionary members, almost all of them teachers at the École des Beaux-Arts, was not fully exploited from the start, the new procedure certainly opened the way to a far more liberal selection process, a development that seemed to confirm Manet's somewhat cautious restraint in the past.

Manet certainly felt flattered by any form of official recognition and a triumph at the Salon as an independent counted more than a "succès de scandale" at his friends' group shows. When his painter friend Giuseppe de Nittis was distinguished in 1878 with the red ribbon of the Légion d'honneur, an award Manet himself was to receive in December 1881, he declared to Degas: "You must take everything that distinguishes you from the crowd ... In this dog's life of ours, where everything is a struggle, one can't be too heavily armed ..." To which Degas, who had no sympathy for such weaknesses, maliciously replied: "To be sure, I was almost forgetting what a bourgeois you are."

In his battle against the institutions Manet slowly but consistently gained ground. During the mid-1870s the influential critic Jules Antoine Castagnary changed his previous negative opinion and began to defend Manet's works: "His place is marked in the history of contemporary art. When the time comes to write about the evolutions or deviations of nineteenth-century French painting, one can forget about M. Cabanel [a leading academic painter] but one must reckon with M. Manet." Even a skeptical voice like that of Albert Wolff of *Le Figaro* concluded: "In the end he has an individual temperament. His painting is not for everybody; it is the work of an incomplete artist, but still of an artist ... There is no denying it; Manet's art is entirely his own." These words were published in Wolff's review of the Salon of 1882. By then, Manet had only one more year to live.

A Brief Career

One must bear in mind that Manet's oeuvre, from *Le déjeuner sur l'herbe* to *A Bar at the Folies-Bergère*, unfolded over little more than two decades. After a rather late start, his career ended at the height of his powers, when the dreams of his youth began to bear fruit.

Manet's fatal illness, locomotor ataxia, was a nervous disorder. During the last months when he was already confined to his bed, Manet painted a series of still-lifes of flowers, brought or sent to him by his friends. In these works, nature is represented in the only form Manet liked: cultivated, culled, displayed.

The Bathers
1874c. or 1876;
oil on canvas; 52 x 38 1/2 in. (132 x 98 cm.). São Paulo, Brazil, Museu de Arte.
This painting is sometimes considered a study, given its unfinished aspects. The work has a unique position in Manet's oeuvre as it depicts nudes, a subject he almost completely avoided. The women recall certain bathers of Renoir, and Manet might very well have been stimulated by similar examples of his friend.

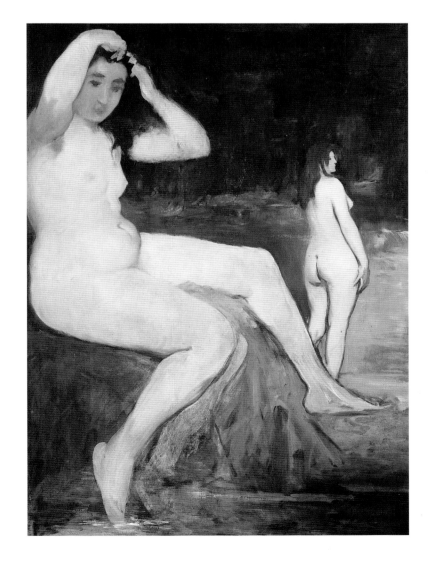

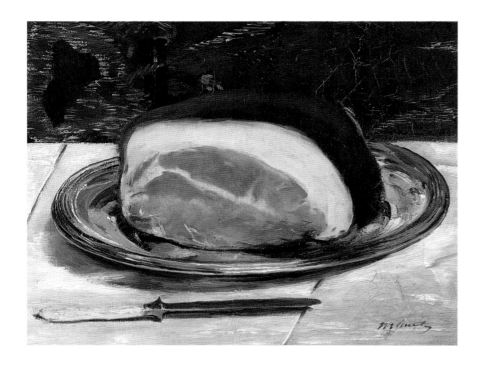

Ham
c. 1875–1878; *oil on canvas; 12 5/8 x 16 1/2 in.*
(32 x 42 cm.). Glasgow, Burrell Collection.
The subject of this still-life is quite unique
and not only in Manet's oeuvre. It appears
to have been painted during the artists's later
years, when he also produced still-lifes of lemons
and asparagus. The work was first owned by
Pertuiset, whose portrait Manet also painted,
and later by Degas. In its simplicity it recalls
the works of Chardin, whom Manet admired.

Manet died on April 30, 1883. Monet received the sad news while he was just moving to his new home in Giverny. He left everything behind and hurried to Paris. Of all the Impressionist artists, he was the only one to serve as a pallbearer at the funeral, which took place on May 3.

Posthumous Popularity

Soon after Manet's death, a noticeable change in the general attitude toward his works took place. Prices for his paintings began to rise. In January 1884, less than a year after Manet's death, a large retrospective was mounted at the École des Beaux-Arts with the help of Berthe Morisot and her husband. The introduction to the catalogue was written by Zola. Félix Fénéon published what was perhaps the most pertinent review of the Manet show: "If I had to give any advice to the public which today, in front of the master's works, opens wide and blissfully its bovine eyes, I should incite it to check a little its tardy admiration and to endeavor conscientiously to understand the paintings of those artists who drew inspiration from Manet without copying him, who—in the sincere expression of modern life—sometimes surpassed their initiator; I refer to the gallant clan of impressionists, to Camille Pissarro, Raffaëlli, Renoir, Mary Cassatt, Claude Monet, J.-L. Forain, Degas, de Nittis, Berthe Morisot, and Sisley."

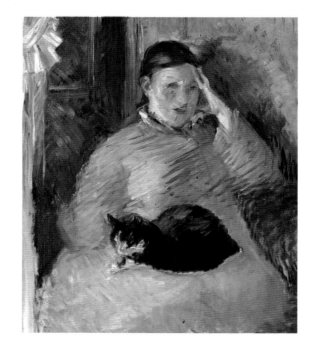

Woman with a Cat
1880; *oil on canvas; 36 1/4 x 28 3/4 in.*
(92 x 73 cm.). London, The Tate Gallery .
According to Léon Leenhoff, the
woman depicts the artist's wife
Suzanne at the apartment in rue
de Saint-Petersbourg. The motif
of the cat, which is quietly resting
on her lap, is a recurrent feature
in Manet's oeuvre and can also
be found in his Olympia as well
as in graphic works. The painting
belonged to Degas for some time
before it was purchased for the muse-
um at the sale of the artist's estate.

Amazon
1882; *oil on canvas; 28 x 20 1/2 in.*
(74 x 52 cm.). Madrid,
Thyssen-Bornemisza Museum.
In French usage, the word
"amazon", signifies a proud
woman, in addition to alluding
to the mythological Greek
women, who were famous for
their strength and independence
from men. Manet borrowed
the riding costume from the
painter Gallard-Lepinay for
the occasion. The model was
most likely the daughter of a
bookseller on rue de la Moscou.

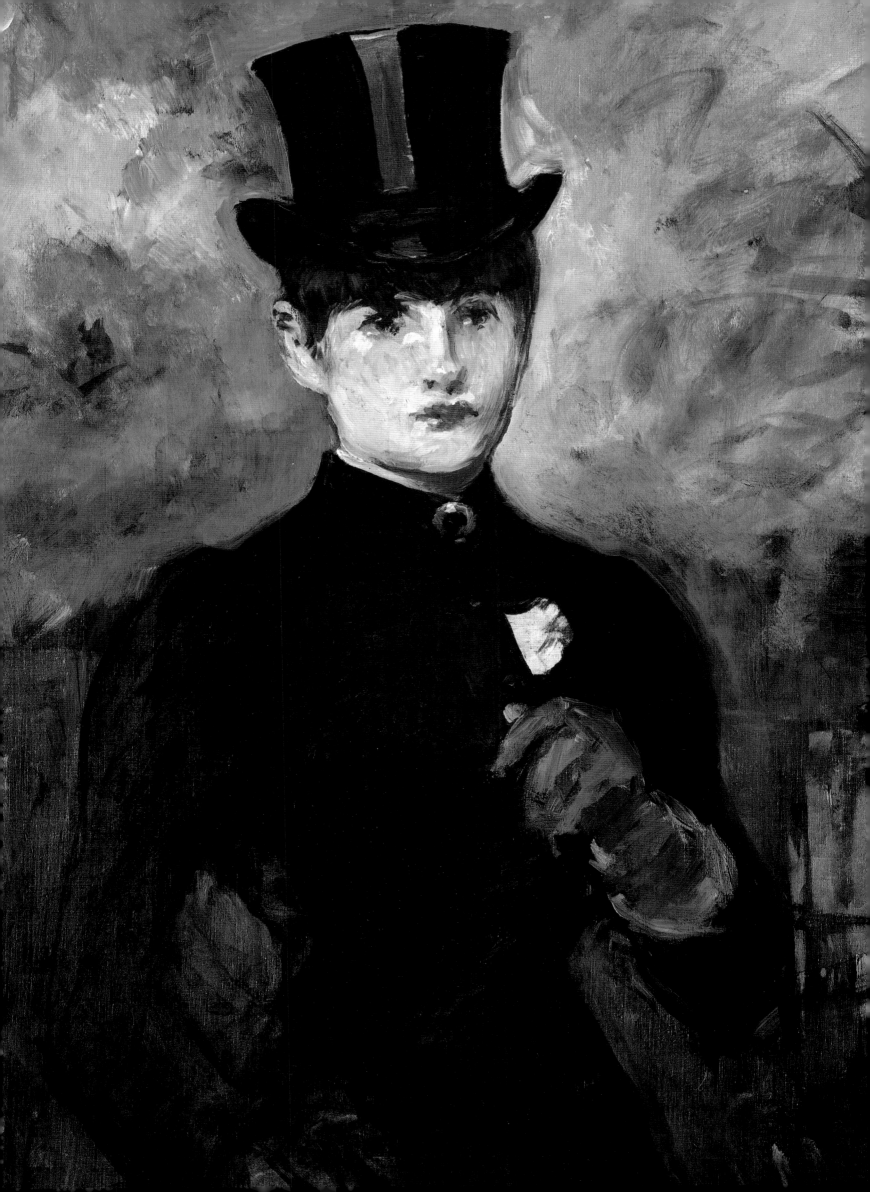

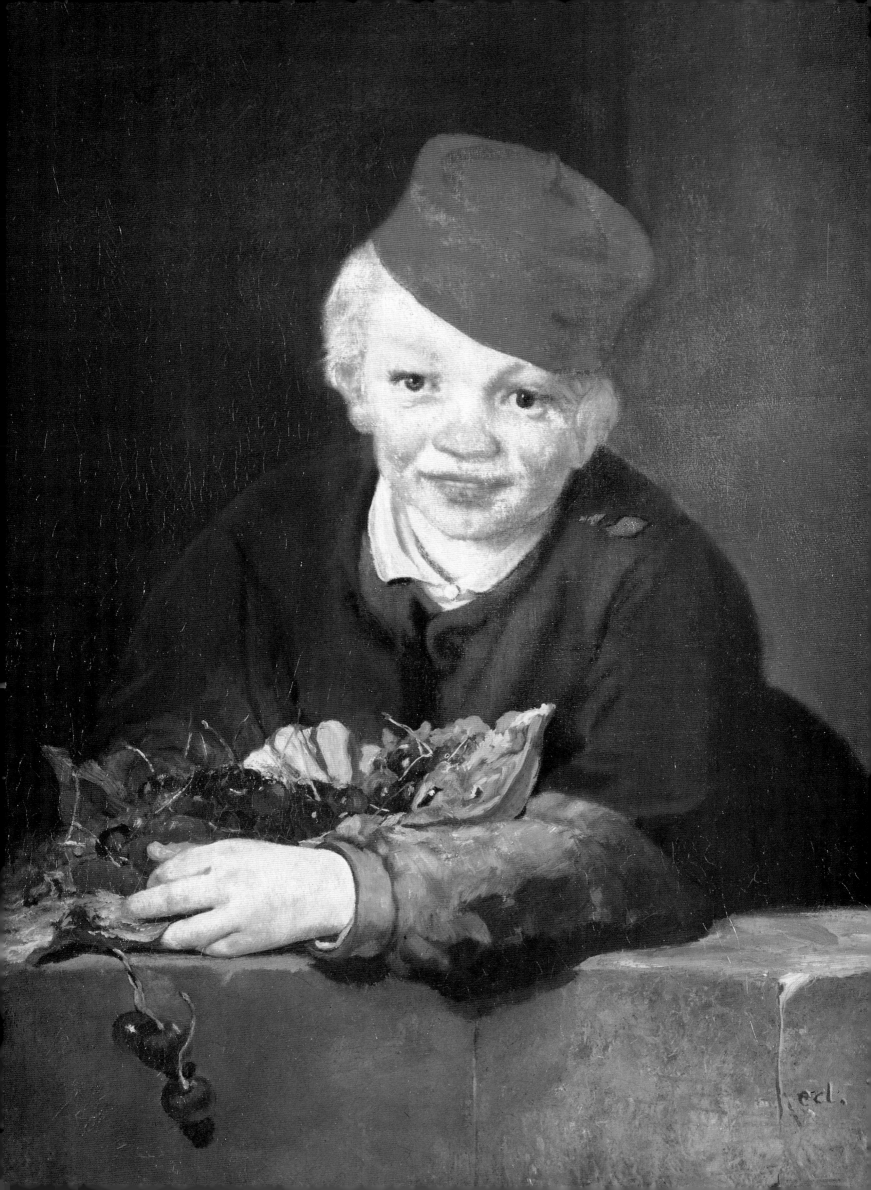

CHAPTER 1

EARLY SUCCESS AND SCANDAL

*B*efore the advent of commercial art galleries and dealers in the last quarter of the nineteenth century, the official Salon was virtually the only public place to exhibit art works. Recognition could only be gained through acceptance to the annual show, but the selection process, controlled by predominantly conservative jury members, was painstaking and often unpredictable.

Manet's first attempt to exhibit there was a failure. *The Absinth Drinker*, which he submitted to the jury of the Salon of 1859, was refused. "I did ... a Parisian character," Manet commented, "whom I had studied in Paris, and in executing it, I put in the simplicity of technique I see in Velázquez's work. People don't understand. Perhaps they will understand better if I do a Spanish character." Manet had chosen a typical character of the Parisian underclass, a ragpicker by the name of Colardet. By painting this low-life subject in a large format, he endowed it with a weight and importance that nobody before him had ever dared. The broad handling of the brush, reminiscent of the sketchlike treatment of preparatory studies, must have startled the jury members, accustomed to judging smoothly painted canvases with mythological or genre subject matters. The only jury member to vote in favor of the young artist was Eugène Delacroix, who himself worked with a lively brushwork and thick impasto.

Manet had apparently been inspired by a passage in Charles Baudelaire's collection of poems *Les Fleurs du Mal*, published in 1857, where the writer describes a similar poor working-class character. The painting was executed in the studio, however, as can be deduced from the artificial lighting which comes from two different sources and in the overall arrangement of the figure and its accessories.

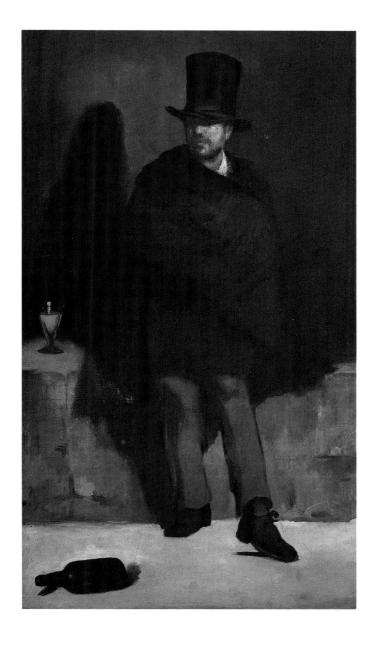

Boy with Cherries
1859; *oil on canvas*; 25 3/4 x 21 1/2 in. (65.5 x 54.5 cm.).
Lisbon, Calouste Gulbenkian Museum.
The influence of seventeenth-century Dutch genre scenes is evident in this work, where a young boy is leaning over a parapet presenting cherries to the viewer. The bright red cap on his head corresponds to the complementary green of the vine leafs, on which the cherries have been arranged. The model, a boy named Alexandre, who worked in Manet's studio, eventually committed suicide at the age of fifteen.

The Absinthe Drinker
c. 1859; *oil on canvas*; 72 x 41 3/4 in. (181 x 106 cm.).
Copenhagen, Ny Carlsberg Glyptotek.
Inspired by a passage in Baudelaire's Fleurs du Mal, *Manet painted this portrait of an alcoholic by the name of Colardet, who was a ragpicker. Leaning against the wall, a glass of absinthe at his side, the sitter is gazing into the distance. An empty bottle on the ground provides a sense of depth. The jury of the Salon of 1859 rejected the work, probably because the subject matter was considered indecent in such a large-scale painting.*

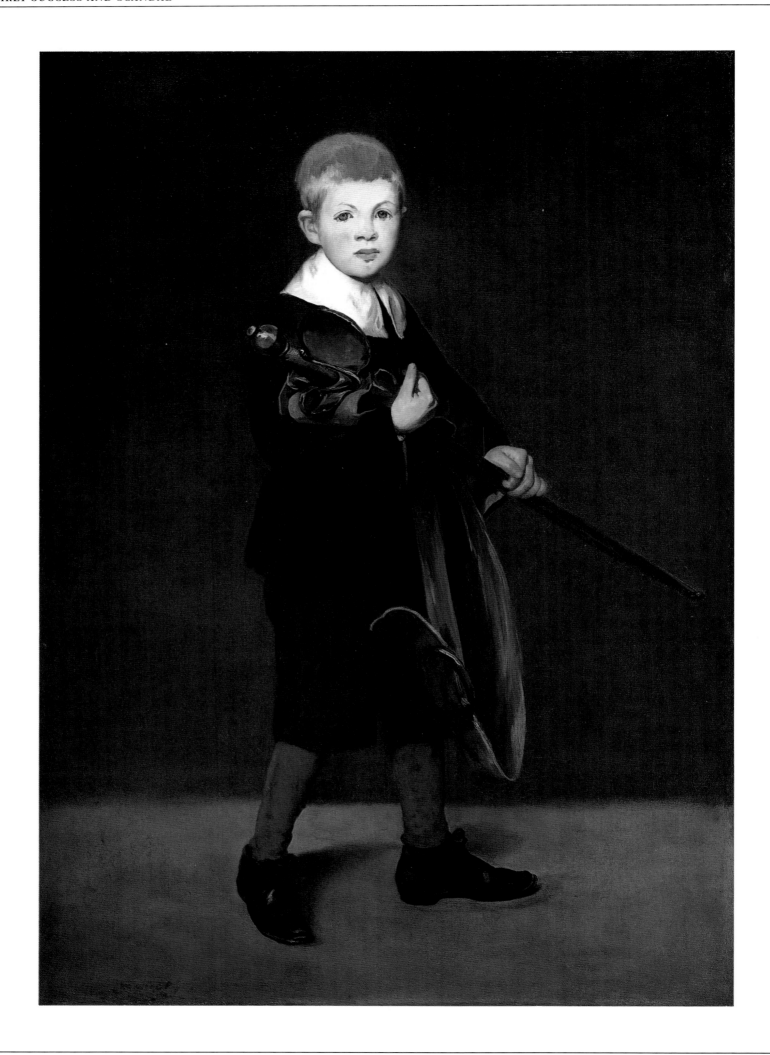

Spanish Subjects

Manet's interest in Spanish painting, Velázquez, Goya, and Murillo, in particular, was fused eventually into a series of paintings with Spanish subjects. At the Salon of 1861 he presented *The Spanish Singer*, together with *The Portrait of M. and Mme. Auguste Manet*, both of which were accepted this time. While the double portrait of his parents shows the influence of Frans Hals, whom Manet especially admired, *The Spanish Singer* undoubtedly owes much to the Spanish Old Masters. This painting brought the artist his first popular and critical success, despite its poor hanging in the show. Its broad execution, its vivid colors, and the charm of the subject all attracted visitors and critics, who lauded the artist's keen observation of real life and the exotic and picturesque costume of the sitter.

Due to the favorable comments, the canvas was rehung to a more advantageous location, an extraordinary event which foreshadows Manet's experience with future Salons. It finally earned him an "honorable mention." At age twenty-nine, Manet thus became a promising young artist with a reputation as a leading modern painter. The few denigrating remarks voiced by some critics failed to spoil this position. On the contrary, a group of young painters and writers went to Manet's studio to express their admiration for *The Spanish Singer*. As the critic Fernand Desnoyers later remembered, they were stunned "like children at a magic show: Where could Manet have come from? The Spanish musician was painted in a certain new, 'strange' way that the astonished young painters had believed to be their own secret, a kind of painting lying between that called realist and that called romantic." Manet welcomed his guests, answering their questions about the painting and himself. This episode was important as it is the starting point for Manet's status as the acknowledged leader of a new generation of young artists.

Manet's earlier remark that the public would understand better if he did a Spanish subject had proved to be correct. In fact, there had been a strong and growing interest in Spanish art and culture in France since about 1840, and Manet's work fit into this development. And critic

Théophile Gautier noted that the costume of *The Spanish Singer* was a mixture of various elements. The jacket, for instance, was a type used in Marseilles and the pants were common in Paris at that time, while only the headscarf and the espadrilles were actually Spanish. In other words, the figure was a creation of the studio, not an authentic Spanish character. Zola reports that Manet kept Spanish costumes in his studio and liked their colors. They appear indeed in other paintings from that time.

Boy with a Sword

1861; *oil on canvas*; 51 5/8 x 36 3/4 in. (131.1 x 93.3 cm.).
New York, Metropolitan Museum of Art.
Manet's interest in the works of seventeenth-century Spanish masters, Velázquez in particular, is strikingly evident in the present work. Léon Koëlla-Leenhoff, who was most likely Manet's own son, served as the model, represented in the costume of a page boy in the aristocratic society of that time. The sword, which Manet had borrowed for the occasion, may allude to the painter's accomplishments as a swordsman.

Young Man in the Costume of a Majo

1863; *oil on canvas*; 74 x 49 1/8 in. (188 x 124.8 cm.).
New York, Metropolitan Museum of Art.
The model was the artist's younger brother Gustave, whose stylish and somewhat flamboyant costume is typical of those worn by the young working-class Spanish 'majos.' The black velvet dress contrasts with the bright scarlet mantle thrown over his arm, with the beige waistband and the gray lining of the jacket, as well as with the red and green foulards hanging out of his pockets.

A last word should be said about the musician and the guitar. Manet presented his model obviously as a left-handed guitarist, although the instrument is strung for a right-handed player. Furthermore, the chord indicated by the right hand suggests that the player knew nothing about the music. Manet himself did not seem to care much about this incongruence when asked about it. He preferred to point out the importance of the painterly execution: "Just think, I painted the head in one go. After working for two hours, I looked at it in my little black

mirror, and it was all right. I never added another stroke." Other parts of the painting show numerous "pentimenti" (changes), as for example in the jug, a Spanish type known as "alcarraza," and in the neck of the guitar and the model's right hand.

When *Boy with a Sword* was exhibited at Louis Martinet's gallery in March 1863, the subject's kinship to Spanish masters was immediately noticed. But some critics followed Zola's formalist approach, who wrote in his article on Manet in 1867: "Painters, especially Édouard Manet, who is an analytical painter, do not share the crowd's overriding concern with subject matter; for them, the subject is but an excuse for paintings, whereas for the general public, the subject is all there is."

At first glance, the painting is little more than a costume piece. The boy has been identified as the young Léon Leenhoff, who was most likely the artist's illegitimate son. Dressed in a seventeenth-century Spanish costume, the boy is represented as a page in the aristocratic society of that time. The figure itself and the light around it define the space, the background being of a neutral uniform brown, the ground of a complementary green. Only the sword carried in his arms provides some sense of depth. The influence of Goya's portraits of children was probably of as equal importance as the works of Velázquez. The boy is looking directly at the viewer or the painter himself. The sword, a studio prop Manet had borrowed for the occasion from the painter Charles Monginot, might allude to Manet's own accomplishments as a swordsman, transcending the aesthetic and art-historical reference to reach the realm of personal life.

Allusions to Goya's *Clothed Maja* are obvious and intentional in the *Young Woman Reclining, in Spanish Costume*. A sturdy young woman dressed in revealing trousers is lying on a crimson red couch, her right arm raised behind her head, face framed by a spit-curl hairdo. The masculine disguise was commonplace in the Romantic period and adds to the exotic character of the sitter. The luminous accent is not so much the woman's face and neck but the cream-velvet knee breeches and pale stockings. The model's provocative pose contrasts with her sulky air and her passive, languid attitude. Because of the dedicatory inscription to Manet's friend, the photographer Nadar, it has often been assumed that the model was Nadar's mistress. In fact, the woman's identity is not known. The static character of the composition is broken up by the presence of a cat playing with oranges. The animal's fur reflects the black and gray hues of the sitter's clothing on the couch, while the orange color adds a lively and humorous contrast. Henceforth, felines were favored by Manet, who used a cat later in his famous *Olympia* and in several drawings and engravings.

Mademoiselle Victorine in the Costume of an 'Espada'
1862; *oil on canvas*; 65 x 50 1/4 in. (165.1 x 127.6 cm.).
New York, Metropolitan Museum of Art.
The model, Victorine Meurent, began posing for Manet that year. She is wearing a Spanish costume, although Manet did not visit Spain until three years later. Émile Zola, however, told of a collection of such costumes he saw at the painter's studio, which Manet might have obtained from a Spanish tailor in Paris. The fact that a woman is wearing men's clothing and shoes unsuitable for bullfighting leaves no doubt about the fictive character of the composition.

**Portrait of
Victorine Meurent**
1862; *oil on canvas;*
16 7/8 x 17 1/4 in.
(42.9 x 43.7 cm.).
Boston, Museum of Fine Arts.
*When Manet encountered
the eighteen-year-old
Victorine Meurent in a crowd
outside the Palais de Justice,
he was "struck by her unusual
appearance and her decided
air." Victorine was a profes-
sional model and would pose
numerous times for Manet
over the following decade.
The painter was fascinated by
her red hair and creamy skin
that caught the light so well
as exemplified in* Olympia.

His Favorite Model

When Manet met Victorine Louise Meurent, she was
about eighteen years old. According to Théodore Duret,
the painter saw her in a crowd outside the Palais de
Justice in Paris and was "struck by her unusual appear-
ance and her decided air." Victorine was a professional
model who posed at the studio of Thomas Couture,
Manet's former teacher. She was to become his favorite
model, posing in numerous paintings between 1862 and
1875, including *Olympia* and the *Le Déjeuner sur l'herbe*.
She was amusing and talkative during the sittings, while
professionally patient and motionless. Her fair, creamy
skin and red hair caught the light well, as can be seen
in the small *Portrait of Victorine Meurent*, probably painted
shortly after the painter first saw her. The stark light
models her face with no shading or contrast. Pale eye-
lashes soften her absentminded look, while her chin
reveals the same indifference mingled with defiance we
encounter later in *Olympia* the *Le Déjeuner sur l'herbe*.
She even wears the same black ribbon around her neck
as *Olympia*, which has caused much discussion and
interpretation to the present day.

One of the earliest paintings for which Victorine
Meurent modeled was *The Street Singer*. Manet's long-
time friend Antonin Proust recalled later in his mem-
oirs an incident which apparently led to the creation of
this work. Walking on the streets around the boulevard
Malesherbes, where many buildings were being torn
down or rebuilt as part of the gigantic replanning and
modernization project of Paris under the direction of
Baron Haussmann, the two friends approached
Manet's studio in the rue Guyot, when a woman with a
guitar emerged from a cheap café. The artist was
intrigued by her appearance and thought immediately
of her as a suitable subject for a painting. He asked her
if she would pose for him, but the woman went off
laughing. Thus Victorine became the model for *The
Street Singer*.

The painting was shown at Martinet's gallery a month
before the jury began to review the works submitted to
the Salon of 1863. Apparently, Manet hoped to receive
some favorable response beforehand which would facili-
tate his entry to the Salon accordingly, but this strategy
failed. The critic Paul Mantz lamented the artist's failure

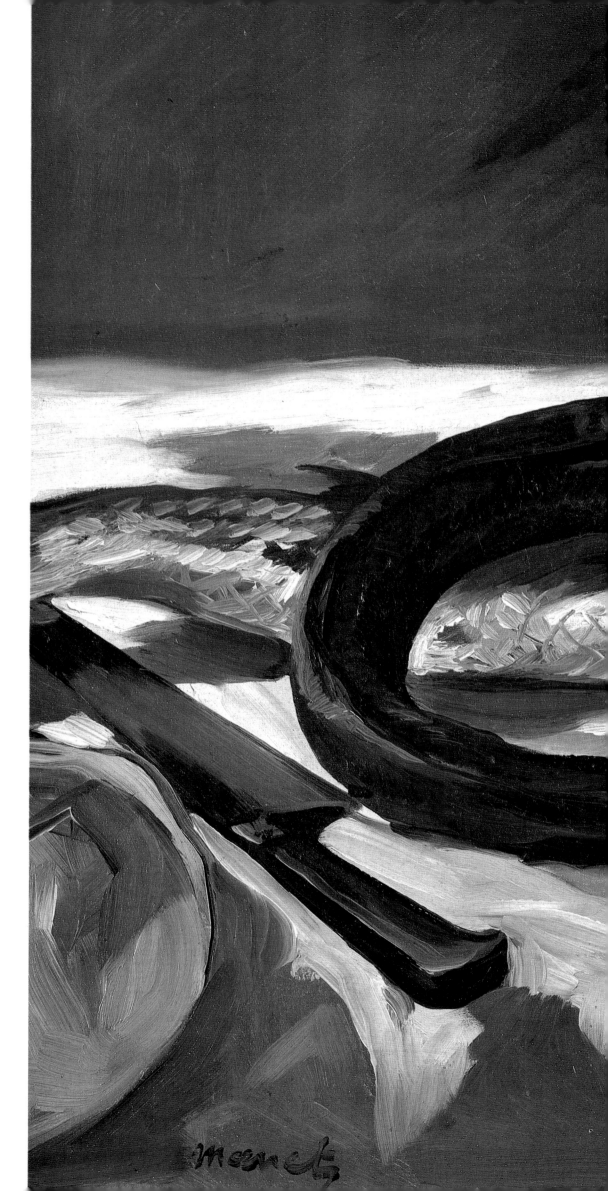

Eel and Red Mullet

1864; *oil on canvas;*
15 x 18 in. (38 x 46 cm.).
Paris , Musée d'Orsay.
The similarities of style and
conception to Still-Life with
Fish *indicate that this work was*
painted at about the same time.
Here, Manet emphasizes the
contrast between the solid body
of a red mullet with the
curvilinear shape of an eel.
A knife on the left serves
to stress a diagonal movement
already introduced with the eel.

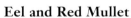

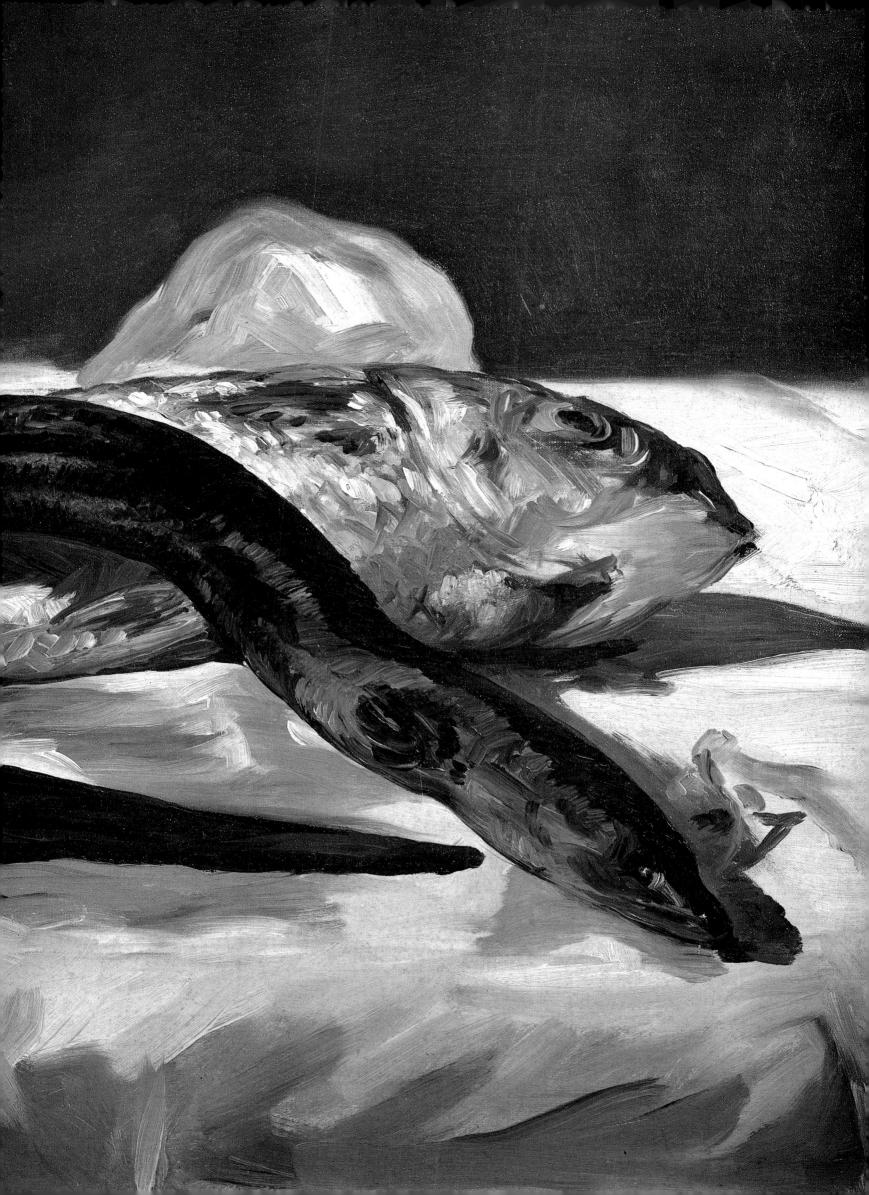

to fulfill his promise of *The Spanish Singer* from two years earlier: "All form is lost in his [Manet's] big portraits of women, particularly that of the "Singer," where because of an abnormality we find deeply disturbing, the eyebrows lose their horizontal position and slide vertically down the nose, like two commas of shadow; there is nothing there except the crude conflict of the chalk whites with the black tones. The effect is pallid, hard, sinister . . . " It took four years before a positive review about the work was published by Zola. Among a group of paintings, he singled out *The Street Singer* as the canvas he liked best: "The whole work is a soft, blond gray, and it seemed to me that it analyzes life with extreme simplicity and exactitude. A picture like this, over and above the subject matter, is enhanced by its very austerity; one feels the keen search for truth, the conscientious effort of a man who would, above all, tell frankly what he sees."

Later commentators have noticed the influence of Japanese prints on the style of this painting. The same year Manet worked on this canvas, Mme. de Soye opened a shop for Japanese prints and Manet is known to have been among her very first customers. Furthermore, the simplifications and lack of half-tones may reflect the new medium of photography. The hard edges and sharp distinctions between light and dark, characteristic of photographs of the time, were exactly the traits Manet sought to incorporate into his work. Harsh lighting and reduced modeling are in fact obvious elements of *The Street Singer* and provide the image with its sense of modernity.

But contemporary viewers must have been confused about the subject itself. Instead of looking at an impoverished, shabby street musician, they saw a fairly well-dressed, charming young woman eating cherries. Manet might have added the fruit wrapped in yellow paper and held in the crook of the woman's arm for merely pictorial reasons. The red and yellow certainly add stronger hues to the otherwise subdued tonalities of the painting. The whole composition has been artificially arranged and hardly anybody would expect the woman to start

The Street Singer
1862; *oil on canvas;* 67 3/8 x 41 5/8 in. (171.3 x 105.8 cm.).
Boston, Museum of Fine Arts.
The subject of this painting was inspired by a casual encounter between Manet and a woman guitarist on the streets of Paris. Lacking the sentimentalism and anecdotal character cherished by contemporary taste, the painting was initially ill-received by the public. However, Émile Zola pointed out that the work "analyzes life with extreme simplicity and exactitude."

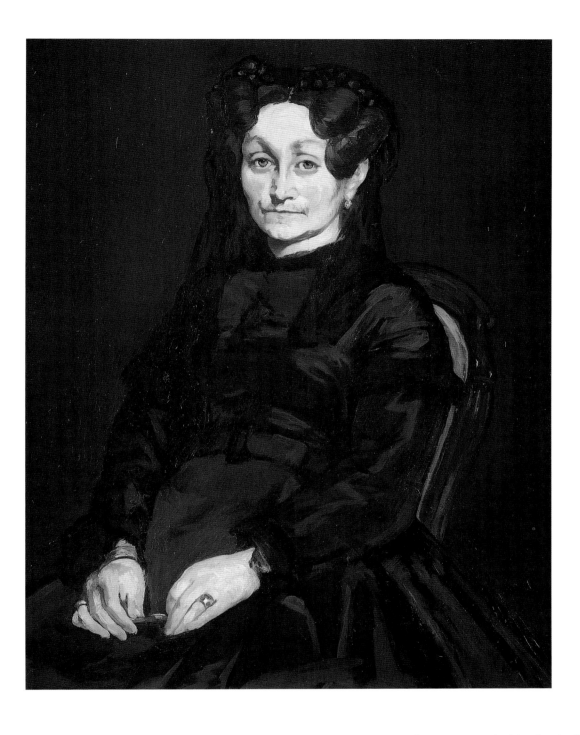

Portrait of Mme. Auguste Manet
1863; *oil on canvas;*
38 1/2 x 31 1/2 in. (98 x 80 cm.).
Boston, Isabella Stewart Gardner Museum.
This portrait of the artist's mother dressed in widow's black might well have been painted after her son got married and she came to live with him and his wife Suzanne. The effect of this work is somber, the palette limited, and the sitter's pose and expression severe. Her piercing blue eyes contrast with the pale tone of her flesh, lightened up by the warmer shades of her brown hair and golden jewelry.

playing the guitar she is casually holding with her left hand. The instrument has become merely a decorative element in the overall scheme. The cabaret doors behind the figure may have been adapted from the green shutters which were apparently part of Manet's studio and play such a prominent role in *The Balcony*.

A similar implausible arrangement of pictorial elements underlines also the artificiality of *Victorine Meurent in the Costume of an 'Espada'*, painted around the same time. The ground plane rises sharply and the figures in the background are too small relative to Victorine. The painter seems to have willfully shortened the illusion of depth in order to focus on the presence of the figure. Wearing men's clothing and shoes

that are unsuitable for bullfighting, Victorine clearly appears as a studio model posing before the artist. The bolero, hat, and headscarf are the same as in *The Spanish Singer*. Manet must have intentionally contrasted the skillfully painted figure with the flat background, which responds more to abstract pictorial needs of varying colors and values than to the visualization of a rational spatial relationship.

Victorine Meurent in the Costume of an 'Espada' was shown at the "Salon des Refusés" in 1863 alongside with *Young Man in the Costume of a Majo*, featuring Manet's younger brother Gustave in Spanish garb, and the famous *Le Déjeuner sur l'herbe*, which caused a furor lasting for several decades.

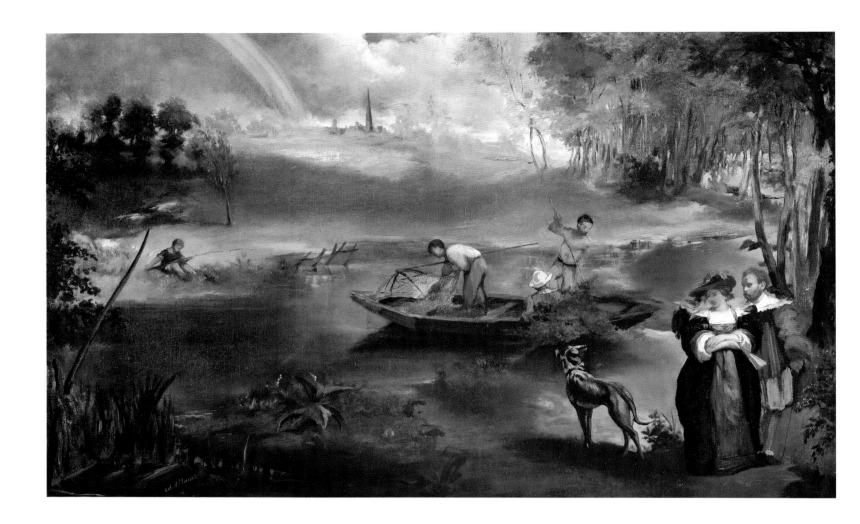

A Salon for the Rejected

In 1863 the jury of the Salon had been even more severe than in previous years, rejecting 2,783 out of 5,000 works submitted. Nobody could remember a similar proportion of refusals and rumors about this veritable "massacre" circulated widely in artistic circles of the capital. Petitions were drafted and plans discussed as to how to react to this outrage. The agitation among the artists was such that news about it reached the ears of the Emperor. On the afternoon of April 22, Napoleon III himself visited the "Palais de l'Industrie" inspecting some of the rejected works and decided that a "Salon des Refusés" was to be held in another part of the same building. Since the judgment of the jury could hardly be reversed, the imperial order appeared as a wise solution to the problem, leaving "the public as judge of the legitimacy of the complaints" as the official announcement said. Some artists, however, were uncertain if they should show their works under the given circumstances, afraid that exhibiting together with other rejected artists could hamper any future career at the official Salon.

Needless to say, Manet and his friends welcomed the Salon des Refusés, first because the new showcase had

Fishing in the Saint-Ouen near Paris (La Pêche)

1861–1863; *oil on canvas;* 30 1/4 x 48 1/2 in. (76.8 x 123.2 cm.). New York, Metropolitan Museum of Art.

The man and the woman on the right are none other than Édouard Manet himself and his future wife Suzanne Leenhoff. The figures are related in costume and pose to Rubens's portraits of himself and his wife, Hélène Fourment, in his painting Park of the Château of Steen *in Vienna. The landscape is also largely based on paintings by Rubens and Annibale Carraccio, preserved at the Louvre or known to the painter through engravings.*

been officially sanctioned by the highest authority, and secondly because it allowed them to show their works in competition with the art of the traditional École des Beaux-Arts. They hoped the public would conclude that the future of art belonged to them.

The Salon des Refusés was attended by more than seven thousand visitors on the first day alone. Most came out of curiosity, expecting a good laugh rather than an uncensored view of the latest works of art. One of the biggest attractions was Manet's *Le Bain* (The

Bath), later re-named *Le Déjeuner sur l'herbe*, the more so because Napoleon III had called it "immodest." Harsh critiques rained down upon the artist: "Manet will show talent once he learns drawing and perspective, and taste once he stops choosing his subjects for the sake of scandal ... We cannot find it altogether a chaste enterprise, to set down under the trees, beside students in cap and gown, a female clad only in leafy shade ... M. Manet plans to achieve celebrity by outraging the bourgeois ... His taste is corrupted by infatuation with the bizarre," critic Ernest Chesneau wrote. Others discerned "vulgarity" and "indecency" in this painting. But for Manet, the most disappointing criticism came from Théophile Thoré, a friend of Baudelaire's: "*Le Bain* is in questionable taste. The nude woman lacks beauty of form, unhappily ... and the gentleman sprawled beside her is as unprepossessing as could be imagined ... I fail to see what can have induced a distinguished and intelligent artist to adopt so absurd a composition. Yet there are qualities of color and light in the landscape, and indeed very true bits of modeling in the torso of the woman."

These comments pointed out some of the disturbing qualities which made the work indeed the most dazzling of the show. One was the unsettling contrast between the figures and the landscape. The unclad female figure, for which Victorine Meurent served as the model, and the two men beside her are studies made in the artist's studio and seem inserted into the landscape, painted with large, somewhat summarily treated brushstrokes like a stage set. Possibly both Eugène and Gustave Manet posed for the man to the right while the individualized face of the bearded man behind Victorine is the young Dutch sculptor Ferdinand Leenhoff, brother to Suzanne Leenhoff, soon to become Manet's wife. The second woman emerging from the stream has not been identified and might be a composite figure.

What were Manet's intentions in this work? To shock the public could hardly have been a valid motif for a serious artist such as Manet. From his friend Antonin Proust we know that he wished to present a modern version of an old subject. He wanted to show figures in a landscape, just as Giorgione, Titian, Watteau, and other Old Masters had done before him. To that end he even

Le Déjeuner sur l'herbe
detail. 1863;
Paris, Musée d'Orsay
This still-life of fruit and garment is painted with great skill and serves to stress the nudity of the woman sitting right behind it. It is modeled with a light hand and helps to create a perspective and depth in the foreground of the canvas. The unrealistic combination of fruits—the cherries of June, the figs of September— are born out of the artist's self-styled sense of reality painted in his studio.

borrowed compositional details from Giorgione's *Concert Champêtre* in the Louvre and from an engraving of the *Judgement of Paris* after Raphael. Gustave Courbet's realistic bathers and young ladies in landscapes served as more contemporary sources. *Le Déjeuner sur l'herbe* has little of the idyllic settings of his predecessors, though, and he obviously avoided any connections deliberately. Only the still-life of the clothes and fruit in the left foreground provides a tangible manifestation of a bucolic scene.

The woman's nudity alone could hardly have sparked such a violent reaction as it did during the show. It was rather the fact that she did not represent anything else but herself. She was not Venus nor Eve, but a model taking a rest between poses. Artist's models were already reputedly of easy virtue and the reaction of the painter Odilon Redon is quite instructive in this regard: "The painter is not being intelligent if, after he has painted a nude woman, she leaves us with the feeling that she is about to get dressed again ...There is one in Manet's *Le Déjeuner sur l'herbe* who will hasten to do so, after the discomfort of sitting on the cold grass beside the down-to-earth gentlemen she is with."

A similar fate befell his *Olympia*, shown at the Salon of 1865. Again, the model for the nude figure was Victorine. Stretched out on a couch in the tradition of Titian's *Venus of Urbino*, Goya's *Naked Maja* and Ingres's *Odalisque*, she again presents herself as who she is: a prostitute, whose black servant is bringing a bouquet of flowers from one of her admirers. The unveiled realism of the subject, which had disturbed so many contemporaries, still appears striking today. Contemporary comments such as "shocking" or "monster of profane love" contrast, however, with the modern notion that the painting is a definitive masterpiece, the subject of many erudite interpretations and eloquent discourses.

Focusing on the merely painterly qualities might help us to come to a better understanding of the work. There is the undeniably provocative presence of the female nude, who is presented without any restrictions or inhibitions. There is no mythological or allegorical excuse for her nudity. Olympia's body does not follow any standards of classical beauty. Her torso is narrow and small, the legs a bit short. She gazes at the viewer with a cold and challenging regard, without blushing. The finely modeled pale color of her flesh contrasts with the exuberant range of colors of the flowers and the dark skin of the maid. The black cat at her feet is the final exclamation mark of an arch that starts with the black velvet ribbon around Olympia's neck.

The wild reaction to the painting made Manet "as famous as Garibaldi," as Degas put it. But few recognized the delicacy of the color accords and the virtuosity with which Manet had created harmonies of blacks, grays, and whites. His technique was clear and almost cold but at the same time exuberant and full of temperament. Some of the shock which the painting provoked at the Salon might be explained by the analogy with contemporary pornographic photographs, but perhaps even more so by its pairing with *The Mocking of Christ*.

Manet painted only two ambitious religious works, *The Dead Christ and the Angels* and *The Mocking of Christ*. No external motivation, such as a commission from a church, seems to have prompted these canvases, although the recently published *Vie de Jésus* by Ernest Renan can not have escaped Manet's attention. The extremely popular and controversial biography interprets the person of Christ as a mortal human whose deification was explained in rational, not spiritual terms. This could illuminate critical comments that the figure of Christ in *The Dead Christ and the Angels* looks like that of a coal miner or an unwashed cadaver. The combination of *The Mocking of Christ* and *Olympia* at the Salon might have been stimulated by an apocryphal story about Titian, which at the time was believed to be true, according to which the painter presented his famous "Christ Crowned with Thorns" (today in the Louvre) together with a *Venus* to Emperor Charles V in order to satisfy his feelings of devotion and sensuality at the same time. It would have been therefore an artistic rather than a spiritual force which drove Manet to execute these paintings and show them together.

The widespread negative reaction to his works at the Salon caused Manet considerable uneasiness, as he confided to Baudelaire, who was concerned that the painter might be discouraged in his pursuit of realism. Manet finally decided to visit Spain, probably hoping to find new inspiration from a country he felt he knew so well. His short stay left a deep impression on him, but after his return to Paris he soon abandoned his Spanish subjects and focused on contemporary Paris.

Olympia

detail. 1863;Paris, Musée d' Orsay.

The exquisite bouquet of flowers, a present from one of Olympia's clients, is more sensitive and more expressive than the model herself. The black maidservant's elegant hands contrast effectively with the white paper, while the pink tonalities of her dress subtly relate to Olympia's white flesh. The presence of the black woman with bouquet is a pictorial rendering of passages from Baudelaire's Fleurs du Mal.

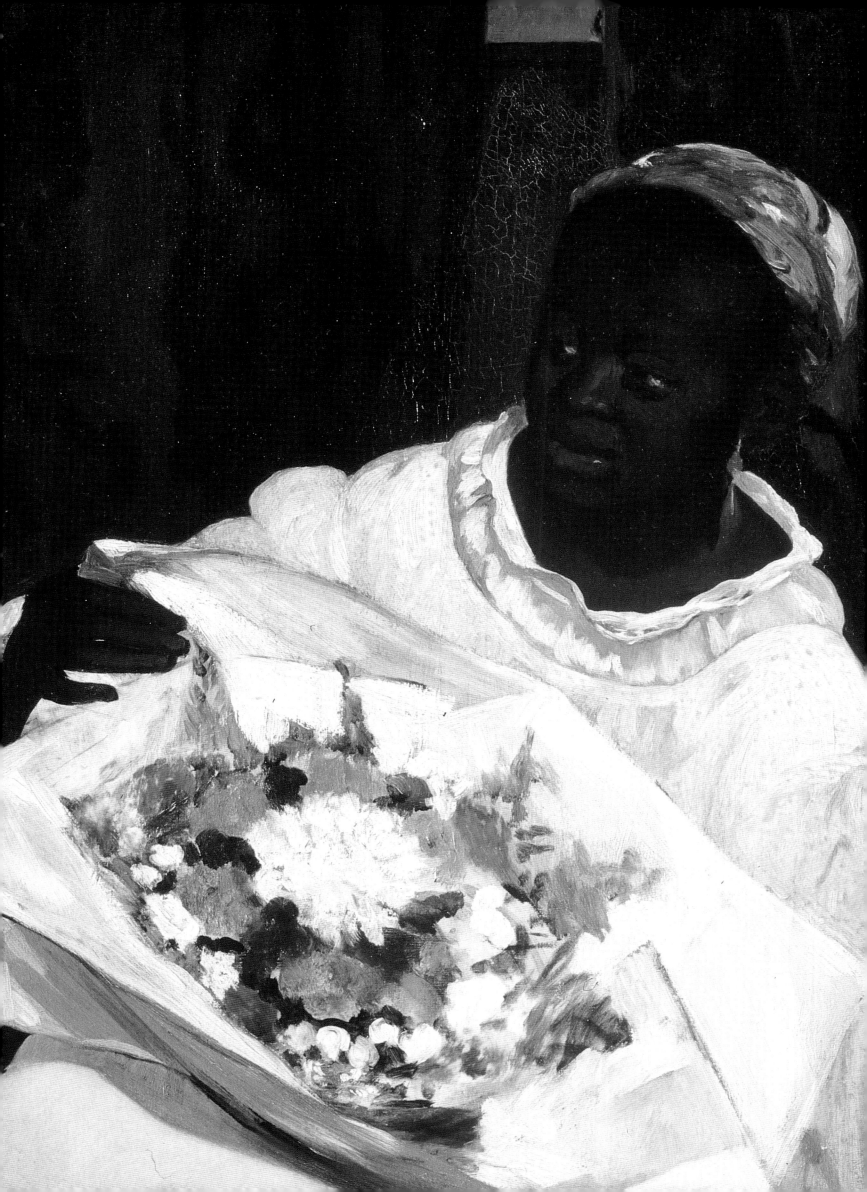

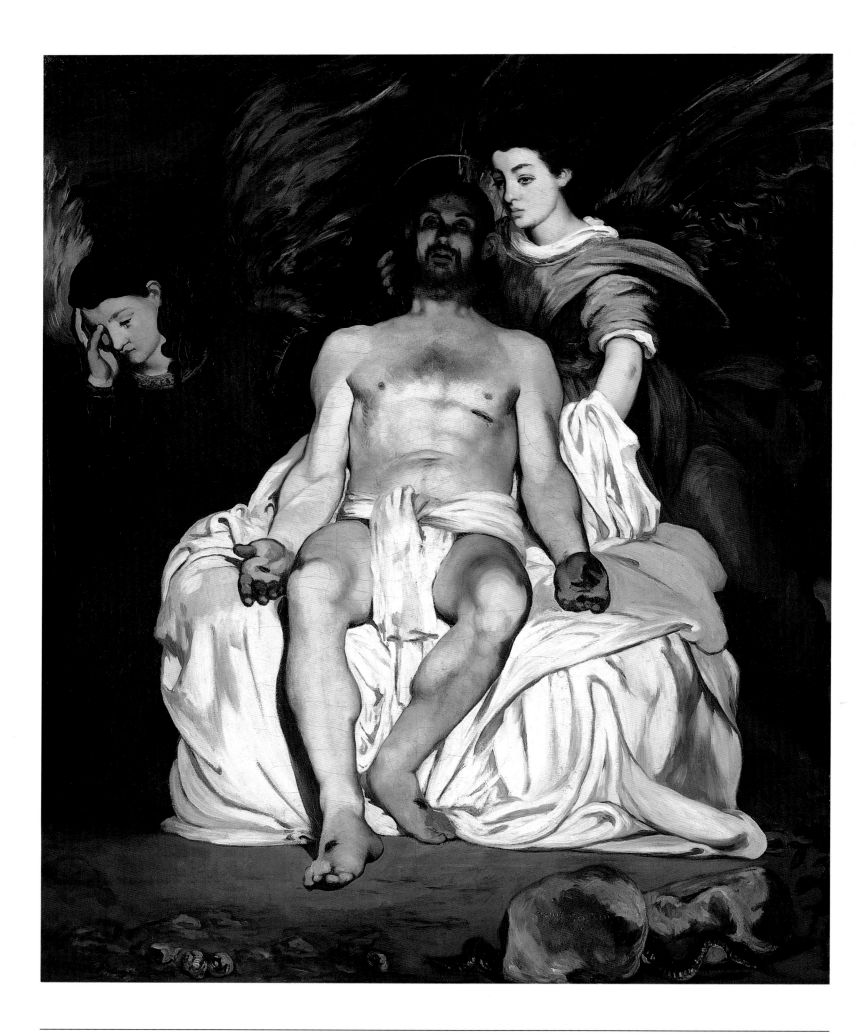

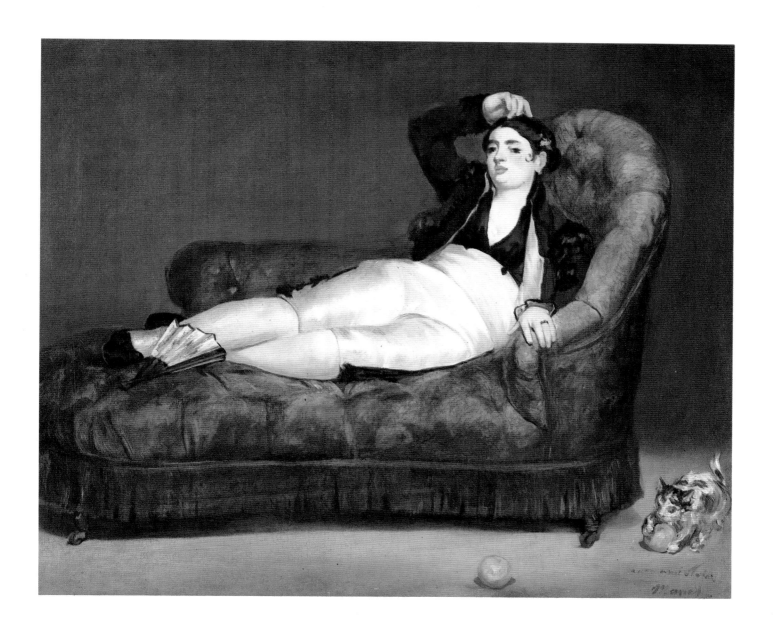

Young Woman Reclining, in Spanish Costume

1862; oil on canvas; 37 x 44 1/2 in. (94 x 113 cm.).
New Haven, Connecticut, Yale University Art Gallery.
The dedicatory inscription at bottom right to Manet's
friend, the photographer Nadar, has led to the assumption
that the woman, dressed in masculine Spanish garb,
represents his mistress. The allusion of her pose to
Goya's famous Clothed Maja *is obvious and intentional.*
More than her face, the luminous accent here is the
astonishing cream-velvet knee breeches and pale stockings.

The Dead Christ with Angels

1864; *oil on canvas;* 70 5/8 x 59 in. (179 x 150 cm.).
New York, Metropolitan Museum of Art.
Reactions to this painting, shown at the Salon in 1864,
were predictably mostly hostile, although artists like Degas
admired the painting for its formal prowess. Zola commented
later: "It has been said that this Christ is not a Christ,
and I acknowledge that this could be so; for me, it is a
cadaver freely and vigorously painted in a strong light,
and I even like the angels in the background, children with
great blue wings who are so strangely elegant and gentle."

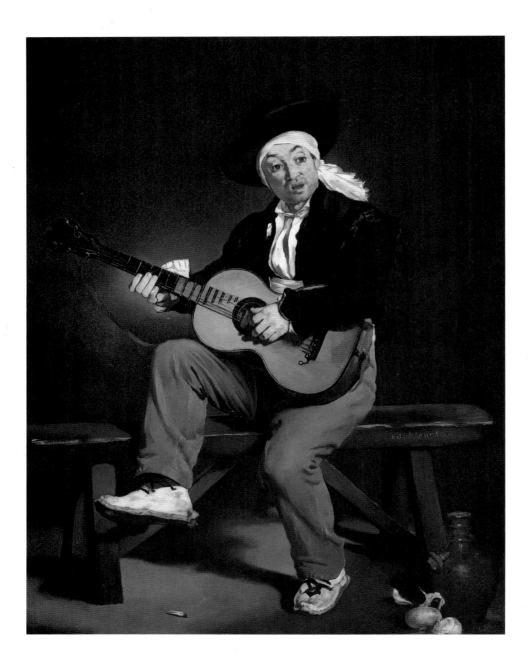

The Spanish Singer

1860; *oil on canvas*; 58 x 45 in. (147.3 x 114.3 cm.).
New York, Metropolitan Museum of Art.
After the failure of The Absinthe Drinker *at the Salon of 1859,
this painting with a Spanish character as a subject matter brought
Manet his first popular and critical success. Attentive visitors of the
Salon in 1861 noticed, however, that the costume of the sitter was
rather a mixture of Spanish and French elements, indicating that
the singer is a picturesque counterfeit created in the artist's studio.*

Lola of Valence

1862, and after 1867; *oil on canvas;*
48 1/2 x 36 1/4 in. (123 x 92 cm.).
Paris, Musée d'Orsay.
*A "beauty at once darkling and
lively in character," as Baudelaire
was to describe the Spanish ballet star
Lola Melea, called Lola de Valence.
She is seen standing at rest, her feet
in the fourth position. The stage
scenery in the background, added
some years later on the advice of
Manet's friends, shows Lola as though
she is about to make her entrance
on the stage. The composition is remi-
niscent of works by Francisco Goya.*

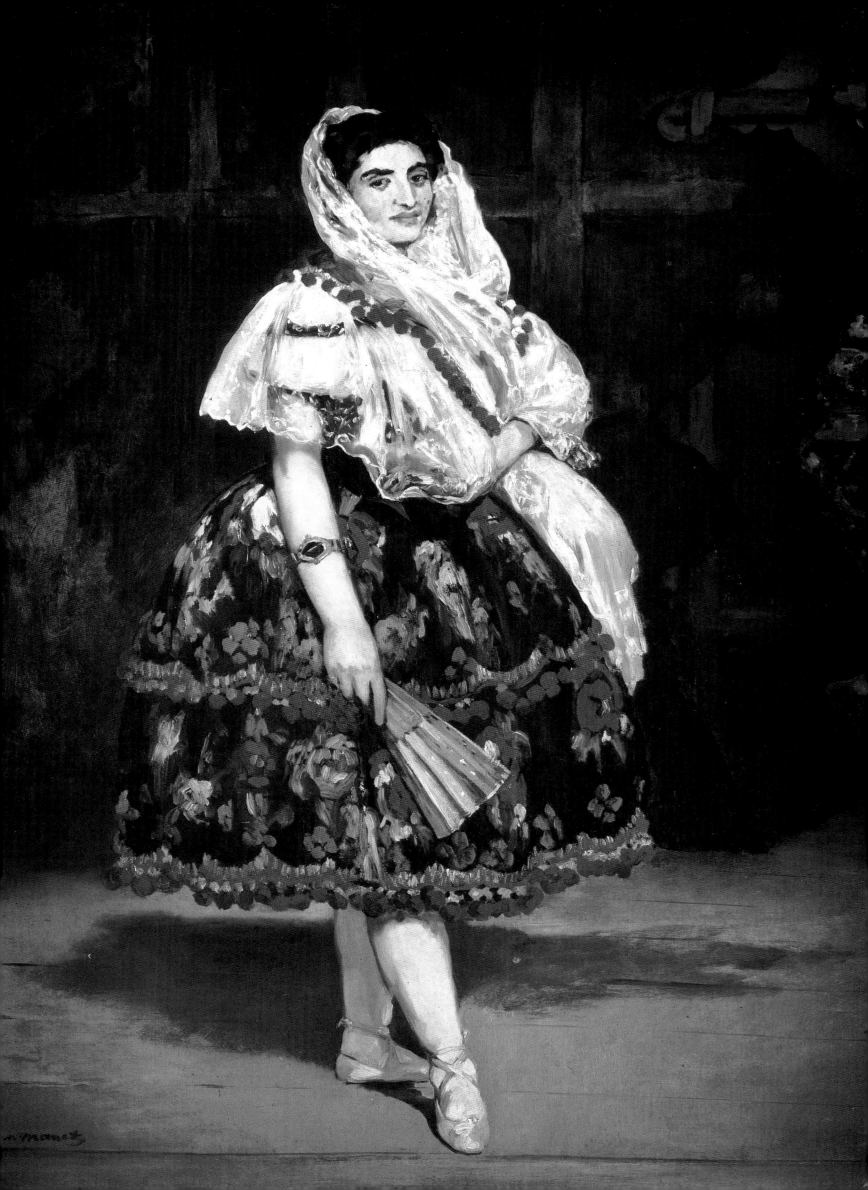

Music in the Tuileries Gardens

1862; oil on canvas; 30 x 46 1/2 in. (76 x 118 cm.). National Gallery, London.
*The elegant Parisian society of the Second Empire gathered twice a week at
the Tuileries gardens to attend outdoor concerts. Nobody seems to be paying
much attention to the musicians, probably a military band, which must be
imagined being near the painter's or the viewer's station. Seated behind the
artist's brother Eugène, dressed in white trousers, is the composer Jacques
Offenbach, whom Rossini called the Mozart of the Champs-Élysées.*

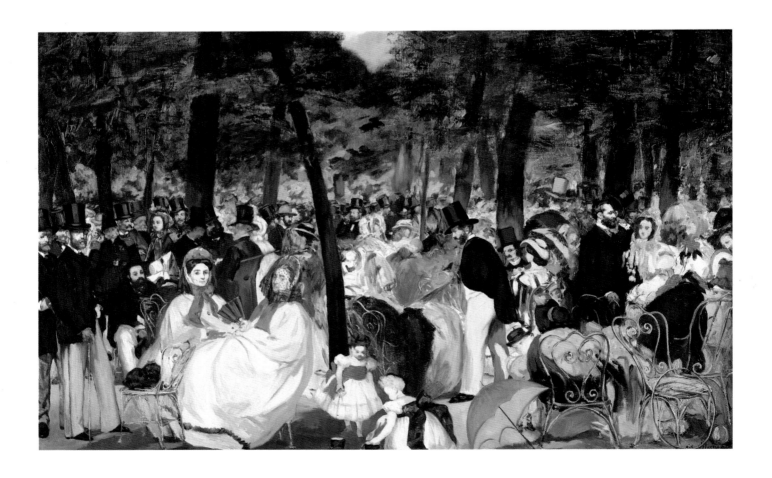

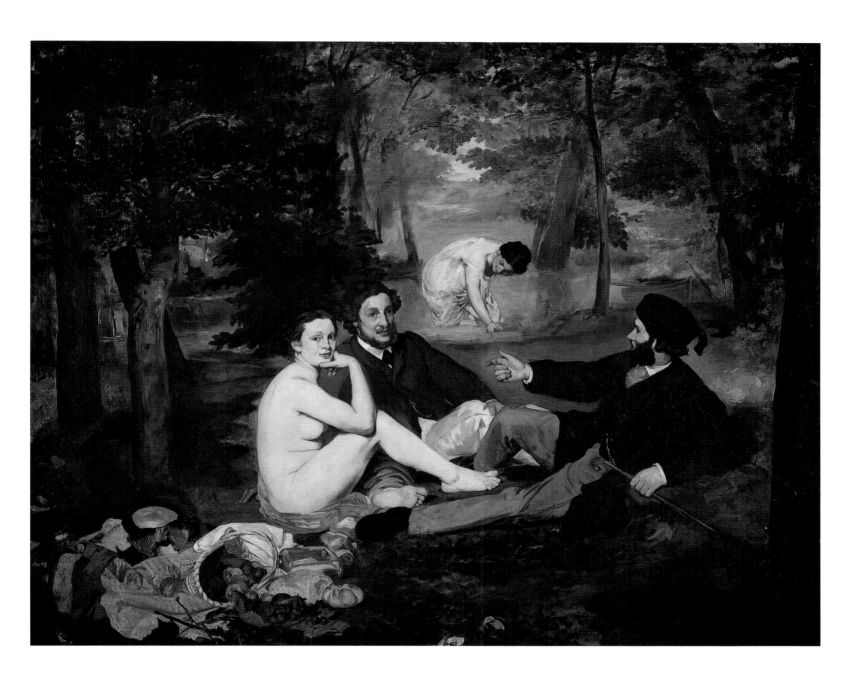

Le Déjeuner sur l'herbe (Luncheon on the Grass)
1863; *oil on canvas;* 82 x 104 in. (207 x 264.5 cm.). Paris, Musée d'Orsay.
*Rejected by the Salon of 1863, this painting was seen by more than
seven thousand visitors on the first day of the "Salon des Refusés."
Originally known as "The Bath," the painting offended viewers because
of its modern style and subject matter: a picnic outing of two young
students with an unclad female in a classical pose. The figures were obvi-
ously painted in the studio, and the landscape added in a sketchy manner.*

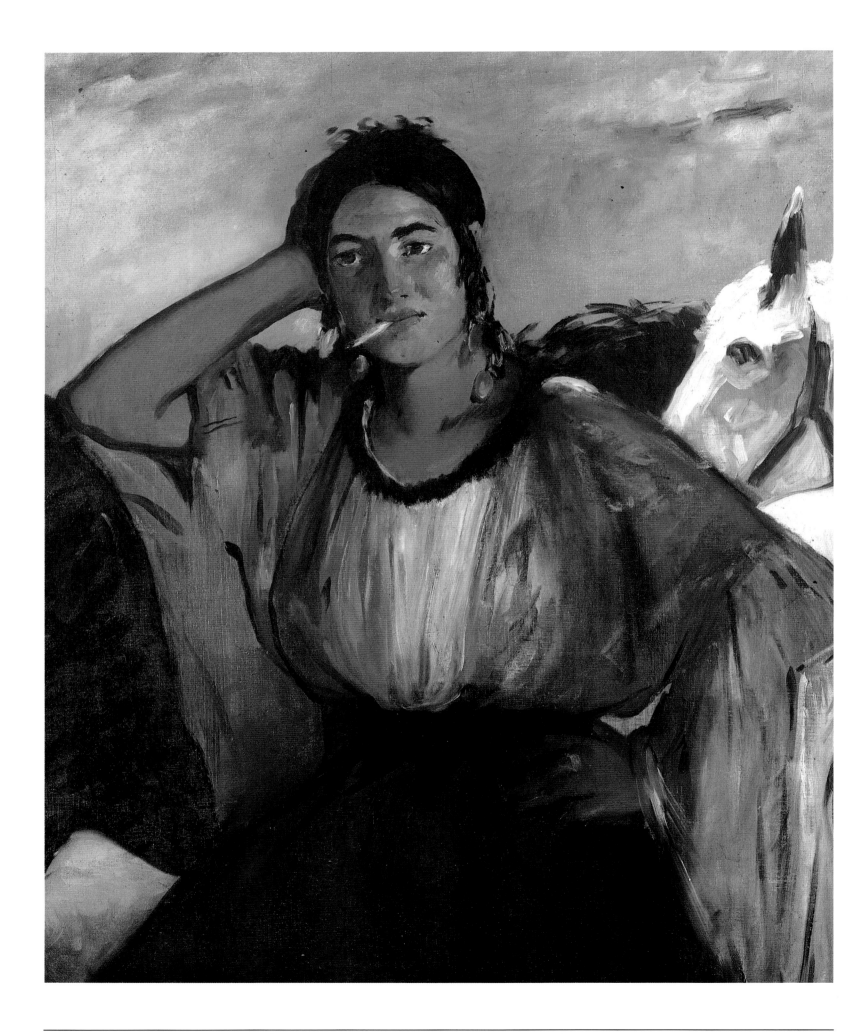

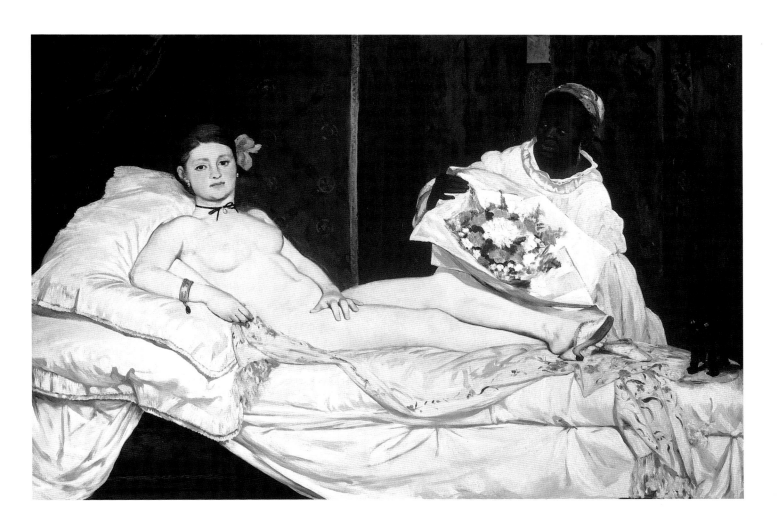

Olympia

1863; *oil on canvas*; 51 3/8 x 74 3/4 in. (130.5 x 190 cm.).
Paris, Musée d'Orsay.

The provocative, shockingly natural appearance of Olympia upset its first viewers during the Salon of 1865. The figure has a startling immediacy, and her face a cold directness, which led one critic to call Olympia a "free daughter of Bohemia, artist's model, butterfly of the brasseries...with her cruel, childlike face and eyes of mystery." The black velvet lace around her neck serves to stress her nakedness.

Gypsy with a Cigarette

c. 1862; *oil on canvas*; 36 1/4 x 29 in. (92 x 73.5 cm.).
Princeton, New Jersey, The Art Museum,
Princeton University.

This astonishing painting came to light only after the artist's death in 1883. Eventually, it was purchased by Edgar Degas, who must have liked the unconventional pose and abruptly cropped composition, because similarly bold effects occur in his own works. The gypsy, with an expression of diffidence and melancholy, is leaning against the back of a dark-colored horse, while on the right appears the head of a white horse.

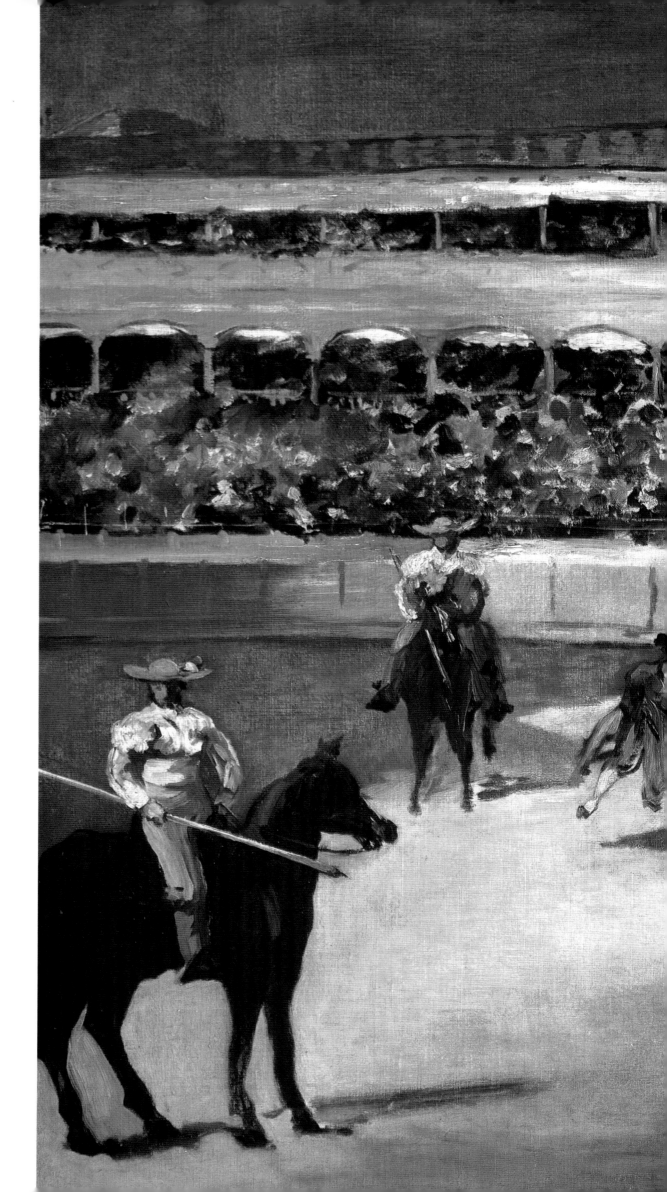

Bullfighters

1865-1866; *oil on canvas;*
35 1/2 x 43 1/4 in.
(90 x 110 cm.).
Paris, Musée d'Orsay.
An ardent admirer of
bullfights ("one of the
finest, strangest, and
most fearful spectacles
to be seen"), Manet
executed this painting
in his Paris studio from
sketches made on the
spot during his visit to
Spain in 1865. Focusing
on the colorful multitude
of visitors gathered in a
sun-drenched stadium,
the canvas is more of a
cheerful travelogue than
a dramatic rendering of
a fearful event.

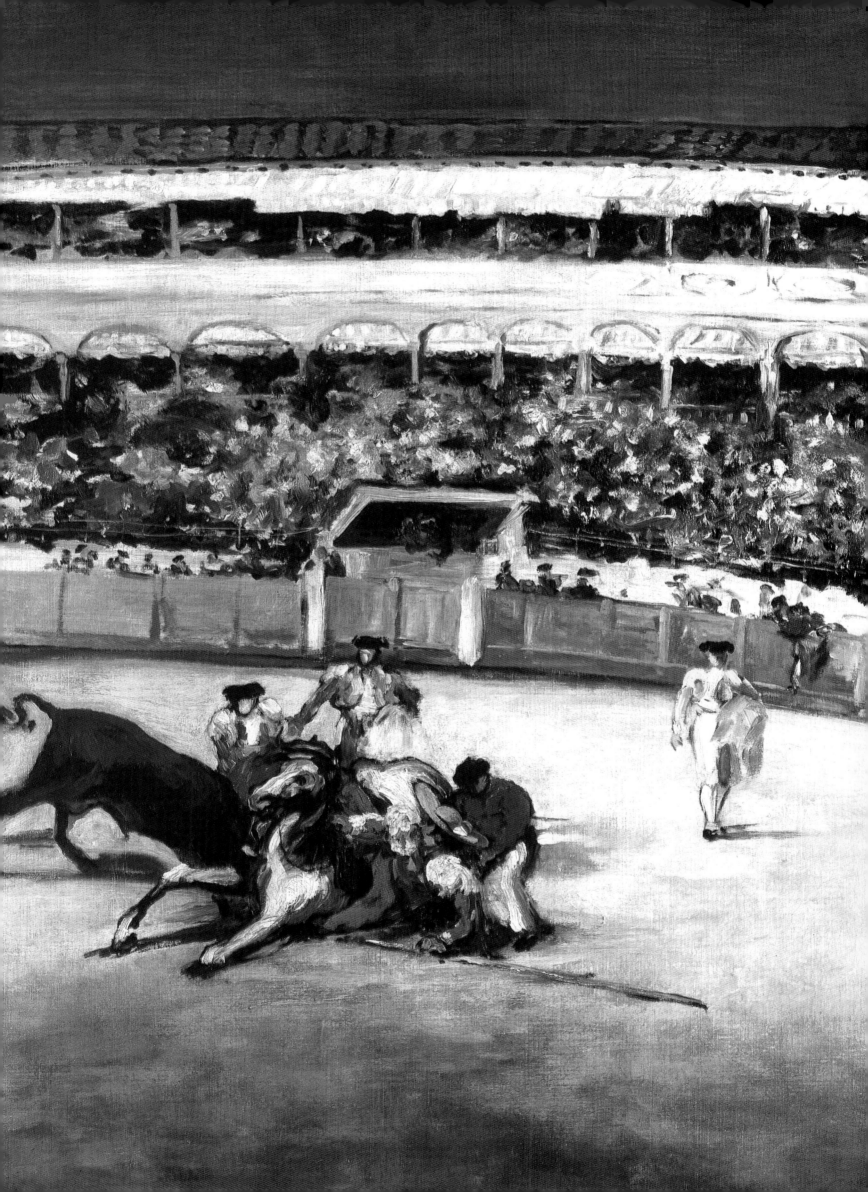

The Mocking of Christ

1865; *oil on canvas*; 75 1/8 x 58 3/8 in. (190.8 x 148.3 cm.).
The Art Institute of Chicago.

The only other similarly ambitious religious
painting besides The Dead Christ and the Angels
was this canvas, shown side by side with Olympia
at the Salon of 1865. In both works the presence
of the figures is highly realistic and immediate.
Here, Christ truly suffers at the hands of the brutal
soldiers. The harsh studio lighting, which is some-
what reminiscent of the works of Caravaggio and
Ribera, accentuates the realism of the scene.

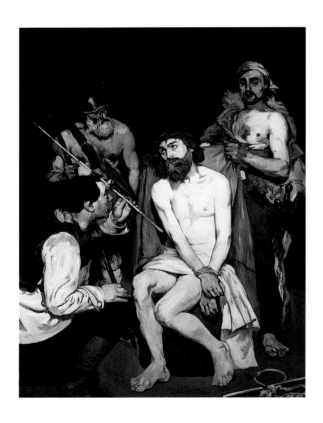

The Fifer

1866; *oil on canvas*; 63 x 38 1/2 in. (160 x 98 cm.). Paris, Musée d'Orsay.
A few months after returning from his trip to Spain, Manet
began work on The Fifer, *for which a boy trooper of the*
Light Infantry Guard served as a model. Painted with almost
no revision, the boy appears almost like a cutout figure set
before a neutral background. Never before had Manet's
technique been so radical in simplifying the forms. Émile Zola
recognized in this picture "a man who searches out the true."

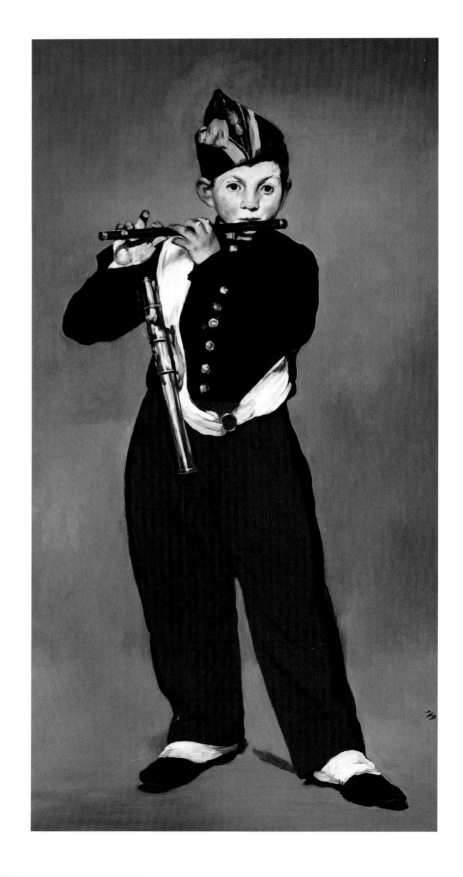

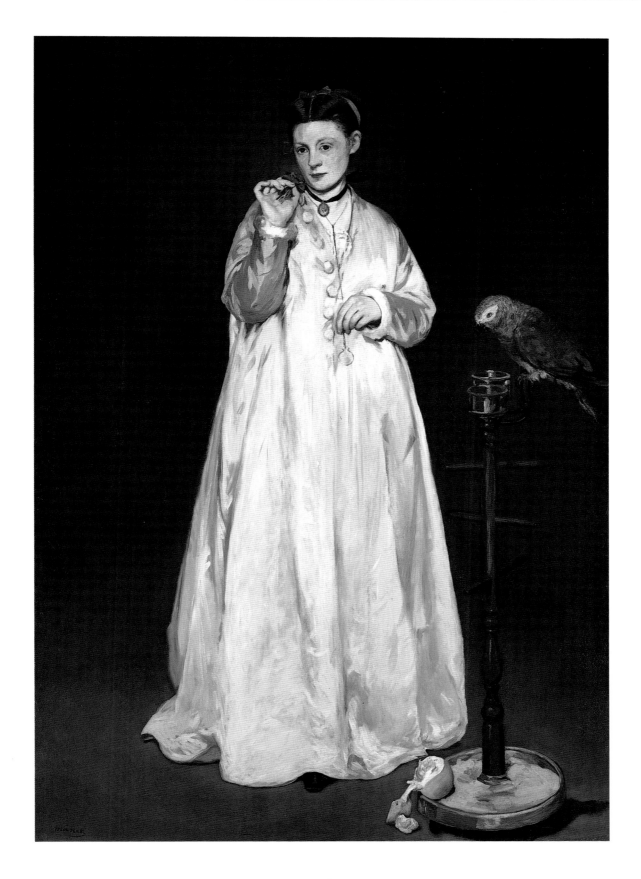

Woman with a Parrot

1866; *oil on canvas*; 72 7/8 x 50 5/8 in. (185.1 x 128.6 cm.). New York, Metropolitan Museum of Art.
*A young woman dressed in an elegant pink dressing gown and set against a gray background
breathes in the scent of violets, her head gracefully tilted to her right. A parrot on its
perch is her confident companion. This sweet and charming scene, balanced by the painter's
characteristic spareness and simplicity, was among the fifty works exhibited at Manet's
pavilion on the avenue de l'Alma during the Exposition Universelle in 1867.*

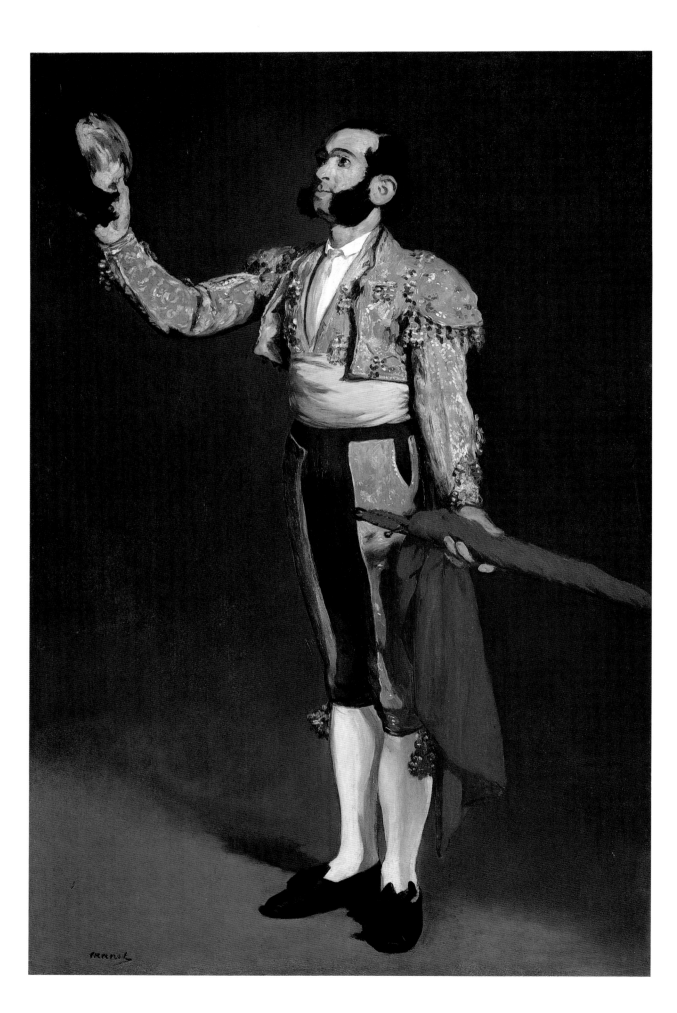

A Matador, or Matador Saluting
1866 or 1867;
oil on canvas;
67 3/8 x 44 1/2 in.
(171.1 x 113 cm.).
New York,
Metropolitan
Museum of Art.
*His visit to Spain
in 1865 had briefly
revived Manet's
interest in Spanish
subject matters.
The model for this
matador was
probably a member
of a troupe of
Spanish dancers
who performed
in Paris during
the Exposition
Universelle. The
saluting gesture
might refer to
the moment when
the bullfighter
asks permission
to kill the bull.*

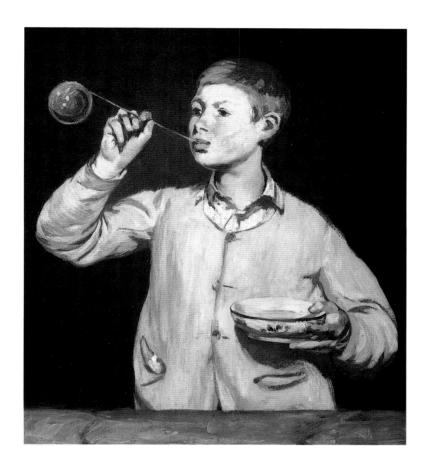

Blowing Soap Bubbles

1867; *oil on canvas;* 39 5/8 x 32 in.
(100.5 x 81.4 cm.).
Lisbon, Calouste Gulbenkian Museum.
*Contemporaries recognized in
this painting art-historical references to
Hals, Murillo, and Chardin. Soap
bubbles were indeed a common vanitas
motif, symbolizing the precariousness of
life. The presence of an adolescent boy—
for whom Léon Leenhoff reportedly posed—
was also traditional, but Manet imbued
the subject with an unprecedented immedi-
acy, removing all trace of sentimentality.*

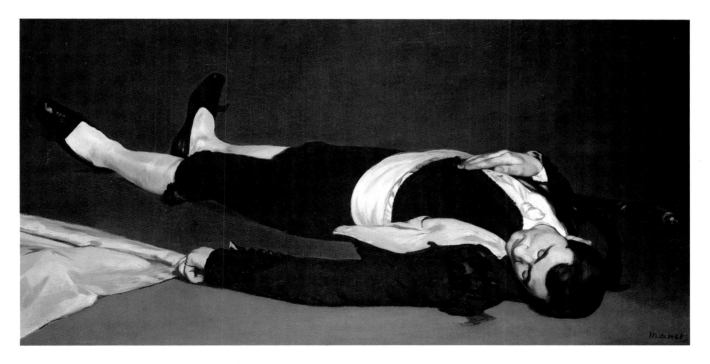

The Dead Toreador

c. 1864; *oil on canvas;* 29 7/8 x 60 3/8 in. (76 x 153.3 cm.). Washington, D.C., National Gallery of Art.
This work, which was originally part of a much larger Episode from a Bullfight, *is the result and victim of the artist's
on-going revisions. Unsatisfied with his painting, Manet cut off the lower part of the canvas with the toreador, repainted
some areas, and showed it in his independent exhibition on the avenue de l'Alma in 1867 during the Exposition
Universelle in Paris.* The Dead Toreador *was welcomed as "the most complete symphony in black major ever attempted."*

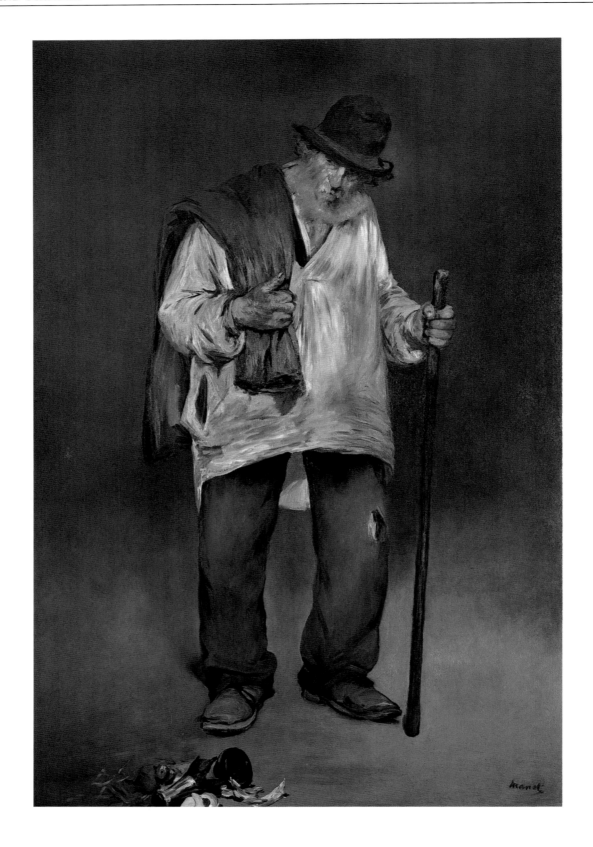

The Ragpicker
c. 1865–1869; *oil on canvas;* 76 3/4 x 51 1/4 in. (195 x 130 cm.).
Pasadena, California, Norton Simon Museum.
The Parisian types of low-life street people had fascinated Manet at the time of his
Absinthe Drinker *and in* The Philosopher. *The choice of the subject matter was certainly
influenced by his readings of Baudelaire's poems in* Les Fleurs du Mal. *This rather late
example is painted with a lighter palette and more in the manner of a sketch.*

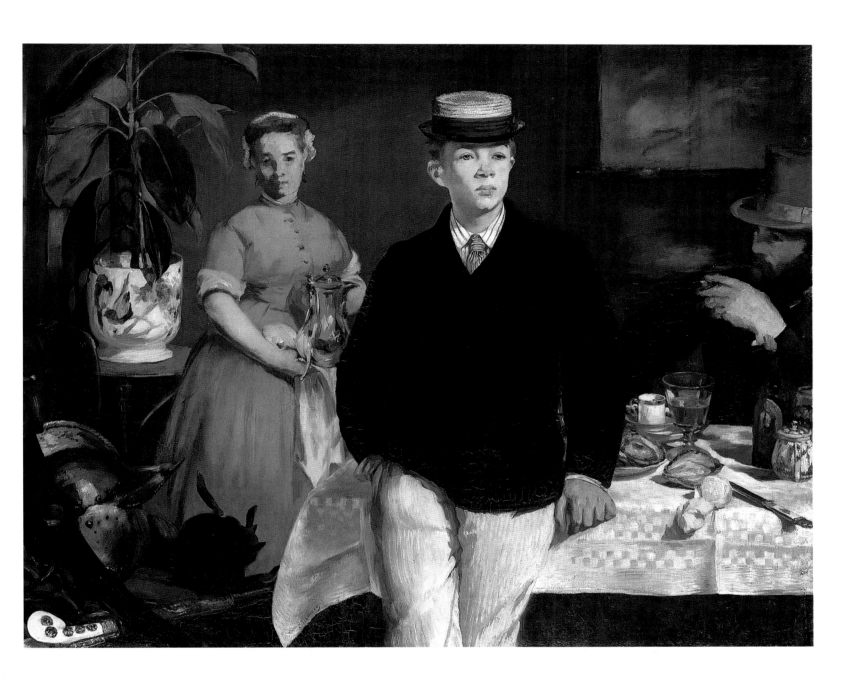

The Luncheon in the Studio

1868; *oil on canvas*; 46 1/2 x 60 5/8 in. (118 x 154 cm.). Munich, Neue Pinakothek.

In this painting, one of Manet's most enigmatic, Léon Leenhoff, presumably the artist's son, is prominently shown in the foreground leaning against a table haphazardly covered with food and plates. Elegantly dressed in a black velvet jacket, striped shirt with cravat, and a small straw hat, the young man appears to be ready to leave the house for a walk or a rendezvous. The sixteen year old Léon had just started working in the banking house of Edgar Degas's father when the painting was executed, during a summer stay in Boulogne-sur-Mer. The weaponry on the chair to the left is the only feature that might justify the name of "studio" for this room.

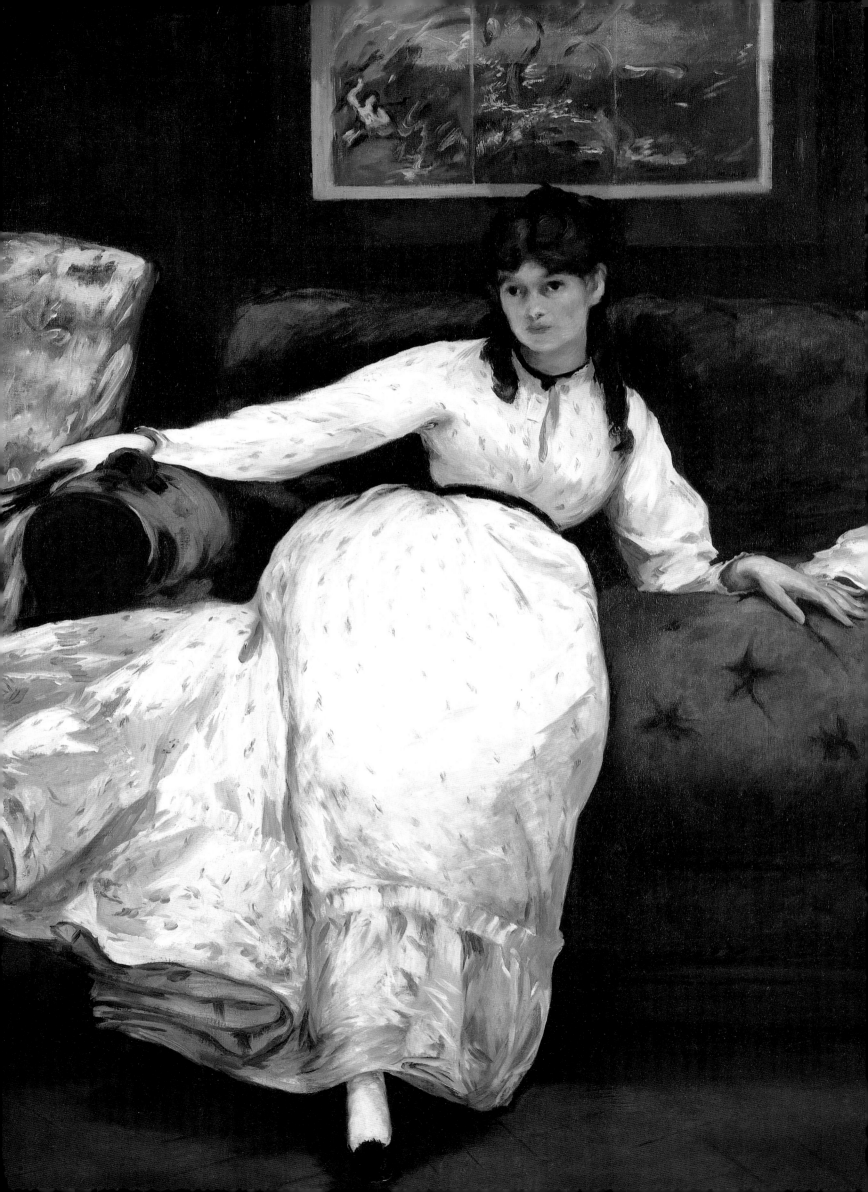

CHAPTER 2

TOWARD IMPRESSIONISM

anet always kept his distance when asked to exhibit with his Impressionist friends. He preferred not to see his name mentioned in the context of his more rebellious colleagues Monet and Degas, but his work is closely associated with the development of the Impressionist style, and he adopted some of its characteristics in works of the 1870s, when his palette became brighter and his subjects included occasional outdoor scenes and even landscapes.

Primarily, however, Manet was a painter of urban subjects (*The Railroad; Rue Mosnier*). He also painted many portraits of his family and his friends as well as society scenes like *Masked Ball at the Opéra*. In 1867, the political events in Mexico prompted him to react with a painting. The execution of Maximilian of Austria, Emperor of Mexico, and two of his generals by the troops of Benito Juárez on June 19 was considered a tragedy in France. The horror of the bloody event brought indignation against Napoleon III, who, after imposing Maximilian's reign on the Mexicans, had withdrawn the French forces and abandoned his protégé. Manet had just experienced a personal disappointment with the presentation of his works at his own pavilion during the Exposition Universelle in Paris. The expense of the construction of the building had been very high, but his efforts had hardly been paid back with any form of recognition. Like most liberal-minded citizens, he had a critical opinion of the Empire and took the occasion to produce a new painting in the grand historical mode.

He worked on the project for more than a year, from the summer of 1867 to late 1868. His efforts resulted in

four oil paintings and one lithograph. The development followed several stages, beginning with the preparatory *The Execution of Emperor Maximilian, (study)*, and followed by another study in Copenhagen, to the final and most elaborate version, *The Execution of Emperor Maximilian*.

Manet left for Boulogne in July of that year. It is not quite clear if he began the first study before his departure or right after his return to Paris at the end of the summer, as Baudelaire had died on August 31 and Manet returned for the interment on September 2. In any case, the events reported from Mexico in the French newspapers gave him ample information about the subject to start a painting. "The melancholy news had been circu-

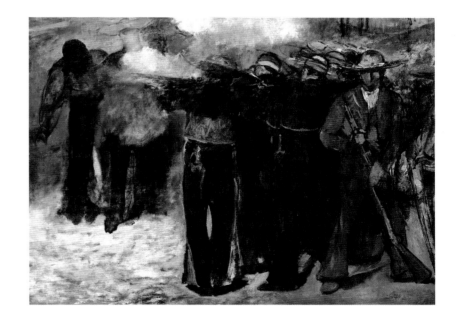

Portrait of Berthe Morisot (Le repos)
1870; *oil on canvas;* 58 1/4 x 43 3/4 in. (148 x 111 cm.).
Providence, Rhode Island, Rhode Island School of Design.
Just one year after The Balcony *Berthe Morisot posed
a second time for Manet., Nearly thirty and going through
a period of personal and professional uncertainty, she is
shown as a pensive, troubled woman, whose eyes seem to
express haunting reveries. However, the casual pose and the
brilliantly painted white dress with its Impressionistic brush-
work — a sign of reverence toward the esteemed artist and
friend — offer a gesture of hope and high expectation.*

The Execution of Emperor Maximilian (study)
1867; *oil on canvas;* 77 1/4 x 102 1/4 in. (196 x 259.8 cm.).
Boston, Museum of Fine Arts.
*This is the first study in a series for the final canvas in
Mannheim. Close to the execution scene in Goya's* Third of
May, *it still has the warm tones and romantic spirit which
in the further development of the subject was to be replaced
by a cool harmony of grays, greens, and blacks. Here the
event is recorded directly on the canvas with an emotional
verve and immediacy rarely noticeable in Manet's oeuvre.*

lating in Paris since morning," reported Ludovic Halévy on July 1. "The Emperor Maximilian shot by order of Juárez. What a tragic ending to that ruinous, bloody farce, the war in Mexico." Various papers published a gruesome picture of the Emperor in his coffin which caused a stir among readers.

Manet's first study is more full of movement, more charged with emotions, and more dramatic even in its technical aspect than any other version in the series. The immediacy of the scene's impact, the closeness of the firing squad to the viewer, and the painting's romantic spir-

it and warm tones are more vivid than the cool harmonies of grays and greens in the later version. The general idea for the composition goes back to Goya's famous *Third of May, 1808*, which Manet had seen in the Prado, Madrid, just two summers before. The firing squad is seen at the moment of the fusillade with smoke coming out of the soldiers's guns, thus evoking the action rather than concealing it. To the left, the Indian general Mejía is already hit, his body bent forward; somewhat indistinct on the right the figure of general Miramón. The Emperor, distinguished by a large sombrero, is still alive, his executioner, on the extreme right, awaiting his turn. In the final version the soldier is still loading his rifle in preparation and a group of onlookers is seen above the wall in the back. This canvas shows more restraint, distance, and objectivity, and is based on the intense research Manet did for this painting.

Manet had often dismissed the subject of history painting, but here he intended a work in the grand tradition of Jacques Louis David, Antoine-Jean Gros, and—naturally—Francisco Goya. It was certainly reportage of a recent event, but a historic one nonetheless. The monumental format alone is ample proof of Manet's ambitions and his awareness of his predecessors. The final version was originally intended for the Salon of 1869, but Manet was given to understand that it would not be accepted. Instead, the painting was shown in the United States from December 1879 to January 1880, but with indifferent success. Renoir, upon seeing the canvas, exclaimed: "This is pure Goya, and yet Manet was never more himself."

Portraits of Friends

After completion of this lengthy project, Manet returned to subjects which were more familiar to him. One of the next paintings he did was *Portrait of Émile Zola*. The writer, who was eight years the painter's junior, was an ardent admirer of Manet's work. In 1866, he wrote a strong defense of Manet in his review in *L'Evénement* of the Salon from which the artist had been

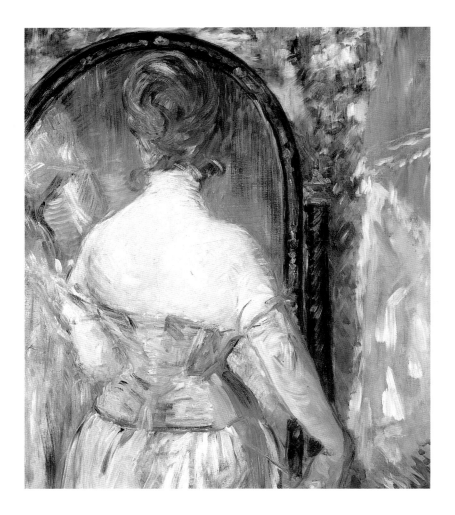

Before the Mirror
1876; *oil on canvas;* 36 1/4 x 28 1/8 in. (92.1 x 71.4 cm.).
The Solomon R. Guggenheim Museum,
New York, Gift, Justin K. Thannhauser 1978
The erotic charge that this work once must have had is hard to grasp. Not so the quality of the luminous paint, the freshness of the brushwork, and the spontaneity of the event–the undressing of a woman in front of a mirror. The vivid color and movement of the drapery and curtain have an almost abstract quality and are frequently quoted to illustrate Manet's modernity.

The Balcony
detail. 1868; Paris, Musée d'Orsay.
The thoughtful expression on the face of the painter Berthe Morisot provoked the sitter's comment: "I look strange, rather than ugly." However, Manet held her and her work in high esteem and the two artists remained close friends throughout their lives. Several years after this painting, Morisot married Manet's brother Eugène, thus becoming the painter's sister-in-law.

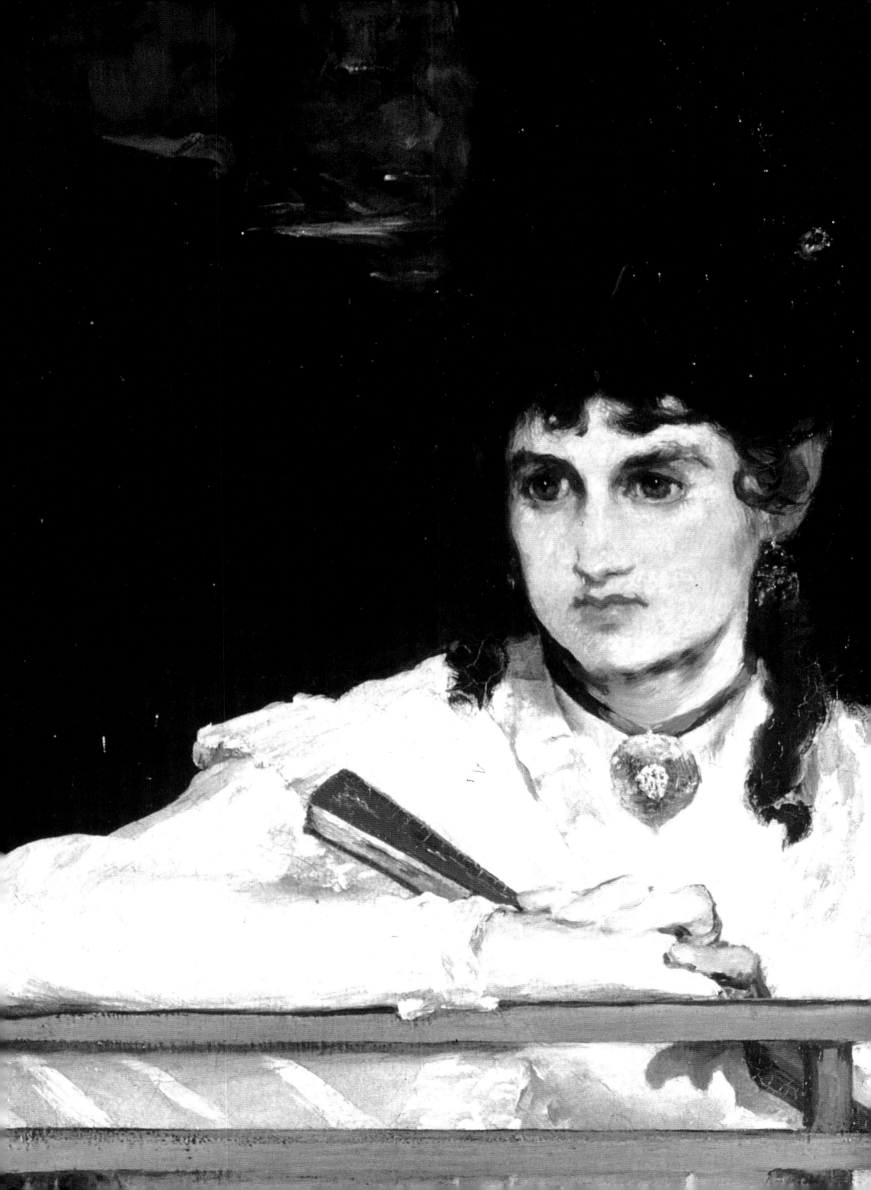

excluded: "Since nobody is saying it, I will say it myself; I will shout it from the housetops. I am so sure that M. Manet will be accounted one of the masters of tomorrow that I think it would be a sound investment, if I were a wealthy man, to buy all his canvases today ... M. Manet's place is marked for him in the Louvre, like Courbet's, like that of any artist of strong and uncompromising temperament." If Zola indeed had such a clear sense of judgment in artistic matters, it remains subject to discussion. In any event, Manet, in his response to the author, thanked him for his support: "Dear Monsieur Zola ... how proud and happy I am to be championed by a man of your talent." But the two men did not become more familiar with each other until somewhat later.

Zola had been introduced to the artistic milieu in the 1860s through his boyhood friend Cézanne. He had visited the Salons of 1861, where he saw Manet's *The Spanish Singer* and the Salon des Refusés in 1863, where the *Le Déjeuner sur l'herbe* had caused considerable public commotion. In January 1868, Zola published his defense of the previous year in a longer paper which included expanded suggestions.

Although the writer clearly took advantage of advocating his own literary theories in this pamphlet, Manet was very much pleased by its publication and offered to do the writer's portrait for the next Salon. By February, Zola was already posing at the painter's studio. In his review of the Salon of 1868 he described these sessions: "I recall those long hours of sitting. In the numbness that overtakes motionless limbs, in the fatigue of gazing open-eyed in full light, the same thoughts would always drift though my mind, with a soft, deep murmur. The nonsense abroad in the streets, the lies of some and the inanities of others, all that human noise which flows worthless as foul water, was far, far away ... At times in the half sleep of posing, I would watch the artist, standing before the canvas, face tense, eye clear, absorbed in his task. He had forgotten me, he didn't know I was there, he was copying me as he would have copied any human animal, with an attention, an artistic awareness, the like of which I have never seen ... All about me, on the walls of the studio, were hung those characteristically powerful canvases which the public has not cared to understand."

Manet had chosen to represent the sitter in a traditional setting, where the subject's activities and tastes were on display. On the table, books have been placed in a carefully arranged disorder. Next to the inkstand appears the light-blue cover of the pamphlet, bearing Manet's name. The open book on Zola's lap seems to be a volume of Charles Blanc's *Histoire des peintres*, which Manet consulted frequently in his studio. On the wall behind the desk, a frame with slipped in prints and photographs includes a reproduction of *Olympia*, her gaze fixed on the writer, who had defended this very painting as Manet's masterpiece, as if to thank him. The Japanese print as well as the folding screen on the left might represent the sitter's modernist taste, but they were also simply studio accessories at that time.

In 1885, two years after Manet's death, Zola described himself in notes for a new novel: "Dark complexion, heavyset but not fat — at first. Head round and obstinate. Chin square, nose square. Eyes soft in mask of energy. Neckpiece of black beard." This seems to have been the idea Manet had of him some eighteen years earlier.

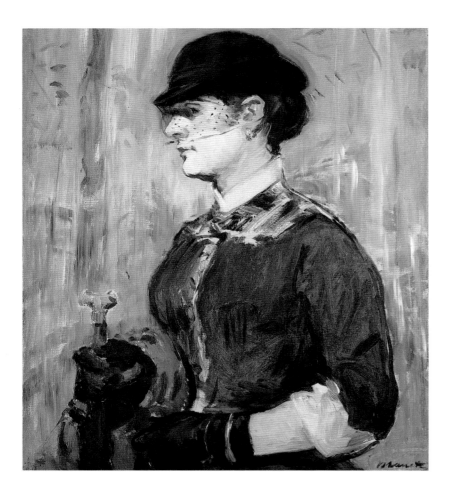

Young Woman in a Round Hat

c. 1877–1879; *oil on canvas;* 21 1/2 x 17 3/4 in. (55 x 45 cm.).
The Art Museum, Princeton University.
Lent by the Henry and Rose Pearlman Foundation, Inc.
Less a specific portrait than a typical rendering of a woman prepared for an outing, this image testifies to Manet's vivid interest in fashion. Wearing a tight-fitting blue dress, black gloves which hold a cane with a gilded knob, and a small hat with a veil, this woman is dressed for a particular role in the urban society of Parisian life. The half-length profile figure appears also in other works of the late 1870s and early 1880s.

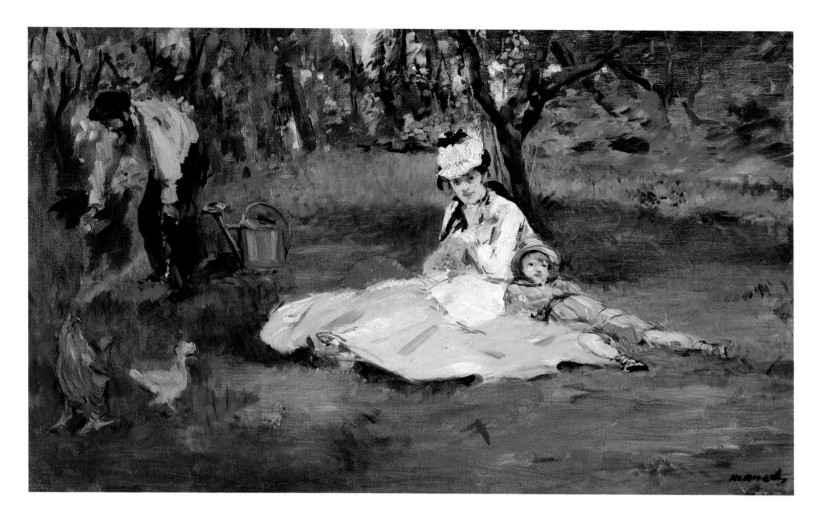

The painter Berthe Morisot appeared for the first time in a canvas in 1868, in *The Balcony*. Manet had been introduced to her and her sister Edma at the Louvre by fellow painter Fantin-Latour, where Berthe was copying a Rubens painting. Soon the sisters and their mother became regulars at Manet's Thursday evenings, where Suzanne Manet performed for friends at the piano. In a letter to Fantin-Latour written during a summer stay at Boulogne, Manet confided: "I quite agree with you, the Mlles. Morisot are charming. Too bad they're not men. All the same, women as they are, they could serve the cause of painting by each marrying an academician, and bringing discord into the camp of the enemy." The chauvinistic tone of this note notwithstanding, a deep artistic respect and a strong affection was soon to develop between Manet and Berthe Morisot.

Somewhat brooding and melancholic, Berthe appears seated to the left in the painting. Her companions were Fanny Claus, a young concert violinist, who regularly played music with Suzanne Manet, and the landscape painter Antoine Guillemet, a friend of the future Impressionists. In the darkness of the room appears young Léon Leenhoff with an ewer. The enigmatic work has lost none of the strangeness which struck its contemporaries. The bright green shutters and railing contrast with the white dresses of the two women and above all with the blue cravat of Guillemet. Each sitter appears isolated and bound up in a private world. All three models look in different directions and there is no communication between them. The blue hydrangea to the left softens the dark green and adds an outdoorsy touch to the scene, which otherwise was almost completely painted in the artist's studio. Not even the little dog under Morisot's chair playing with a ball is able to add some life to this frozen, mysterious scene.

The Monet Family in their Garden
1874; *oil on canvas*; 24 x 39 1/4 in. (61 x 99.7 cm.). New York, The Metropolitan Museum of Art. *During a visit to Claude Monet, who had lived at Argenteuil since 1871, Manet painted his friend's family in their garden. Camille Monet and their son Jean are sitting on the grass under a tree, while Claude Monet attends his flowers with a watering can. The rather rapid execution notwithstanding, Manet orchestrated the scene with great subtlety. He used for instance the same bright red for the crest of the rooster, for the fan of Mme. Monet, for the flowers, and for the hats and shoes.*

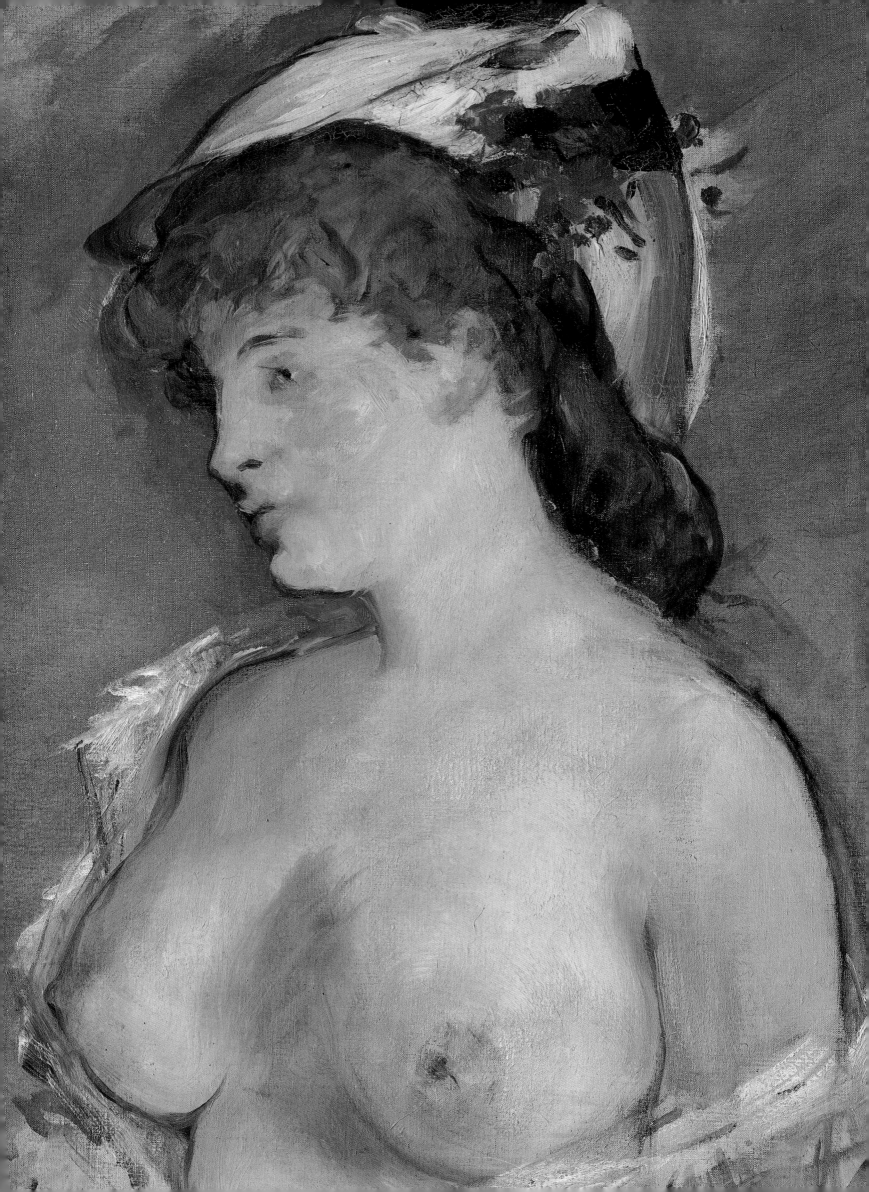

Berthe Morisot felt that "I look strange, rather than ugly. It seems that the term 'femme fatale' has been circulated among the curious." A little more than a year later, Manet painted another portrait of her, this time with her as the sole subject, (*Le repos*);*Portrait of Berthe Morisot*. Fashionably dressed, Berthe is lounging casually on a plum-colored couch in her own studio. Her expression is pensive; her pose seems to express both high expectation and momentary dejection. She was in fact going through a time of uncertainty, personally and artistically. Almost thirty, she was still unmarried, although she would become Eugène Manet's wife in 1874. She greatly admired Édouard Manet and her feelings for him might have been somewhat more than those of mere friendship, but her jealousy of Eva Gonzalès, Manet's only student, seems to have been primarily of a professional nature. During a visit to Berthe's studio, Manet reassured her of her immense talents by praising her paintings. Years later he even sent her the encouraging present of an easel as a New Year's gift. Loose brushstrokes define her white dress as well as the chair. Behind her head on the wall appears a Japanese print suggesting the hazards of her artistic experience.

This is Manet's most intimate and revealing portrait of his friend and colleague. The painting was well received at its showing at the Salon of 1873, but mostly because of the extraordinary success of *Le Bon Bock*, featured also at the same exhibition. An illuminating observation came from Castagnary who noted that "he [Manet] is after an impression, he thinks he has caught it on the wing, and he stops. He leaves it at that." Only a little later, the same kind of critical remark was voiced against Monet as well as Morisot's own paintings. This prophetic remark is all the more fitting of her, since she became the principal link between Manet and the Impressionists.

Other Subjects

In autumn of 1872, Manet began to paint *Gare Saint-Lazare* The train station was to become a favorite locale for Impressionist painters, above all for Monet who rendered the new, modern poetry of smoke and steam under the glass roof in a series of canvases in the years between 1876-1877. Manet's own work thus anticipated the subject in this masterpiece by a couple of years. Manet must have watched the spectacle of trains coming or leaving from his studio on rue de Saint-Pétersbourg, but unlike Monet, he was not so much intrigued by the lyrical, natural aspects of the scene. Rather, his vision was direct, yet subtle.

The model for the woman dressed in blue twill is Victorine Meurent, appearing years after posing for "Olympia." She is looking up from a book with an indifferent glance while a small puppy sleeps on her right

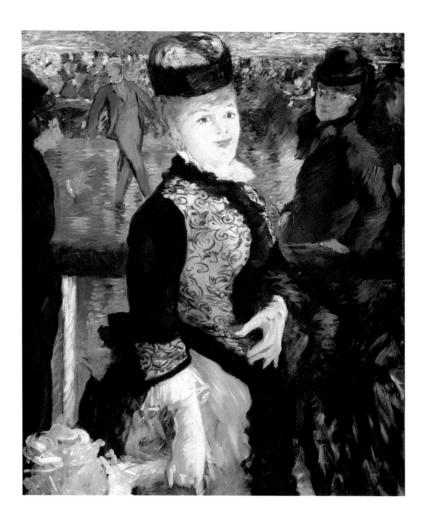

Blond Woman with Bare Breasts

1878c. ; *oil on canvas; 24 1/2 x 20 1/4 in. (62 x 51.5 cm.).*
Paris, Musée d'Orsay.
Although this painting is close in spirit and technique to works by Renoir, Manet approaches the subject of the female nude with more elegance and a more distinct charm. The paint has been applied with flowing strokes. X-ray examination reveals a voluptuous modeling of forms with the brush, especially the left breast, which appears almost sculpted in its round shape.

Skating

1877; *oil on canvas; 36 1/4 x 28 1/4 in. (92.5 x 72 cm.).*
Cambridge, Massachusetts, Fogg Art Museum.
Manet chose the skating rink in the rue Blanche as the locale for this scene from everyday life in Paris. The woman, holding a little girl's hand, is the model Henriette Hauser, an actress and celebrated mistress of the Prince of Orange, who posed also for Nana. *Skating rinks were quite fashionable in Paris during those years and were referred to in English to emphasize their novelty.*

arm. Her long reddish hair falls freely down her shoulders, creating a strong accent against the dark blue of her dress and her pale complexion. Standing at her side with her back to the viewer is the daughter of Manet's friend Alphonse Hirsch, who is looking down at the railroad tracks and the white steam of the engines from a safe distance. The metal bars of the railing animate the composition, dividing the canvas in equally spaced rhythmic fragments. This device serves to heighten the realistic aspects of the scene.

It is a harmonious and serene vision of the industrial world, rendered with brilliant, almost Impressionistic colors. Although possibly painted outdoors, the grill clearly limits the integration of the figures with its surroundings, something Monet sought to avoid later in his works. Ironically, it was with this painting, shown at the Salon in 1874 in the same year as the first dissident "Impressionist exhibition," that Manet was perceived as the leader of the new Impressionist movement. "M. Manet is one of those who hold that art can and should stop short with the 'impression'," a critic wrote. "For that is the whole secret of your 'impressionalistes'—they rest content with shorthand indications, dispensing with effort and style."

Manet became more and more involved with the Impressionistic style as pursued by Monet, Renoir, and other artists. During the months of July and August of 1873, which he spent near Berck-sur-Mer in Normandy, Manet painted *The Swallows*, an "en-plein-air" subject executed with a light palette not unlike that of certain works of his friends. The figures in the foreground are the artist's mother, to the left, and his wife Suzanne. Manet refused the invitation to participate at the first Impressionist show the following year, not wanting to be identified by critics with the rebellious group of artists around Monet, Renoir, and Degas, and preferred to submit this work along with *Gare Saint-Lazare* and *Masked Ball at the Opéra* to the Salon instead. The jury accepted only *Gare Saint-Lazare*, rejecting the other works. This refusal prompted a long article by a then young and virtually unknown critic and poet, Stéphane Mallarmé, who

Portrait of Émile Zola

detail. 1868; Paris, Musée d'Orsay.
Prominently displayed on the table is a copy of the blue pamphlet that Zola had just written in the painter's defense, its cover bearing Manet's name in the place of a more traditional signature. The frame on the wall contains an image of Olympia, *now gazing at the writer in a gesture of gratitude for his support. The Japanese print represents a sumo wrestler, then believed to be that of an actor.*

eventually became one of Manet's closest friends. Referring to the accusation that *The Swallows* was not finished, Mallarmé wrote: "What is an 'unfinished work,' if all its elements are in accord, and if it possesses a charm which could easily be broken by an additional touch?... One never sees the judges deal severely with a canvas which is both insignificant and frighteningly detailed."

The small *Masked Ball at the Opéra* is a rare work as it includes a multi-figured scene, something Manet had not done since his *Music in the Tuileries Gardens*, which it is related to in subject matter. The painting provides a glimpse of Parisian society life, more specifically the famous annual ball at the Opéra in rue Le Peletier. The scene is not the hall, where the dancing was, but the promenade behind the boxes. The ballet of the gentlemen's top hats lined up in close order is balanced by the cream-colored horizontal line of the gallery, above which some limbs appear behind the railing. The charming young women are dressed in costumes of sparkling colors which contrast effectively with the black suits of their male counterparts.

Summer on the Seine

Manet spent the summer of 1874 at the family house at Gennevilliers on the Seine, opposite Argenteuil, where Monet then lived. Although Manet had declined to exhibit with his Impressionist friends at their first independent exhibition in April, the two men saw a great deal of each other, and Manet was possibly never as close to the Impressionists and their way of painting as during that particular period. Frequently, Renoir joined the little group. On one occasion the three artists were working together in the garden of Monet's house, where Manet painted *The Monet Family in the Garden*, while Monet himself did a portrait of his friend sitting before the easel. Renoir, who arrived a little later on the scene, decided to paint the same motif as Manet and borrowed paint, brushes, and canvas from Monet. All three pictures were evidently painted very rapidly, but Manet's work is the most developed and ambitious of them. The carefully orchestrated arrangement belies the casual appearance of the scene. It is important to keep in mind that Manet usually did not paint outdoors and that this new procedure required a different approach from him.

In *Argenteuil* and *Boating*, painted during the same period, he depicted couples on or near a boat on the Seine. In both cases the male model was his brother-in-law Rodolphe Leenhoff, while both female models, whom he summoned from Paris, remain unknown. Earlier, Camille and Claude Monet had posed for Manet in *Claude Monet and his Wife on the Floating Studio*, but the long sessions Manet needed forced him to abandon his project and the painting was left in an unfinished state. *Argenteuil* might correctly be called Manet's most Impressionist painting. It is full of light and bright colors, probably done en-plein-air (entirely outdoors).

La Guinguette (The Tavern)
1878–1879; *oil on canvas;*
28 1/3 x 36 1/4 in. (72 x 92 cm.).
Moscow, Pushkin Museum of Fine Arts.
Done in quick, free brushstrokes, this unfinished study might provide a glimpse of Manet's daily stroll through Paris, during which he made sketches and picked up subjects, colors, and hues. The smoker in a cap is looking at the passersby, while a secondary sketched-in figure is sitting with its back to the viewer. The picture space is sharply cut off at the top, thus giving the scene a peculiar sense of space.

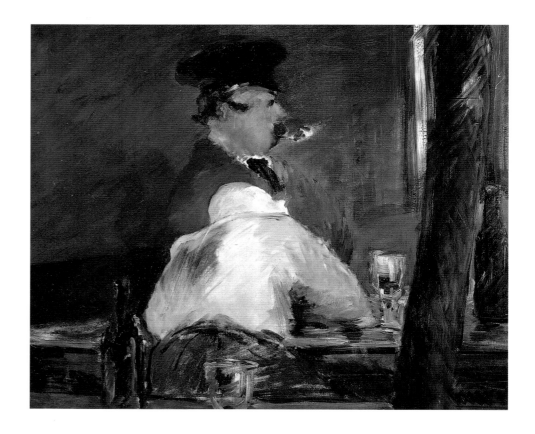

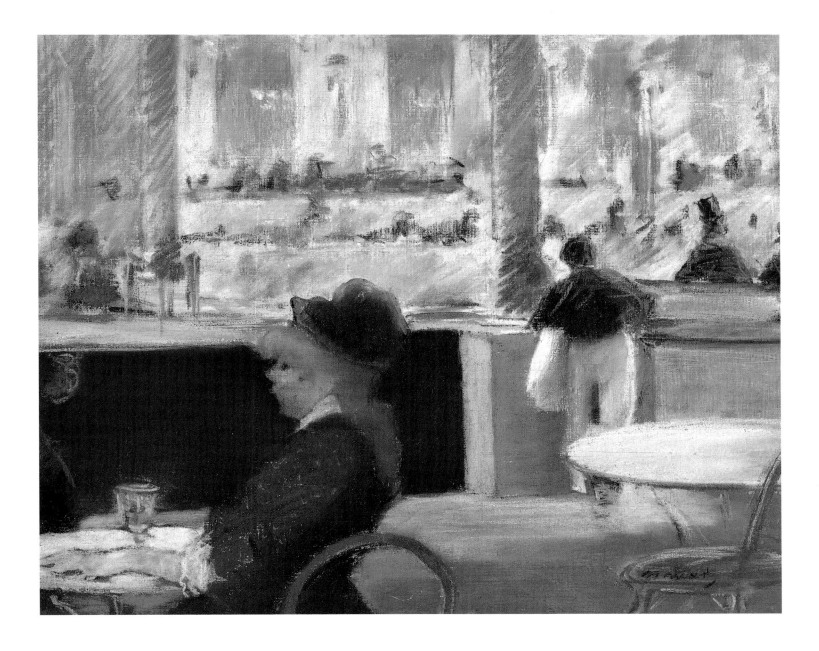

A boatman and his companion are sitting on a dock near some sailing boats. The deep blue water of the Seine separates the couple from Argenteuil on the other bank, where a lonely chimney announces the arrival of modern industry into the small resort town. The woman's dress and the bouquet of flowers on her lap are painted with unusual verve and liveliness. There is even a semblance of intimacy between the two figures, something rare in Manet's oeuvre.

The proximity of Renoir and Monet at Argenteuil notwithstanding, Manet's approach to painting remained quite different from that of his painter friends. In *Boating*, for example, he did yet another outdoor scene, but the handling of the brush is more controlled than that of his colleagues and his palette more subdued. The composition as well as the subject are without precedent. The painting's spatial ambiguities provoked critical comments even from staunch supporters like Zola, who accused Manet of lack of technical ability. But some details indicate that Manet intentionally mitigated the viewer's sense of depth. There seems to be no space between the elements in the foreground and the water. There is no horizon that could offer a sense of perspective. Furthermore, Leenhoff

Café in Place du Théâtre Français

1881; *pastel on board; 12 2/3 x 17 3/4 in. (32 x 45 cm.).* Glasgow, The Burrell Collection.

After his return from Versailles, where he had spent the summer months, Manet was extremely active, as if to dispel rumors that his failing health had finished him as an artist. He worked, saw friends, and visited cafés. This pastel, executed in his studio, is based on sketches Manet did at a café in the Place du Théâtre Fransais.

Sketch for "A Bar at the Folies-Bergère"

1881; *oil on canvas;* 18 1/2 x 22 in. (47 x 56 cm.).
Amsterdam, Stedelijk Museum
(on loan from F.F.R. Koenigs Collection).
*This preliminary study differs considerably from the
painting* A Bar at the Folies-Bergère, *where Manet
had made major changes in order to accommodate
pictorial considerations. It is fascinating to see how the
painter transformed a rapidly sketched Impressionistic
memorandum into an icon of contemporary Paris.*

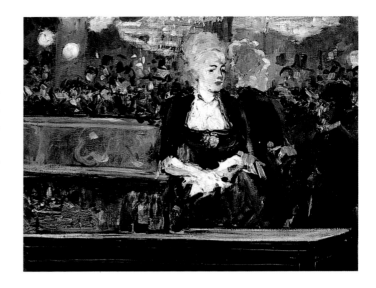

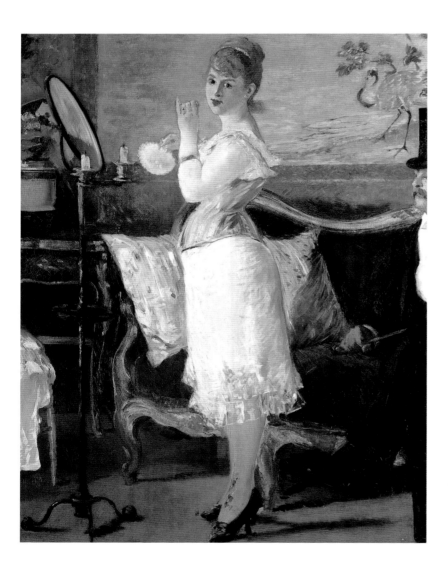

Nana

1877; *oil on canvas;* 60 3/4 x 45 1/4 in. (154 x 115 cm.). Hamburg, Kunsthalle
In his famous Nana *Manet shows a scene of contemporary life,
without moralizing but with frankness and humor. The woman,
a prostitute, is about to powder her face and to add lipstick, while a
customer waits patiently on the couch. Her body is at the center of
the entire composition. The painting provoked scandal, as the model,
Henriette Hauser, was the well-known mistress of the Prince of Orange.*

held originally the rope in his right hand; by moving it
further to the right, the artist diminished considerably
the sense of depth. Manet's formal experimentation was
thus misunderstood and taken for a technical error.

Nana

During the winter of 1876–1877 Manet took up a
favorite theme, that of the courtesan. *Nana*, painted
fifteen years after *Olympia*, is a work done in a natural-
ist mode and without reference to the past. The sub-
ject itself was in the air and treated by writers and
painters alike, such as Zola and Degas. The title of the
painting was indeed inspired by a character of the same
name in Zola's novel *L'Assommoir* (his book *Nana* was
to appear a few years later), in which Nana, a red-
haired young woman, was at the beginning of her
career: "Since the morning, she had spent hours in her
chemise before the bit of looking glass hanging above
the bureau ... she had the fragrance of youth, the bare
skin of child and of woman."

Manet chose the moment in which Nana is at her toi-
lette, about to put some lipstick and powder on her face,
while a customer is waiting on the couch. His figure is
cut off by the picture frame, a device Manet must have
learned from Degas, who adopted it frequently for simi-
lar subjects. The composition revolves around the wom-
an's body. Feminine curves are repeated in the furniture
and the pillows on the couch. Without moralizing but
with humor and frankness, Manet presented a scene of
contemporary life. With the large canvas, the notoriety
of the model (Henriette Hauser was the well-known
mistress of the Prince of Orange), and the combination
of a free technique with a clear and violent palette,
Manet challenged once more the jury of the Salon in
1877, where the painting was inevitably rejected.

At the Folies-Bergère

During the last years of his life Manet painted, perhaps inspired by the works of Degas, a number of café scenes, which culminated in his last great masterpiece, the melancholic *A Bar at the Folies-Bergère*. The painting has long been admired for its dazzling rendering of still-lifes of champagne bottles and fruit on the marble counter top. A serving-girl, dressed in a black velvet dress with white laces, seems to avoid any contact, her tired or sad look being directed somewhere below the viewer's eye level. The mirror behind her reflects the interior of the bar, where spectators seem to ignore a trapeze act that is being performed; small green feet at the top left corner are all we can see of the acrobat. The Folies-Bergère was a café-concert much in vogue at the time; it was considered a place to encounter diverse company as much as spectacle. The first girl's indifference and aloofness is contrasted by the other barmaid's attitude. Seen only from the back, she seems to bend forward toward a mustachioed man who is talking to her.

This was one of several times that Manet used the mirror effect, but he did not exploit its possibilities by presenting several views of the same model. The mirror reflects rather the space in which the viewer would be stationed. Thus the canvas becomes a reflection of the "real" world with the bartender standing in between. The artificiality of the "faulty" perspective was noted from the beginning, but it is a deliberate part of Manet's artistic concept. *A Bar at the Folies-Bergère* was painted while Manet was already quite ill, and the work progressed only slowly. It was a final representation of sensuous objects and of a Parisian world that had been part of his life.

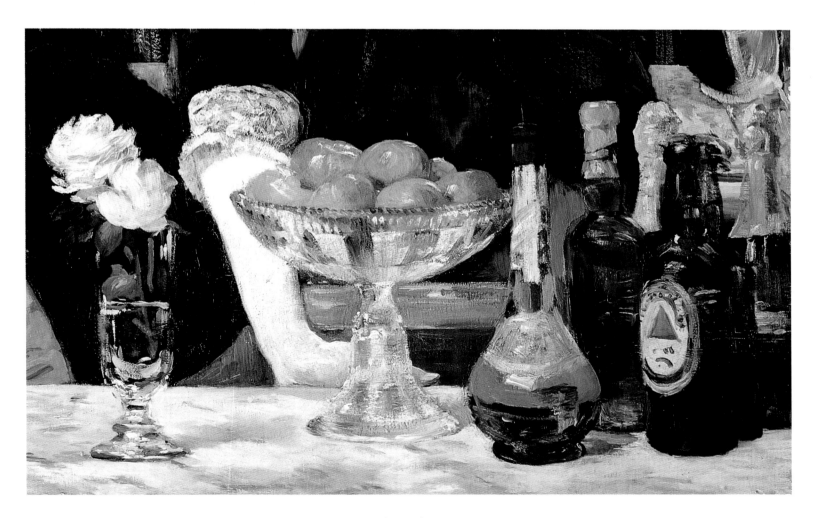

A Bar at the Folies-Bergère

detail. 1881–1882; 37 3/4 x 51 1/5 in. (96 x 130 cm.). London, The Courtauld Institute Galleries.
One of the most striking aspects of this famous painting is the still-life on the marble top of the counter. The bright orange of the fruit is complemented by the green glass of a bottle of crème de menthe. Next to that is a Bass Pale Ale with the red triangle on its label. Two white roses placed in a drinking glass anticipate Manet's late flower still-lifes.

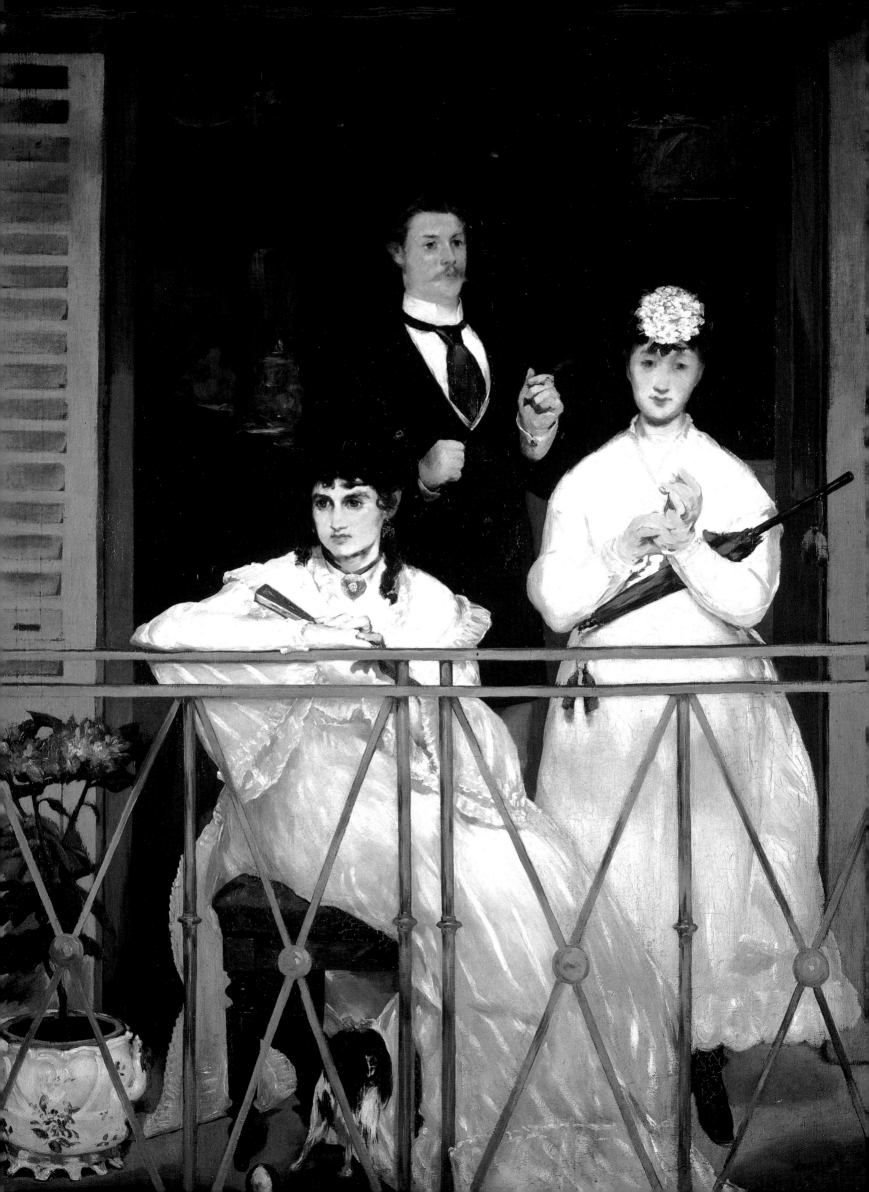

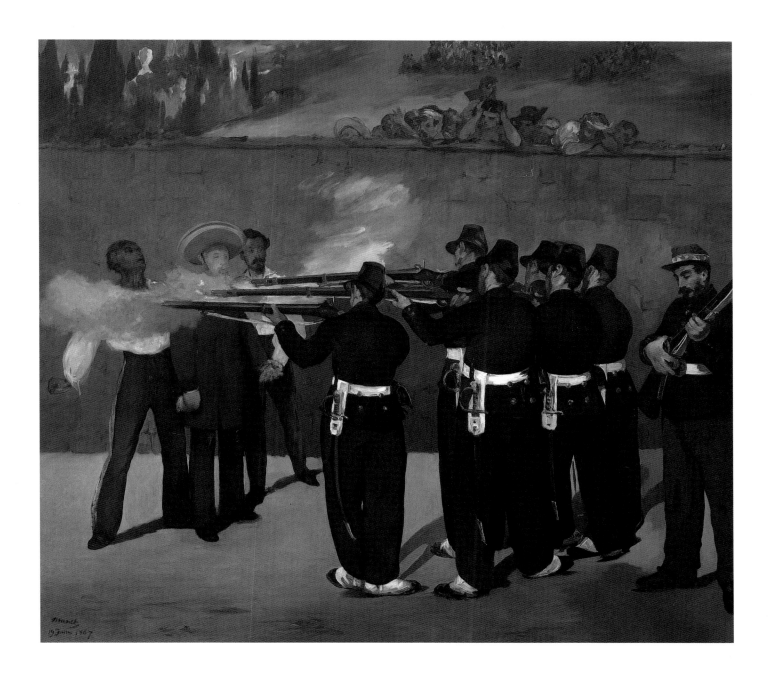

The Execution of Emperor Maximilian

1867–1868; oil on canvas; 99 1/4 x 120 in. (252 x 305 cm.).
Mannheim, Germany, Kunsthalle.
*The news of the execution of Maximilian of Austria,
Emperor of Mexico, on June 19, 1867, shocked all of
France. But soon horror gave way to indignation against
Napoleon III, who had withdrawn his troops from Mexico
at a critical moment thus exposing his vulnerable protégé
to the attacks of his adversaries. Facing the firing squad
with a halo-like sombrero, the Emperor is awaiting his
coup de grâce from the soldier on the far right, who is
about to load his rifle, while the two loyal Mexican
generals are already about to tumble to the ground.*

The Balcony

1868; *oil on canvas; 66 1/2 x 49 1/4 in. (169 x 125 cm.).*
Paris, Musée d'Orsay.
*It is generally believed that Manet conceived this scene of
modern life with three friends posing behind the railing
of a balcony during the summer of 1868 at Boulogne-sur-
Mer. The seated woman is the painter Berthe Morisot,
who became a close friend of Manet's. On the right is
Fanny Claus, a young concert violinist, and in the back-
ground stands the painter Antoine Guillemet. The violence
of the greens of the metal bars and shutters, and of the
striking blue of the cravat, are still arresting today.*

The Folkstone Boat—Boulogne

1869; *oil on canvas*; 23 1/2 x 29 in. (60 x 73.5 cm.).
Philadelphia, Museum of Art.
*The spontaneous quality of the scene is enhanced by
numerous quick brushstrokes, as the Danish author
Georg Brandes noticed: "This throng of people which,
seen at close range, only consists of spots and blotches
of color ... when viewed at a distance, it gives the
impression of turbulent life." The two figures protected
by an umbrella to the far left have been identified as
being Suzanne Manet and her son Léon Leenhoff.*

Portrait of Émile Zola

1868; *oil on canvas*; 57 1/2 x 45 in. (146 x 114 cm.).
Paris, Musée d'Orsay.
*The writer Emile Zola was among the most eloquent
and staunchest supporters of Manet's art. Even before
meeting the artist he had written a thundering defense,
for which Manet was very grateful. The two men
developed a lifelong friendship, which was only tempor-
arily clouded by a misunderstanding in 1880. In this
portrait Zola is surrounded by books and art works
indicating the subject's activities and tastes.*

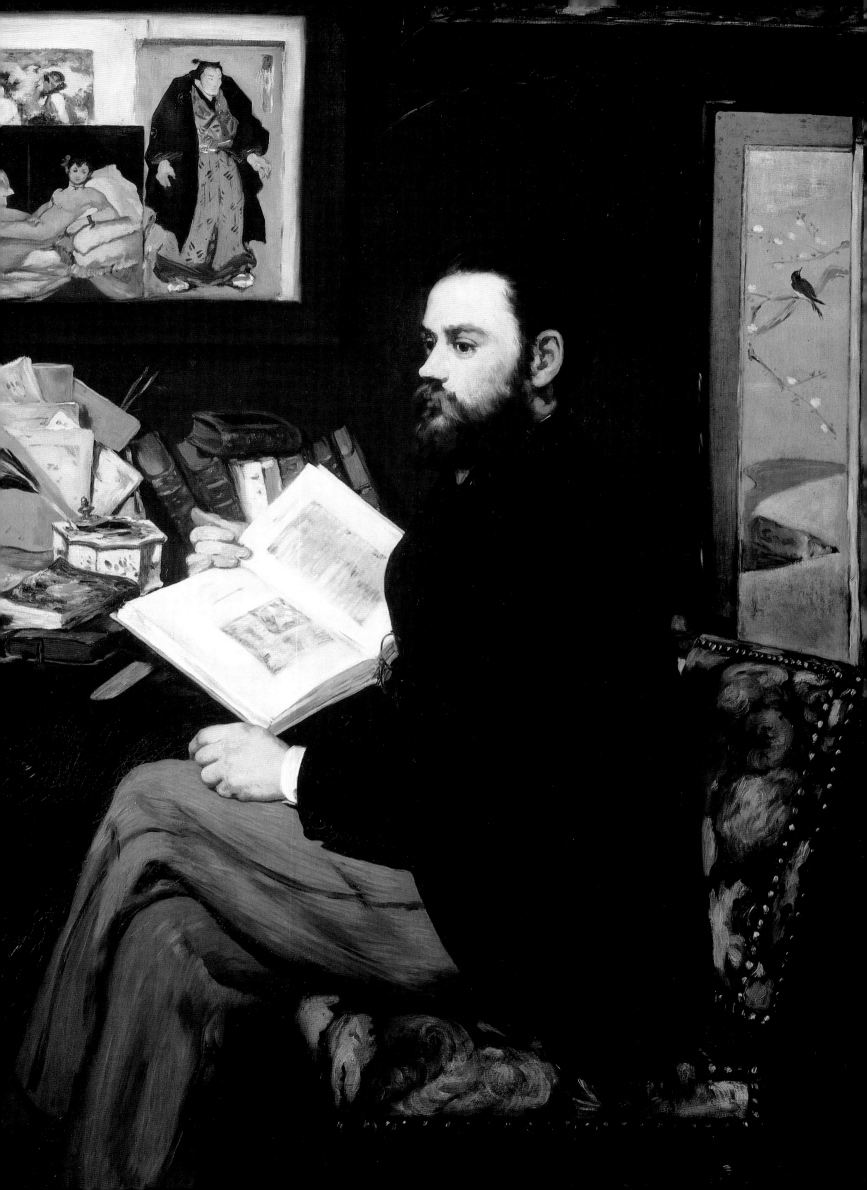

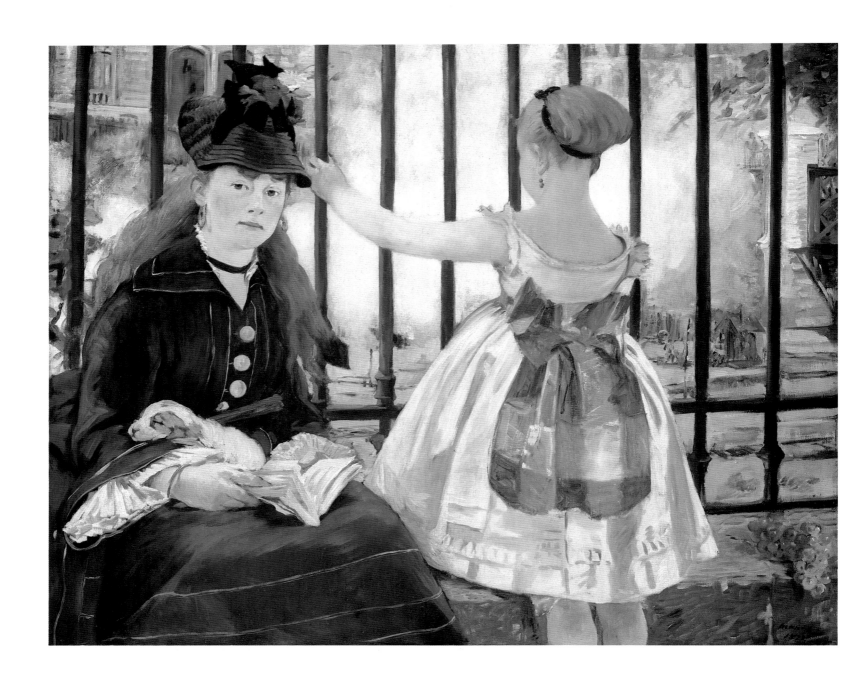

Gare Saint-Lazare

1873; *oil on canvas;* 36 1/2 x 45 in. (93 x 114 cm.).
Washington, D.C., National Gallery of Art.
*This painting, shown with success at the Salon of 1873,established Manet's
position as the so-called leader of the Impressionists, who— ironically—
had opened their first independent show at the same time. Although the
painting may have been done from life, the two sitters, Victorine Meurent
and the daughter of Manet's friend Alphonse Hirsch, are separated from
their environment by the grill behind them. The subject of the Saint-Lazare
train station was to become dear to Monet a couple of years later.*

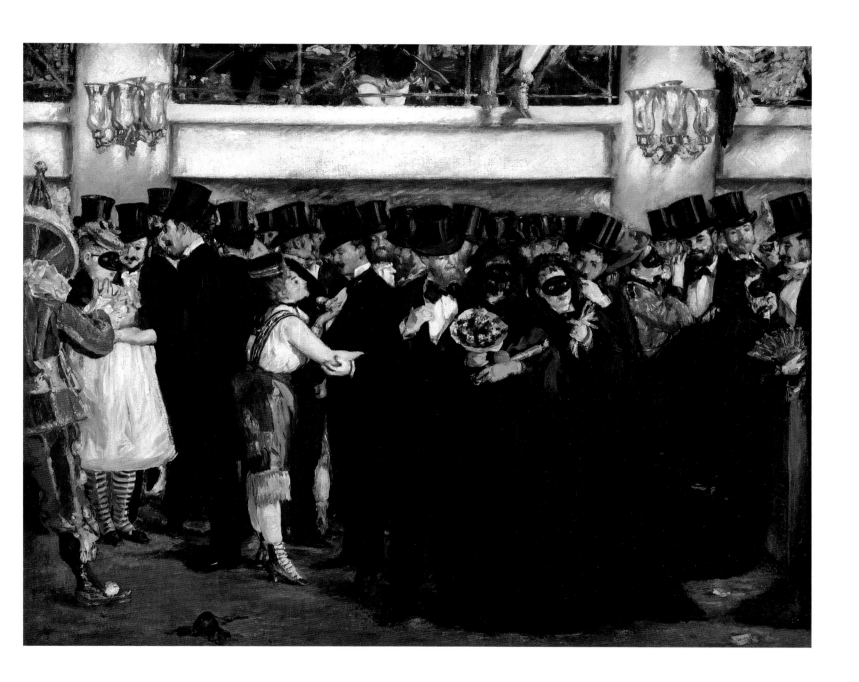

Masked Ball at the Opéra
1873; *oil on canvas*; 23 1/2 x 28 3/4 in. (60 x 73 cm.).
Washington, D.C., National Gallery of Art.
The jury of the 1874 Salon failed to recognize the extraordinary
qualities of this painting, which it rejected together with The Swallows.
In a sea of floating frock coats and black top hats appear the bright color
spots of carnival costumes. The locale is the promenade behind the boxes
at the Opéra in the rue Le Peletier, where the annual masked ball took
place at mid-Lent. The atmosphere is gay, even frivolous at times, and
the festive setting is captured with brilliant touches of light.

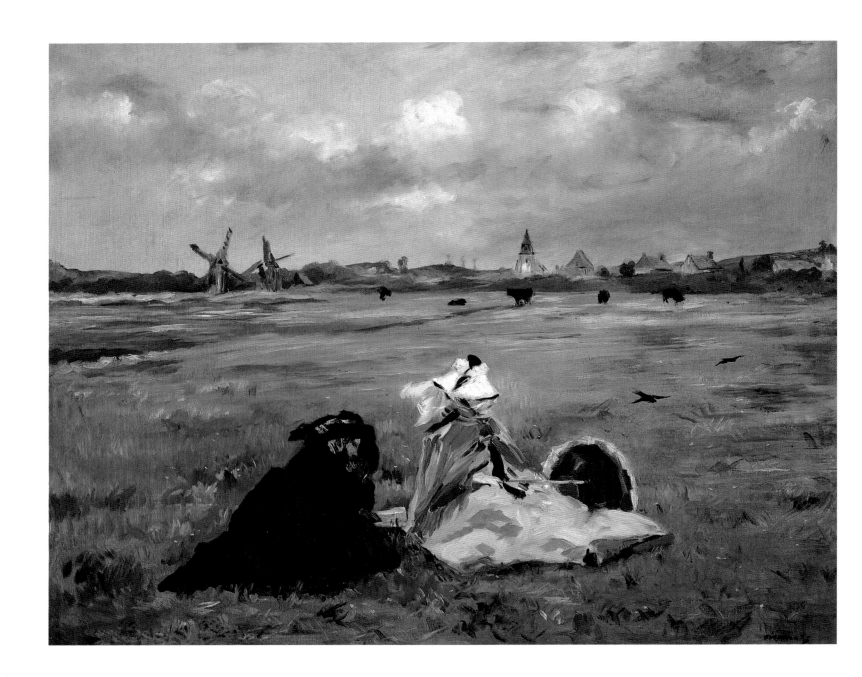

The Swallows
1873; *oil on canvas;* 24 2/3 x 31 3/4 in. (65 x 81 cm.).
Zurich, Switzerland E.G. Buehrle Collection.
The summer months of 1873 in Etaples near Berck-sur-Mer
were quite productive. Manet painted at least fourteen other canvases
besides the present one, which is executed with a light palette.
The figures in the foreground are the artist's mother, to the left,
and his wife. Abandoning seascapes for a moment, Manet had
placed the sitters in a field with swallows flying low over them.

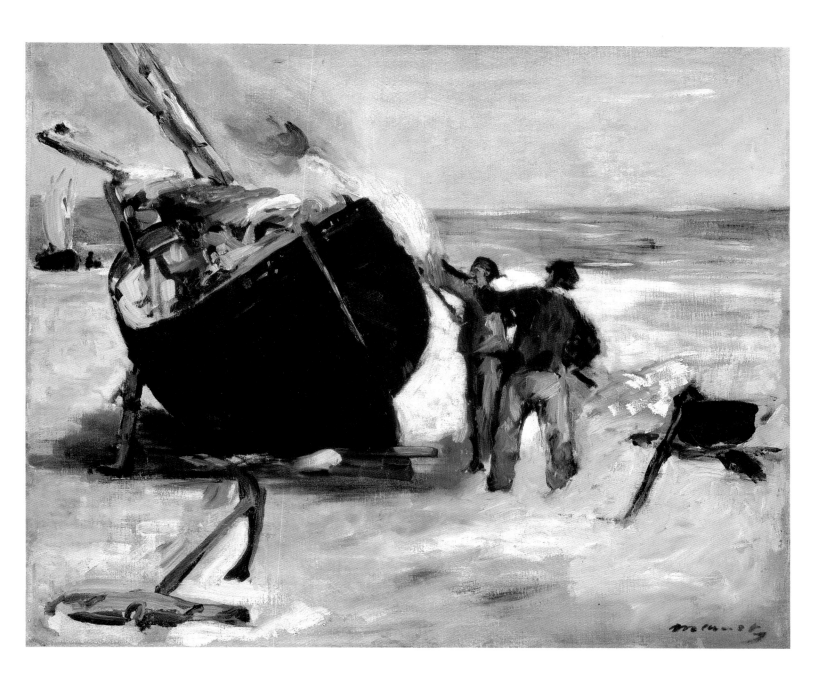

Tarring the Boat
1873; *oil on canvas;* 23 1/4 x 23 5/8 in. (59 x 60 cm.).
Merion, Pennsylvania, The Barnes Foundation.
Manet studied the daily activities of the fishermen during a summer
vacation at Berck-sur-Mer, where he painted also The Swallows *and*
At the Beach. *The scene is dominated by the contrast of the luminous*
blacks of the tar and the orange-colored fire of the workmen preparing
the tilted hull to make it watertight. Far from an anecdote or genre
scene, this image has the power of a poetic evocation.

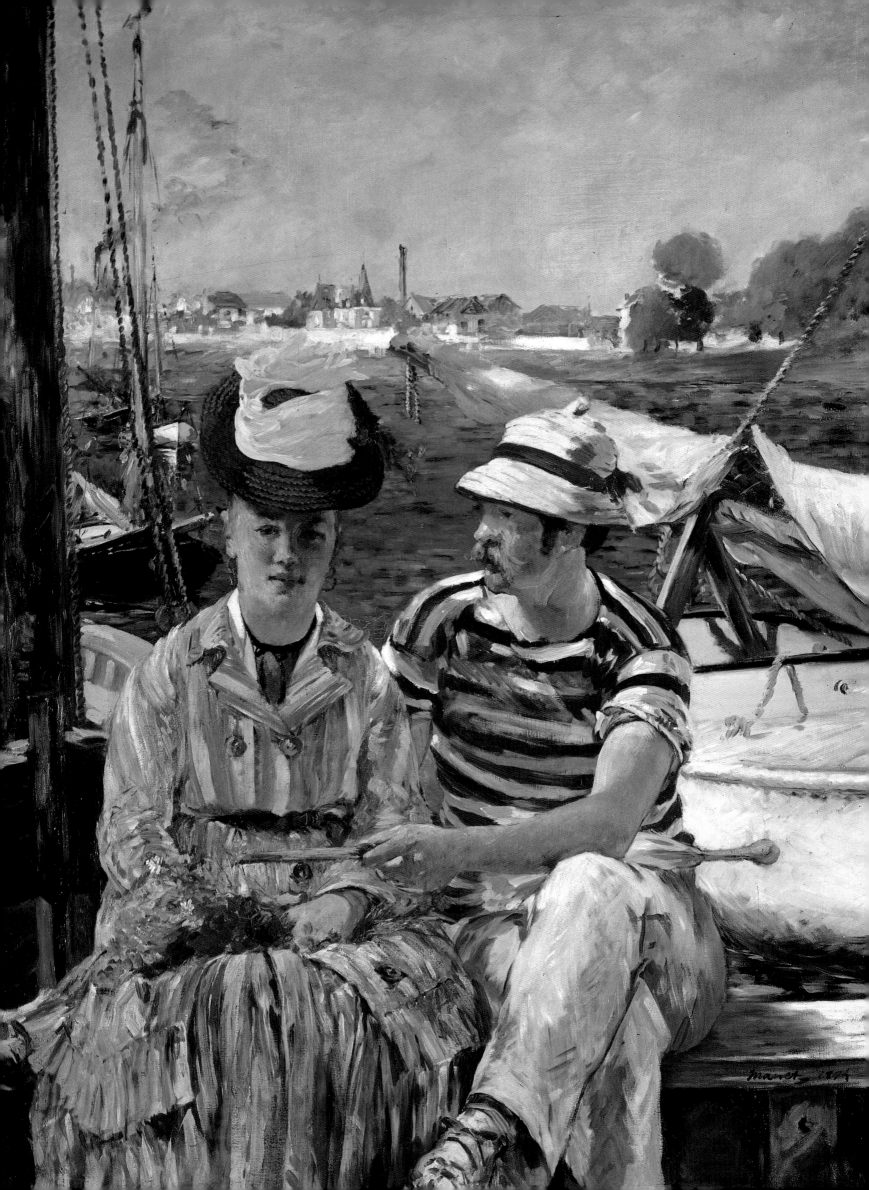

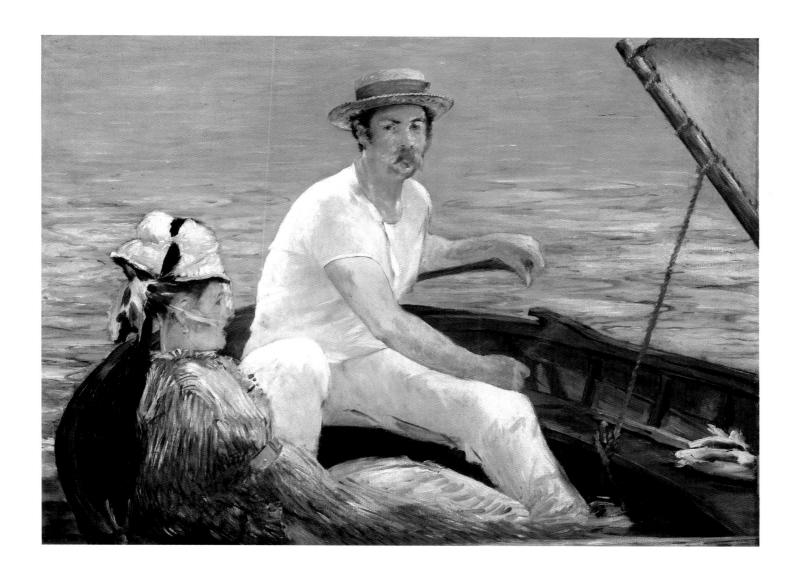

Boating

1874; *oil on canvas*; 38 1/4 x 51 1/4 in. (97.2 x 130.2 cm.).
New York, Metropolitan Museum of Art.
Painted during the summer of 1874 near Argenteuil,
where Manet, Monet, and Renoir came together, Boating
is less of an outdoor painting than other works done
there. The water completely fills the background of
the canvas thus limiting the notion of space, which
is only defined by the shape of the boat and the position
of the sitters. The fluid, rapid brushwork of the woman's
dress, however, is clearly inspired by Monet and Renoir.

Argenteuil

1874; *oil on canvas*; 59 3/4 x 45 1/4 in. (149 x 115 cm.).
Tournai, Musée des Beaux-Arts.
The male sitter is Rodolphe Leenhoff, Manet's brother-
in-law; the woman an unidentified model, called to
Argenteuil from Paris. Nevertheless, there seems to be a
certain tenderness in the couple's attitude, which is a rare
quality in Manet's oeuvre. Although there is no documentary
evidence, it is quite likely that the painting was at least in
part executed out-of-doors during the summer at Argenteui.

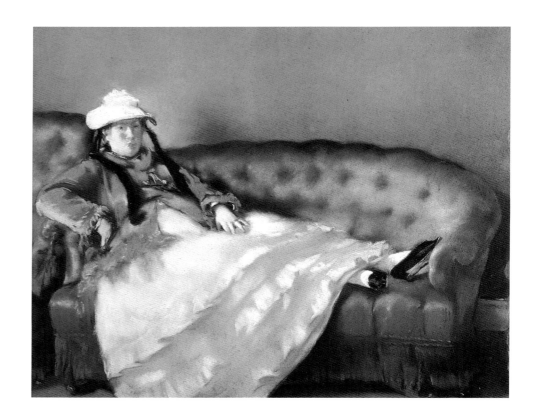

The Artist's Wife on a Blue Sofa

1874; pastel on paper, mounted on cloth;
25 1/2 x 24 in. (50.5 x 61 cm.).
Paris, Musée d'Orsay.

Occasionally, Manet used the medium
of pastel in his portraits. If this was influ-
enced by his friend Degas, who used this
medium quite frequently, or not is a
matter that requires further research. In
any event, Manet recognized the potentials
of the technique and used it to its fullest
advantage. The bright blue couch, the
white skirt, and the ruddy background are
of an intensity unattainable with oil paint.

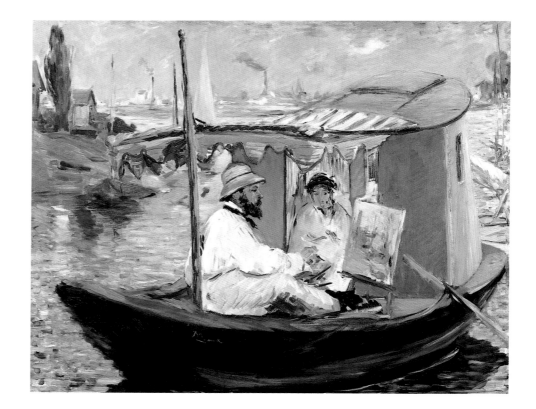

Claude Monet and his Wife
on the Floating Studio

1874; oil on canvas; 31 1/2 x 38 2/3 in.
(80 x 98 cm.). Munich, Neue Pinakothek.
Claude Monet had a floating studio built
on which he would paint during the
early morning hours on the Seine, near
his house at Argenteuil. During his visit
there, Manet began to paint his friend
together with his wife on that boat, but
the long sitting hours that he needed
forced him to abandon the project. But even
in its unfinished state, the painting reveals
a good deal of the atmosphere of a bright
summer day spent in company of close friends.

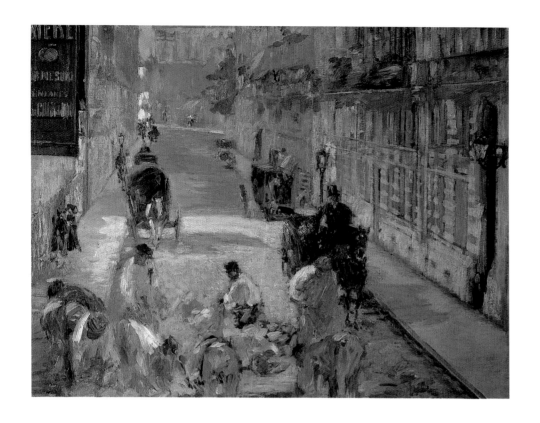

The Rue Mosnier with Pavers
1878; *oil on canvas*; 24 1/4 x 31 1/2 in.
(64 x 80 cm.).
Private Collection
(on loan to the Kunsthaus Zurich).
*Between 1872 and early July 1878,
Manet occupied a studio on rue de Saint-
Petersbourg with a view down the rue
Mosnier (since 1884, known as rue de Berne).
From his window Manet was able to
observe streetworkers paving the road,
and a carriage trying to pass by. Both in
technique and subject matter, the work is
very close to the Impressionists.*

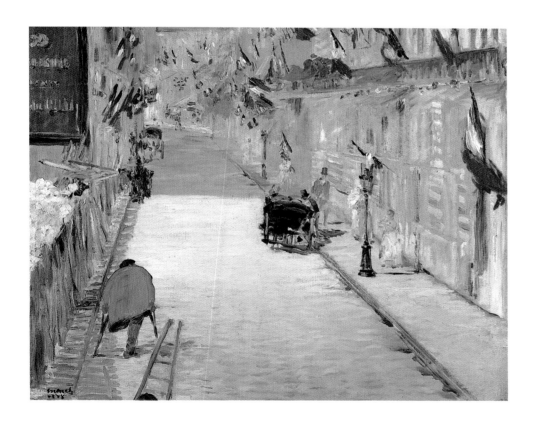

La Rue Mosnier aux Drapeaux
1878; *oil on canvas*; 25 5/8 x 31 7/8 in.
(65 x 81 cm.). Malibu, California.
The J. Paul Getty Museum.
Depicting the same street as in The Rue
Mosnier with Pavers, *here Manet chose
a particular day, June 30, 1878, the
national holiday for the Exposition
Universelle, which was celebrated through-
out France. The street is festively decorated
with flags, but the joyful display is
contrasted with the presence of a man on
crutches seen from behind. He was a local
character, who in all probability lost his
leg in the Franco-Prussian War of 1870.*

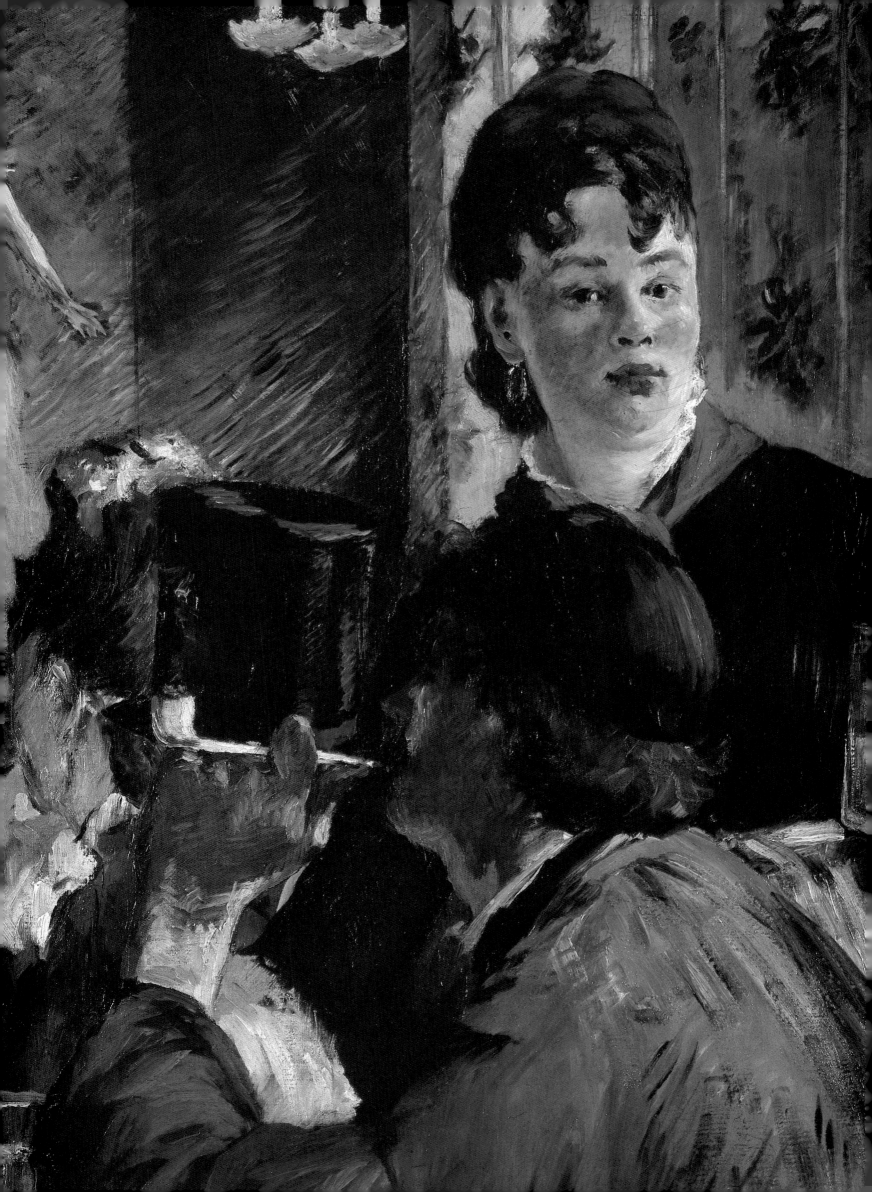

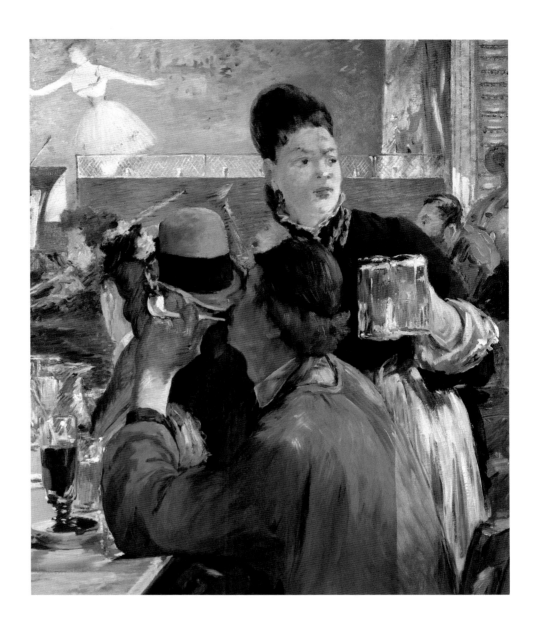

**The Beer Waitress
(La Serveuse de Bocks)**

1878–1879; *oil on canvas;*
30 1/2 x 25 5/8 in. (77.5 x 65 cm.).
Paris, Musée d'Orsay.
*In this unusual closeup of a waitress
serving beer to her customers in a
café-concert, Manet has reached
a high level of concentration and
powerful expression by economizing
his means. Setting one beer mug
down on an invisible table, the woman
is ready to deliver the other two,
while at the same time catching the
viewer's attention and perhaps taking
another order. The customer's white
clay pipe is set off effectively against
the black top hat of another visitor.*

Corner in a Café-Concert

1878–1879; *oil on canvas;* 38 1/4 x 30 1/2 in. (98 x 79 cm.).
National Gallery, London.
*Café-house scenes became a regular subject for Manet during the late
1870s. This painting might have preceded the similar, but more concisely
composed, version* The Beer Waitress (La Serveuse de Bocks). *The angle
of the present scene is larger and shows more of the interior of the café.*

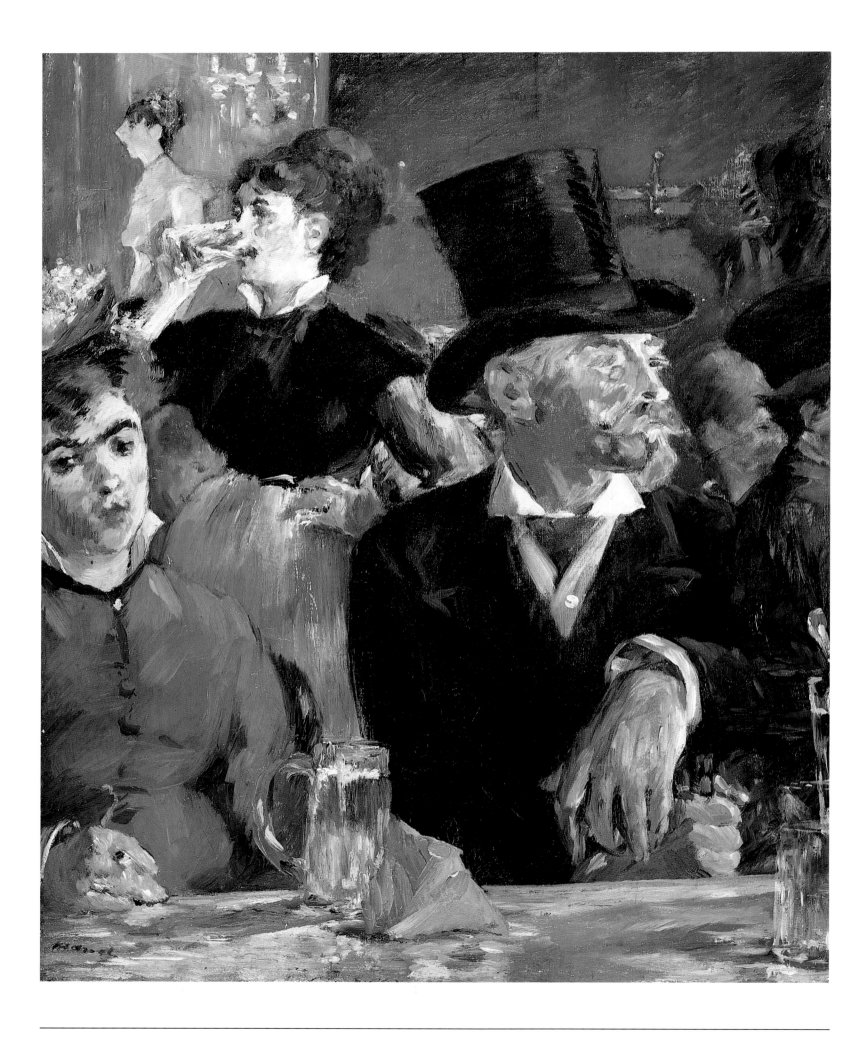

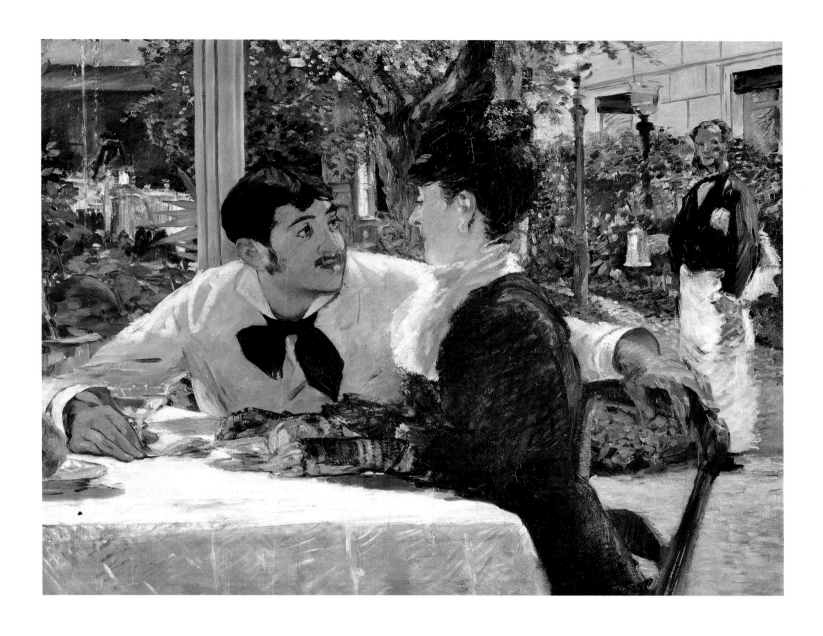

Couple at 'Père Lathuille'

1879; *oil on canvas;* 36 2/3 x 44 in. (93 x 112 cm.).
Tournai, Musée des Beaux-Arts.
The famous outdoor restaurant of "Père Lathuille"
was one of the meeting places for the "Manet gang,"
as the Impressionists were sometimes known. The model
for the young man at the table, who is apparently making
a proposition to the woman, was the son of the restaurant's
owner. The color harmonies of yellow, mauve, and green
hues are perfectly balanced. The scene offers a particularly
successful rendering of contemporary life in Paris as
described in the short stories by Guy de Maupassant.

Café-Concert

1878; *oil on canvas;* 18 5/8 x 15 3/8 in. (47.5 x 30.2 cm.).
Baltimore, Maryland, The Walters Art Gallery.
The characteristic of this picture is the fact that every single
figure, with the exception of the top-hatted gentleman, is
either cropped or overlapped by an adjacent person. This
feature has also been exploited by Degas in many of his
café-house scenes. The setting is the brasserie-concert "Au
cabaret de Reichshoffen" on the boulevard Rochechouart,
which served Manet also as a setting for The Beer Waitress.

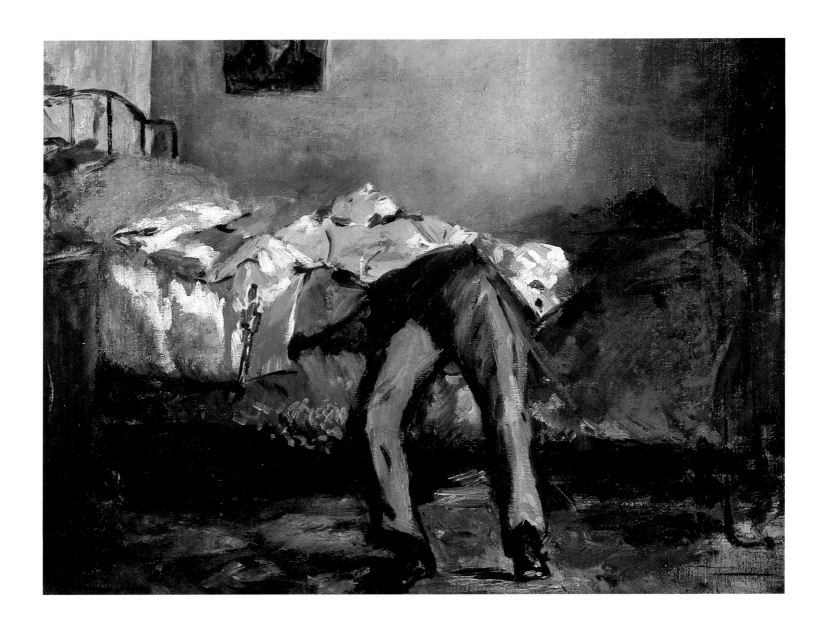

Suicide

1881; *oil on canvas;* 15 x 18 1/2 in. (38 x 46 cm.).
Zurich, Switzerland, E.G. Buehrle Collection.
*The peculiar subject might be explained by the
fact that the painting was donated to an auction for the
benefit of the eccentric musician François Cabaner who
was dying of tuberculosis in a hospital outside of Paris.
Referring to his licentious lifestyle, Zola remarked:
"the truth is that [Cabaner] died for his art." It is possible
that Manet intended* Suicide *as a metaphor for Cabaner's
situation and that he painted it specifically for the auction,
where the painting brought only sixty-five francs.*

Le Journal Illustré

c. 1878–1879; *oil on canvas;* 24 1/4 x 19 7/8 in.
(61.7 x 50.7 cm.). The Art Institute of Chicago.
*This stylishly dressed woman, reading a
newspaper in a café, is less typical of Manet's
café-house scenes, which are usually filled with
people from lower-class positions. The rapidly
stroked brushwork, in particular the bright
greens and reds behind the head, serve as an
effective foil for the comparatively unbroken
fields of black in the figure's hat and dress.*

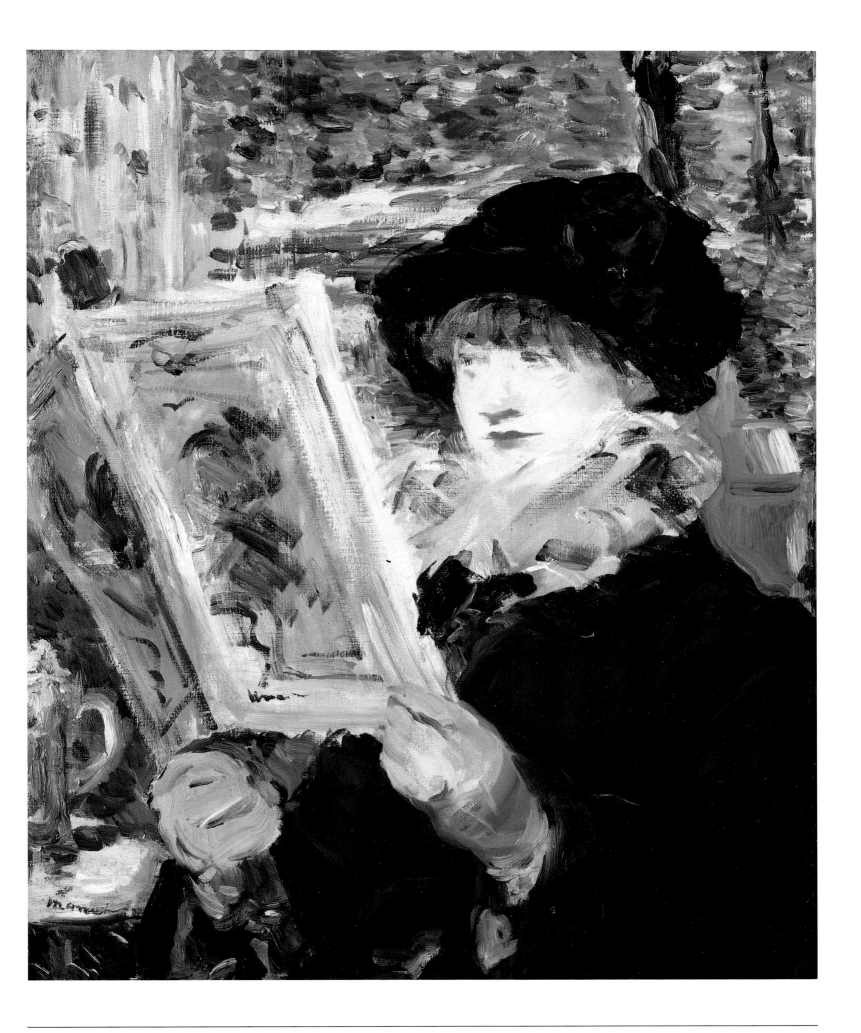

The Plum

c. 1877; *oil on canvas;*
29 x 19 3/4 in. (73.6 x 50.2 cm.).
Washington, D.C.,
National Gallery of Art.
*Although it depicts the
interior of a Parisian café,
the painting was executed
in Manet's studio, where he
kept a characteristic marble
table on an iron support.
The woman seems lost in
thought, oblivious to the glass
in front of her and the unlit
cigarette in her left hand.
Sometimes thought to be a
prostitute, the sitter seems
more likely to represent an
introverted individual.*

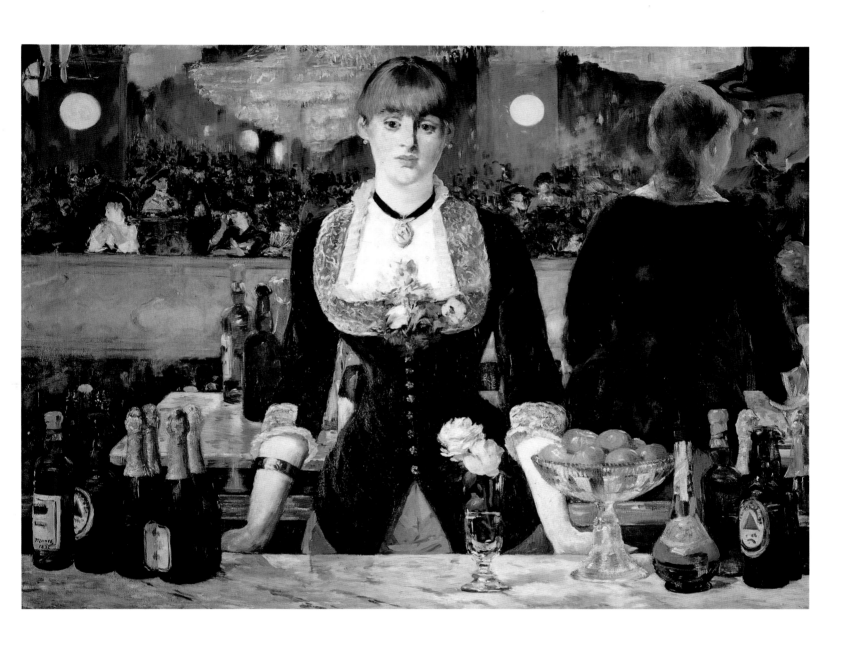

A Bar at the Folies-Bergère

1881–1882; *oil on canvas;* 37 3/4 x 51 1/5 in. (96 x 130 cm.).
London, The Courtauld Institute Galleries.

Manet's last masterpiece is like a melancholic farewell to the gay life of Parisian entertainment. The brilliant still-life on the marble counter, the barmaid's resigned expression, and the mirror with its myriad reflected details have often been commented upon. The exciting quality of the painting makes one almost forget the difficulties Manet experienced during its execution when he often had to interrupt his work for reasons of ill health.

CHAPTER 3
A CIRCLE OF FRIENDS
AND PATRONS

*I*t was customary among Impressionist artists to paint portraits of each other or of their friends, but even more so of patrons who would pay them often urgently needed money for their work. That was particularly the case with Renoir, who was at times in disastrous financial situations. His output in this field is consequently considerable. Manet also painted many portraits, mostly of family members and friends, but—with one exception—never of his Impressionist colleagues.

Some of Manet's earlier portraits have been discussed in previous chapters. In *Boy with a Sword*, he depicted his illegitimate son Léon Leenhoff, and in *Young Man in the Costume of a Majo* his younger brother Gustave was the model, not to mention the various paintings which show Victorine Meurent, including the *LeDéjeuner sur l'herbe* and *Olympia*. Manet also painted portraits of Zola and Berthe Morisot.

Independently wealthy through his father's legacy, Manet was never forced to sell his paintings like Monet or Renoir. He did not court patrons and was in the enviable position to paint whatever subject pleased him. Nevertheless, the number of his portraits is proportionately high compared to his total oeuvre. The reason is that Manet always considered himself a figure painter. Even in those relatively few canvases with outdoor scenes like the ones painted at Argenteuil, he almost always included figures, as if to justify his efforts. In this respect, he was the opposite of Claude Monet, who often preferred to paint landscapes without the presence of human beings. Manet was clearly a city person, attached to Paris as to no other place in the world, while Monet

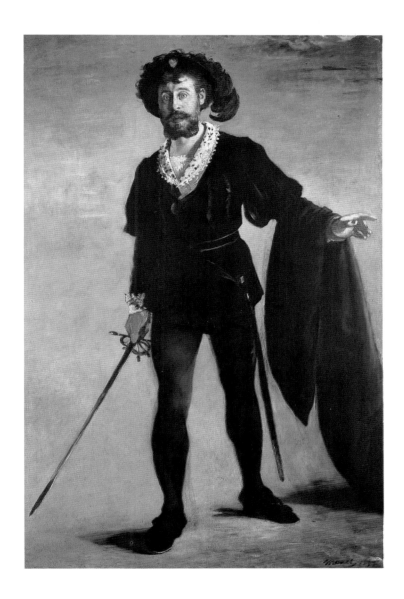

Woman with Fans (Nina de Callias)
detail. 1873–1874. Paris, Musée d'Orsay.
Manet depicted Nina de Callias in one of her "Algerian" dresses in which she used to receive her guests at home. Resting on one arm, her expressive face bespeaks amusement, but also a touch of wistfulness. Black curls fall on her forehead from underneath a black hat decorated with a yellow feather. Nina de Callias died of alcoholism three years after Manet at the age of thirty-nine.

Jean-Baptiste Faure as Hamlet
1877; *oil on canvas; 77 x 51 1/2 in. (196 x 131 cm.).*
Essen, Germany, Folkwang Museum.
The famous baritone and collector of Impressionist art, Jean-Baptiste Faure, commissioned this portrait from Manet, who depicted him in one of the most successful roles of his career. The sessions in the painter's studio were animated by discussions about Hamlet's character, but in the end Faure was not pleased with the portrait and rejected it. His friendship with Manet, however, continued undisturbed.

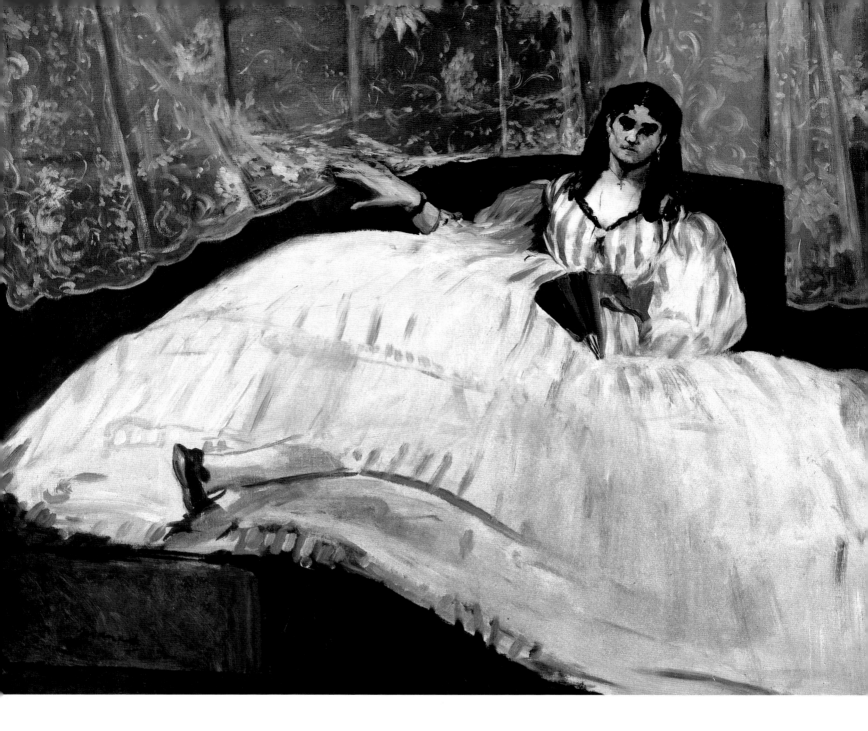

Baudelaire's Mistress, Reclining

1862; *oil on canvas; 35 1/2 x 44 1/2 in. (90 x 113 cm.). Budapest, Szépmüvészeti Múzeum.*

Listed in records drawn up at Manet's death as a painted study, this portrait of Baudelaire's mistress, Jeanne Duval, might never have left the artist's studio, except when it was shown at the Galerie Martinet in 1865. The image is terribly revealing, and one can imagine Baudelaire's reaction to the expression of this hardened and embittered face, once so passionately loved and now disfigured by partial paralysis.

returned to the capital from his homes in Argenteuil and later in Giverny only reluctantly and only when he had to conduct business with his galleries.

The artistic differences between the two painters did not prevent their names from occasionally getting mixed up in the press, a fact which annoyed Manet deeply. "[Manet] is much troubled, by the way, over his rival Monet. So much so, people are saying that, having 'manetized' him, he would now like to 'de-monetize' him." (Letter from Edmond Duranty to Alphonse Legros, early October 1866.) But when introduced to Monet through his friend Zacharie Astruc, Manet discovered his sympathy for his younger colleague, and the two artists became life-long friends.

Manet and Baudelaire

One of Manet's earliest and most influential supporters was the poet Charles Baudelaire, who had come to see the artist at his studio after the success of *The Spanish Singer* at the Salon of 1861. He immediately recognized Manet's "brilliant faculties," but also his "feeble character," which made him ill prepared for the struggle toward recognition. "Never will he completely overcome the gaps in his temperament," Baudelaire wrote later to a friend, "but he *has* temperament, that is the important thing." In an article published in 1862, he lauded

Manet's "decided taste for truth ... a vivid and ample, sensitive, daring imagination without which all the better faculties are but servants without a master."

Manet did an etching of Baudelaire's profile, which he included in his *Music in the Tuileries*, where it appears among a group of men near a tree trunk. An official portrait, however, was apparently never done. When Baudelaire, who had escaped from his creditors to Belgium, returned to Paris in 1866, he was already terminally ill and taken immediately to the hospital where he died the following year.

In 1862, Manet painted a portrait of Jeanne Duval, *Baudelaire's Mistress, Reclining*. Stretched in an undefined pose on a couch, her enormous crinoline covers almost a third of the picture surface. Its undulating rhythms are echoed by the lace curtains, behind which one can discern the windows of Manet's studio in the rue Guyot. In the inventory of Manet's studio the painting is listed under the heading "Painted Studies," indicating that is was considered unfinished, although Manet himself thought it good enough to have included it in a show at the Galerie Martinet in 1865. The fierce portrait might not have pleased Baudelaire very much, which would explain why Manet kept it in his possession. The poet had met Jeanne Duval in 1842, when she was in her twenties. Attracted by her tall, angular appearance, Baudelaire called her his "Black Venus" because of her dark complexion. By the time of Manet's portrait, however, Jeanne was suffering from partial paralysis and lived mostly in a sanatorium at Baudelaire's expense. A true realist, Manet made no attempt to hide her unattractive features, but he ennobled her presence with the masterfully painted white dress.

Other Portraits

For the Salon of 1866, the painter submitted "a portrait of Rouvière in the role of Hamlet, which I am calling the 'Tragic Actor' to avoid criticism of those who might not find it a good likeness," Manet wrote to Baudelaire. *The Tragic Actor* failed to pass the hurdle of the jury and was seen only by friends in Manet's studio. One of the visitors there was Théophile Thoré, who mentioned the work in his review of the Salon: "I prefer Manet's wild sketches to those Herculean academic works [at the Salon]. And so I've been back to his studio, where I found a large portrait of a man in black, in the spirit of Velázquez's portraits, that the jury has turned down." The rich orchestration of various blacks seems indeed to indicate the influence of the Spanish master. Philibert Rouvière had a successful career as an actor, in particular in the role of Hamlet. At the time Manet painted his likeness, however, Rouvière was already very ill and he died before the picture was finished. Depicted in mid-performance, Manet caught his model at the

The Tragic Actor (Rouvière as Hamlet)
1865–1866; *oil on canvas*; 73 3/4 x 42 1/2 in. (187.2 x 108.1 cm.). Washington, D.C., National Gallery of Art.
Although it is actually a portrait of the actor Philibert Rouvière, who had become famous in his role as Hamlet, Manet presented the painting to the Salon under the more generic title The Tragic Actor, *hoping that the image would succeed as a work with broader significance than a portrait of a specific individual. The figure is rendered in a rich orchestration of blacks in the tradition of Velázquez. The declamatory pose shows Rouvière at mid-performance.*

moment of an effective, declamatory gesture with crossed arms and spread legs.

More than ten years later, Manet was asked by the opera singer Jean-Baptiste Faure to paint a portrait of him as Hamlet, one of his most successful roles. Again, Manet chose a rhetorical gesture with Faure's left arm stretched out, his right hand lowering the sword. Ultimately, Faure rejected the portrait as it turned out to be less flattering and more revealing than he had wished. The two men remained, however, on friendly terms.

Madame Manet

1866; *oil on canvas;* 25 1/2 x 19 2/3 in. (65 x 50 cm.).
Pasadena, California, Norton Simon Museum.
This unfinished study is a frontal portrait of Suzanne Leenhoff, whom Manet was living with at the time. Her soft, round features and delicate white skin seem to reveal the gentle character and kindness for which she was known. Manet portrayed her later several times in a less formal way, as in Mme. Manet at the Piano.

Several times Suzanne Leenhoff-Manet was the subject of her husband's paintings, either in the form of a traditional, frontal portrait like *Mme. Manet* or, as in *Mme. Manet at the Piano*, in a larger context, which reflects her own personality. By all accounts, Suzanne Leenhoff was an excellent pianist, known not only as a performer of classical music but of modern German music, notably Schumann, almost unknown in France at the time. At their Thursday evenings at home, she played regularly for their friends. Around the time of this painting, Suzanne Manet went regularly with Mme. Paul Meurice to play four hands for Baudelaire at the hospital Chaillot, where he was being treated with hydrotherapy.

The composition of the painting is based on a work by Edgar Degas, which depicts Édouard Manet and his wife at the piano. After Degas presented it to Manet, the latter—dissatisfied with Suzanne's face—cut off the right part of the canvas. A short-lived rupture between the two friends ensued. Degas's painting, however, must have been the stimulus for Manet's own version of the subject, showing Suzanne playing the piano at the home of Mme. Manet at 49, rue de Saint-Petersbourg, where the couple lived for some months. The partially gilded wall paneling and the mirror enliven the background surface. The clock, reflected in the mirror, is said to have been presented to Manet's mother by Charles XIV of Sweden on the occasion of her wedding in 1831.

After the disastrous reception of *Olympia* at the Salon in 1865, Manet escaped Paris for some time and went to Madrid, where he met Théodore Duret in a restaurant under amusing circumstances. At first Manet thought Duret had recognized him and was trying to play a trick on him, but when his impression turned out to be a misunderstanding, their acquaintanceship became a durable friendship. Duret, whose background was the Cognac trade, had developed an interest in painting and in 1867 published his first work of art criticism, in which he treated his friend severely: "Manet is not doing himself justice; he holds himself well below what he might be, by painting too fast and too carelessly." Manet does not seem to have been offended by this judgment, although Duret soon changed his mind, asking his friend to do a portrait of him.

In 1868, the year of *Portrait of Théodore Duret*, the sitter had founded, together with ardent fellow republicans, an anti-imperial newspaper called *La Tribune* and Manet would often stop by at the offices. Duret gives an illuminating description of the evolution of his portrait, painted in Manet's studio in rue Guyot: "When it was finished—or at least I thought it happily complete—I saw Manet was still dissatisfied. He felt that something should be added. One day when I came in, he had me resume my pose, and placed beside me a low stool, which he proceeded to paint, with its garnet-red upholstery.

Next it occurred to him to pick up a stitched volume and throw it under the stool, and he painted that, in its light green color. Yet again, he set a lacquer tray on top, with carafe, glass, and a knife ... Lastly, he added one more object—a lemon, surmounting the glass on the tray. I had been watching him make these successive additions, in some surprise, wondering what the reason might be, when I realized that I was witnessing in action his instinctive and, as it were, organic mode of feeling. Evidently, a canvas all-over gray and monochrome was not to his liking. He missed the colors that might satisfy his eye, and not having put them in at first, he had added them afterward, in the manner of still-life."

At the sitter's suggestion Manet signed the canvas unostentatiously, for Duret wanted to show it to his bourgeois acquaintances as the work of any of the well-known Salon artists. Once they acknowledged the work's qualities, he intended to reveal the real painter's name, thus embarrassing the "fans" and oblige them to recognize Manet's talents as a painter. However, instead of signing in a dark spot, as Duret had wished, Manet put his signature upside down, making it difficult to read.

Manet met the writer and critic Zacharie Astruc by 1857, when Manet made the acquaintance of Astruc's friend Fantin-Latour. By 1860, they had become intimates, and for the next decade Astruc shared all the vicissitudes of his painter friend from the success of *The Spanish Singer* to the scandals of the *Le Déjeuner sur l'herbe* and *Olympia*. It was in fact one of Astruc's poems, entitled "Olympia," which gave its name to the famous painting. Manet had depicted his friend once before in *Music in the Tuileries Gardens*, where he appears seated to the left of the canvas.

The *Portrait of Zacharie Astruc* shows an engaging person, whose brightly lit features contrast with the dark background. Today the deepening of the bitumen color makes the right side of the picture appear darker than it was originally, a fate that also befalls *Olympia*. There is a strong contrast between the two halves of the painting. On the right is the sitter, facing the viewer almost straight on, his hand in his black velvet vest like Manet's father in the double portrait of the painter's parents. Astruc is not shown writing or reading, a common feature of the portrait of writers; he merely poses. On the table to his side are books and writing utensils, alluding to his range of interests and activities. A Japanese album bears the dedication "au poète Z. Astruc," which relates to a Japanesque play written by Astruc the previous year.

The brightly lit scene to the left has been variously interpreted as being an open doorway, a mirror, or a framed painting. The latter seems to be the most plausible explanation. The motif of this "opening" with a woman seen from the back echoes the background

of Titian's *Venus of Urbino* in the Uffizi, Florence, which had also served as a source of inspiration for *Olympia*. The painting's originality lies mainly in its contrasts of coloristic values, composition, and technique. Astruc's left hand, for example, has been treated only summarily in order not to distract from the sitter's head, an artifice Manet had studied in the paintings of Hals and Velázquez during his recent trip to the Prado in Madrid.

After 1870 the association between the two men became less close. Astruc pursued his own career as a

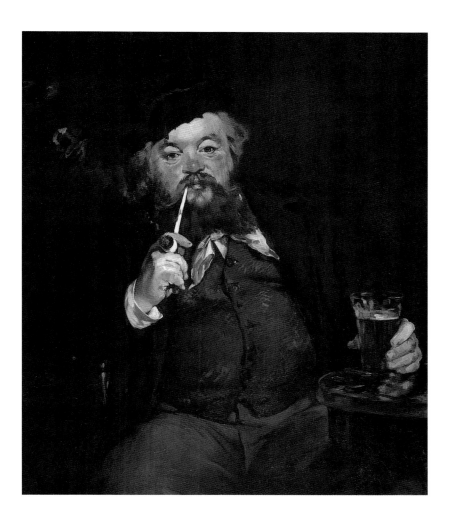

Le Bon Bock (Émile Bellot)
1873; *oil on canvas*; 37 x 36 2/3 in. (94 x 83 cm.).
Philadelphia, Pennsylvania, Museum of Art.
This portrait of the lithographer and engraver Émile Bellot, who joined the regular gatherings of artists at the Café Guerbois, was Manet's first popular success at the Salon of 1873. The subject matter of a jolly drinker may well have been inspired by a visit to Haarlem the previous year, where Manet saw Dutch genre paintings at the newly opened Frans Hals Museum.

sculptor and occasional painter. For Manet, Astruc remained always the incessant defender of his art of the 1860s, namely of *Olympia*, and their relationship continued until Manet's death.

At the Salon of 1873, Manet obtained his first great success since 1861. Perhaps his greatest triumph there, it was an ambiguous achievement. *Le Bon Bock (Émile Bellot)* was a portrait to the liking of the jury and the traditionally minded visitors of the Salon, which had hitherto shown only contempt for the artist. Manet's friends, on the other hand, were disappointed. They missed the vigor and truth manifested in Manet's other works and regretted the Old-Master aspect of this one. The influence of Frans Hals is indeed palpable and the work must be considered as one of Manet's most conservative paintings. While certainly flattered by the warm reception of *Le Bon Bock*, Manet was fearful of being isolated from his friends of the Café Guerbois, all of whom were absent from the Salon with the exception of Berthe Morisot. As a matter of fact, Renoir had submitted two works, but he had been rejected. But the success of *Le Bon Bock* had taught them a lesson. It had become abundantly clear that there would be no liberalization in matters of taste at the Salon. Less than ever were these artists inclined to compromise or paint "acceptable" pictures. The following year saw the first independent Impressionist exhibition, organized by the artists themselves.

Nina de Callias and Stéphane Mallarmé

Woman with Fans (Nina de Callias) is the last, but not the least, stunning painting in a long series of reclining women, which began with *Baudelaire's Mistress, Reclining*, followed by *Young Woman Reclining, in Spanish Costume* up to the scandal-ridden *Olympia*. Marie-Anne Gaillard, called Nina de Villard, was ironically known by the name of a momentary husband, Hector de Callias, writer and journalist at *Le Figaro*. She was a truly Baudelairean character, full of temperament, talented, manic-depressive, and neurotic; she died at the age of thirty-nine, ruined by alcohol.

Portrait of Stéphane Mallarmé
detail. 1876; Paris, Musée d'Orsay.
Mallarmé's hand is holding one of his beloved cigars
about which he later even wrote a poem. White
smoke is rising upward in a twisted movement.
The fingers are suggested with fairly large
brushstrokes of various pink and brown hues modeling
the light as it falls on the upper side of the hand.

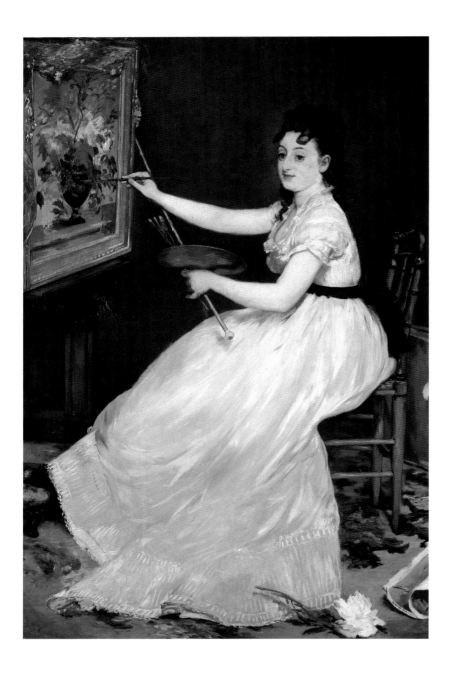

Nina de Callias presided over one of the most brilliant literary and artistic salons in Paris. At her dinner table, one could find regularly writers, musicians, and painters such as Paul Verlaine, Mallarmé, Anatole France, and naturally Manet himself. An eyewitness described an evening at her house, following the obligatory dinner: "Coffee over, there was a rush for the staircase to the salon on the floor above. Nina took over the piano and played with all her heart, a composition by César Franck, while the gentlemen smoked their cigarettes. Raoul Ponchon, by popular demand, recited his latest verses, as did Léon Dierx and Charles Cros. Soon the after-dinner guests began to arrive: François Coppée, Anatole France, Léon Valade, Camille Pelletan, the younger Coquelin, Marcelin Desboutin, Jean Richepin, Léon Boussenard. At last, the door opened and Villiers de l'Isle-Adam entered. He kissed Nina's hand and sat down with her."

Manet painted her likeness in his studio, where he recreated the Japanese bric-a-brac of Nina de Callias's townhouse, dressed in one of her "Algerian" costumes in which she liked to receive. As a backdrop, Manet used the same Japanese wall hanging seen in *Nana* and in *Portrait of Stéphane Mallarmé*. The numerous fans, popular at the time, are simply pinned to the wall, lending the painting the casualness of a boudoir scene. Although only ten years separate it from *Olympia*, the difference between the two figures could hardly be more complete. Style, brushwork, and atmosphere are distinct. De Callias's face expresses warmth and liveliness, but also amusement and wit, charm and curiosity, with a touch of wistfulness.

The poet Stéphane Mallarmé was introduced to Manet in 1873, the year of his arrival in Paris. The two men became so close that Mallarmé wrote to Paul Verlaine after Manet's death: "I saw my dear Manet every day for ten years, and I find his absence today incredible." On his way home from the Lycée Fontane (today the Lycée Condorcet), where he taught English, Mallarmé would stop regularly at Manet's studio in the

Eva Gonzalès

1870; *oil on canvas; 75 1/4 x 52 3/8 in. (191 x 133 cm.).* National Gallery, London.

When Manet met Eva Gonzalès, the twenty-year-old daughter of a then well-known author, he was at once so fascinated by her captivating beauty that he asked her if she would agree to sit for him. Already studying painting with a fashionable artist, the young woman eventually became Manet's student, the only one he ever had. Her presence in the studio caused considerable vexation to Berthe Morisot, who complained about her rival in letters to her sister.

Jeanne Martin in Pink Dress

1881; *oil on canvas; 35 3/4 x 28 1/3 in. (91 x 72 cm.).* Dresden, Germany, Staatliche Kunstsammlungen, Neue Meister. *Jeanne Martin was a friend of the painter Jean-Louis Forain and became temporarily one of Manet's models. Her pose is somewhat formal, but the modeling has been achieved without recurring coloristic contrasts. Even the parts which are in the shadow are rendered with fresh strokes of luminous paint.*

late afternoon to meet the painter's circle of friends. Manet's studio was an important place to meet people. The poet was introduced there to Zola, Monet, and Morisot, but also to Degas and Renoir, who became his closest artist friends after Manet.

In the *Portrait of Stéphane Mallarmé*, the sitter was thirty-four, ten years the painter's junior. He lounges on a chair, as if captured during a casual conversation. In his right hand, placed on a book or manuscript, he holds one of his beloved cigars about which he even wrote a brief poem. It is a moment of thoughtful dreaminess. Undisturbed by the outside world, the painting radiates the friendship of two great minds.

Late Portraits

One of the late large portrait paintings was *In the Conservatory*, a work intended for the Salon, where it was shown in 1879 together with *Boating*. The sitters were M. and Mme. Jules Guillemet, owners of a fashionable shop at 19, rue du Faubourg-Saint-Honoré, and friends of the artist. The setting is halfway between outdoors and indoors, like in *The Balcony* of ten years earlier. The somewhat hatched technique and the bright colors give this work an Impressionistic appearance. The composition is, however, strictly arranged with horizontals and verticals. The center is formed by a square, circumscribing the two figures. Mme. Guillemet, who was of American origin, was known for her beauty and elegance. Manet painted her in a smartly tailored gray dress and a little yellow hat of ostrich feathers. Her glove and umbrella take up the same yellow hues. The sympathetic features of Jules Guillemet bear a certain resemblance to Manet himself, as was noted by contemporaries.

The scene is set in a conservatory. This locale served as a studio, which Manet had rented for a short time for the Swedish painter Otto Rosen. It is not known whether there was a real conservatory or just a kind of winter garden. In any event, the presence of nature is domesticated through the controlled studio light and the flower pots. The verdant background assumes the quality of a tapestry, with its occasional outburst in red or pink, particularly around Mme. Guillemet's head. These coloristic accents serve to enhance her red lips and delicate complexion.

Usually, Suzanne Manet did not enter her husband's studio, but since she was a close friend of the Guillemets she was present at the sittings for *In the Conservatory*. Manet used the occasion to paint his wife's portrait in a similar setting in *Mme. Manet in the Conservatory*. By that time, Mme. Manet had put on some weight, and Manet portrays her with realism and affection. In the background he depicted plants with broader leaves, rendered with generous brushstrokes. The Italian Impressionist

painter Giuseppe de Nittis described Suzanne Manet's character as follows: "There was something very special about Mme. Manet: the gift of kindness, simplicity, candor of spirit; an unruffled serenity. In her slightest words, one felt the deep love she had for her charming 'enfant terrible' of a husband."

To paint *Portrait of Georges Clemenceau* proved to be a difficult venture, given the busy schedule of the

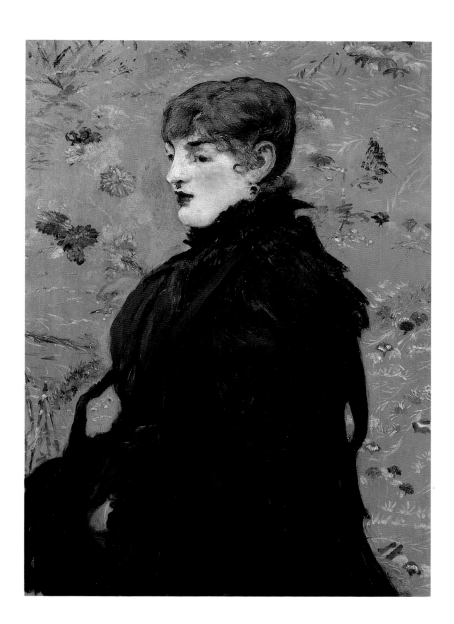

Autumn

1881; *oil on canvas*; 28 3/4 x 20 in. (73 x 51 cm.). Nancy, Musée des Beaux-Arts. *The idea of having a series of four female portraits represent the four seasons came from Antonin Proust. Manet finished only* Spring *and* Autumn, *for which Mary Laurent posed. Her real name was Anne-Rose Louviot. She was to become one of the closest women friends in Manets' last years. Marcel Proust eternalized her mode of life, the furnishing of her house, and certain particulars of her dress in the figure of Odette Swann in* Remembrance of Things Past.

statesman. There exist two different versions. In the present one, Manet concentrated on the rendering of the head and the torso with relatively few brushstrokes, accentuating the politician's Asian cast of feature, which was to become more pronounced with time. Arms crossed over the chest, Clemenceau expresses energy, resoluteness, and firmness. Once asked about this portrait, he answered: "My portrait by Manet? Very bad. I don't have it, and I don't mind. It's in the Louvre. I wonder why they put it there."

One of the warmest and most moving portraits is the *Portrait of Antonin Proust* (1880), Manet's intimate friend since childhood. Although he started out studying painting with Manet in Thomas Couture's studio, Proust eventually became a journalist, critic, and politician. During his brief tenure as minister of fine arts under the Gambetta government, he managed to have Manet awarded the Legion of Honor, a decoration that filled Manet with deep satisfaction. In 1884 he was also one of the organizers of the memorial exhibition in honor of Manet at the École des Beaux-Arts. Proust was a figure of style and character who appealed to Manet as a subject. The painting was hailed at the Salon as a remarkable and spirited work of brilliant execution.

In the Conservatory

detail. 1879; Berlin, Neue Nationalgalerie,
Staatliche Museen, Preussischer Kulturbesitz.
*Of American origin, Mme. Guillemet was known for
her beauty and elegance. Here she wears a yellow hat
of ostrich feathers whose band is tied around her neck.
A smartly tailored dress with a black bow on her chest
provides her with the aura of a self-conscious and
determined woman. Her fair complexion accentuated by
red-colored lips is set off by the pink flowers to her left side.*

Portrait of Georges Clemenceau

1879–1880; *oil on canvas; 37 x 29 1/4 in. (94.5 x 74 cm.).*
Paris, Musée d'Orsay.
*The statesman Georges Clemenceau was one of Manet's most
difficult sitters; he did not have time to spare for lengthy
sessions. Manet painted him with his arms crossed over his
chest, thus expressing energy, resoluteness, and determina-
tion. He accentuated also the Asian cast of features, which
was to become more pronounced with time. Clemenceau
himself does not seem to have cared much about the work.*

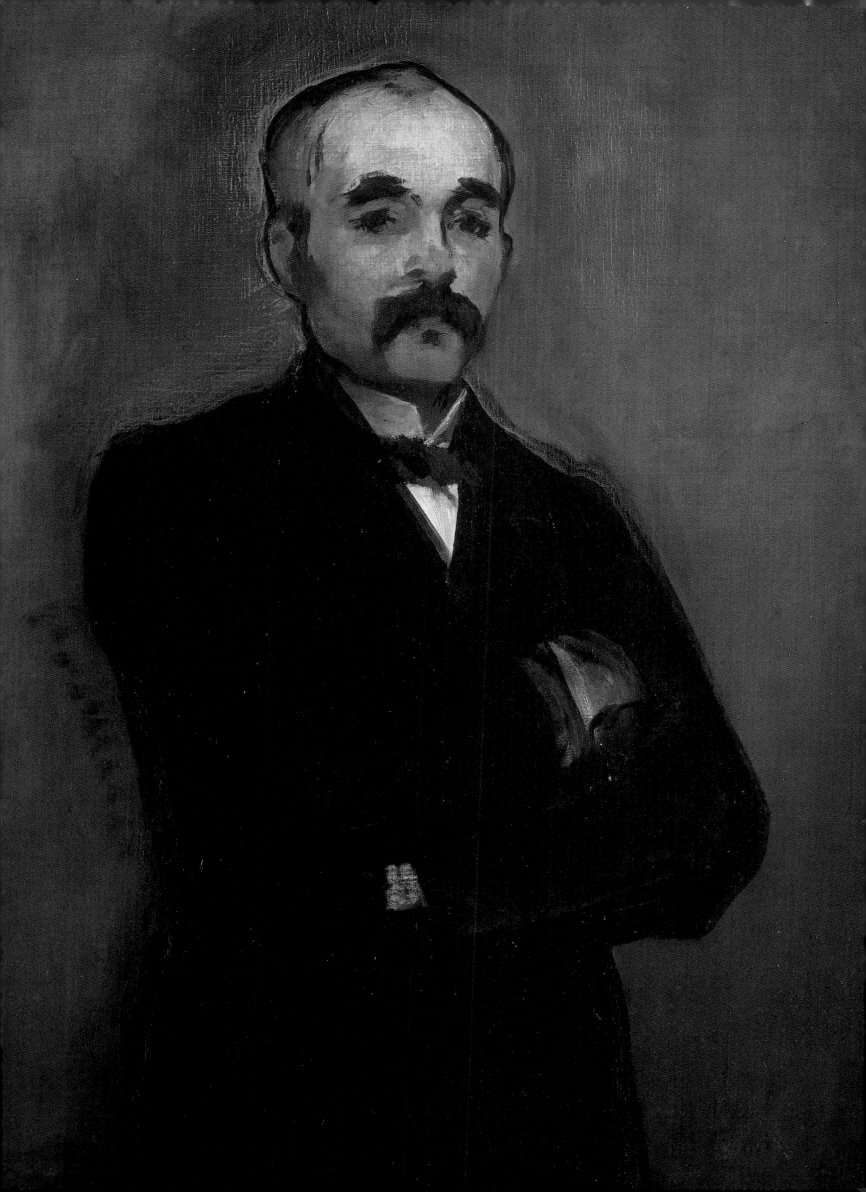

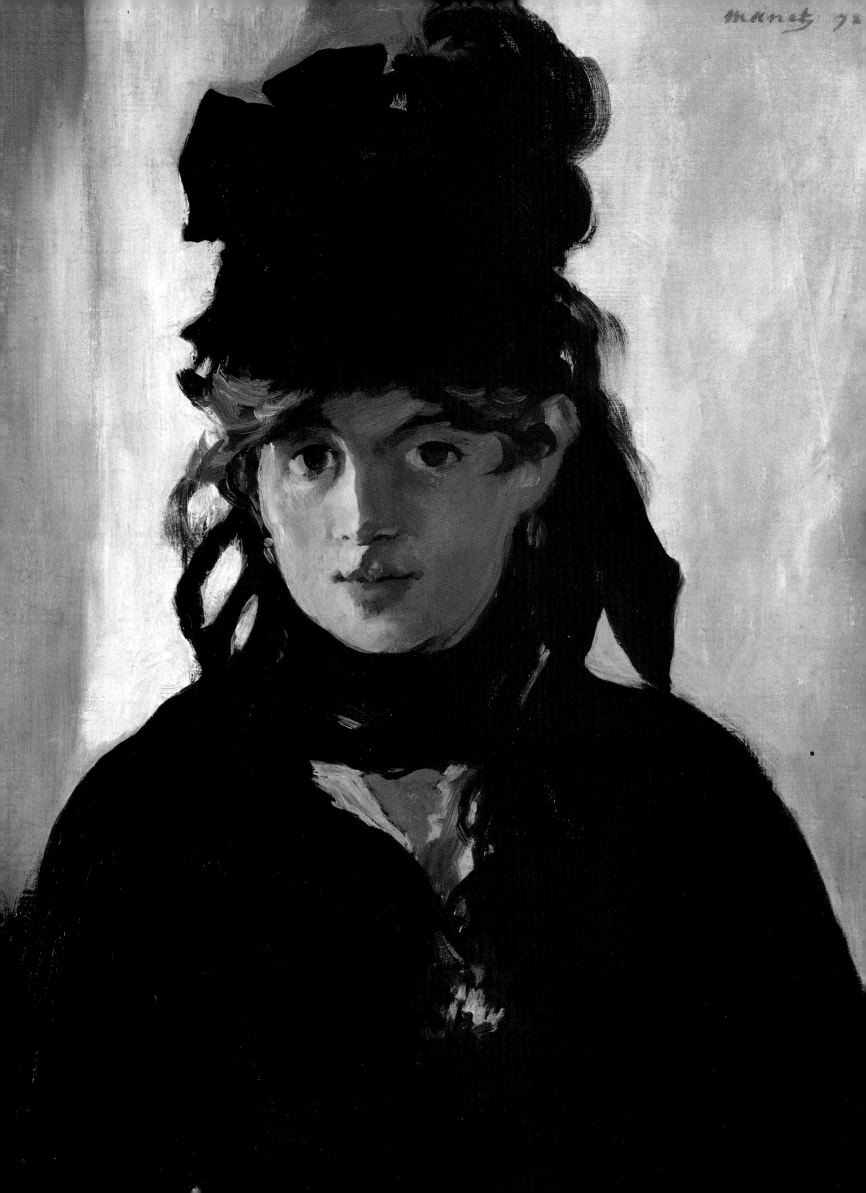

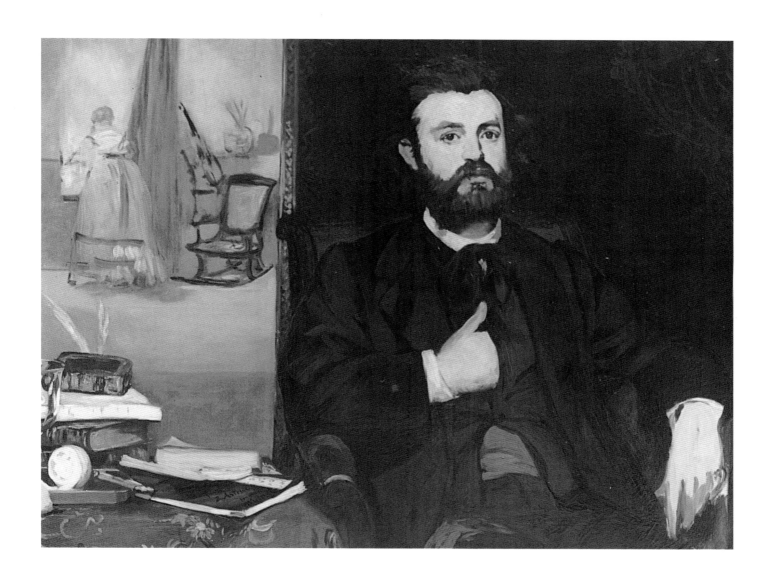

Portrait of Zacharie Astruc
1866; *oil on canvas;* 35 1/2 x 45 3/4 in. (90 x 116 cm.).
Bremen, Germany, Kunsthalle.
*The writer and critic Zacharie Astruc was one of
Manet's most enthusiastic supporters. The work is
reminiscent in some respects to* Portrait of Émile Zola,
*compared to which it is like a rough draft, less
elaborate but warmer. Indeed, Manet was on more
intimate terms with Astruc, who was a man of great
charm and rare insight. It was from his poem "Olympia"
that Manet borrowed the title for his own painting.*

Berthe Morisot with a Bunch of Violets
1872; *oil on canvas;* 21 3/4 x 15 in. (55 x 38 cm.).
Paris, Private Collection.
*The poet Paul Valéry, Berthe Morisot's nephew by
marriage, wrote a lengthy poem about this inspiring
portrait. The face is modeled with strong light coming
from one side, a rare trait in Manet's portraits. At the
time, Morisot went through a difficult period in her
life, but instead of depression her eyes show curiosity
and involvement as if interrupted in a lively discussion.*

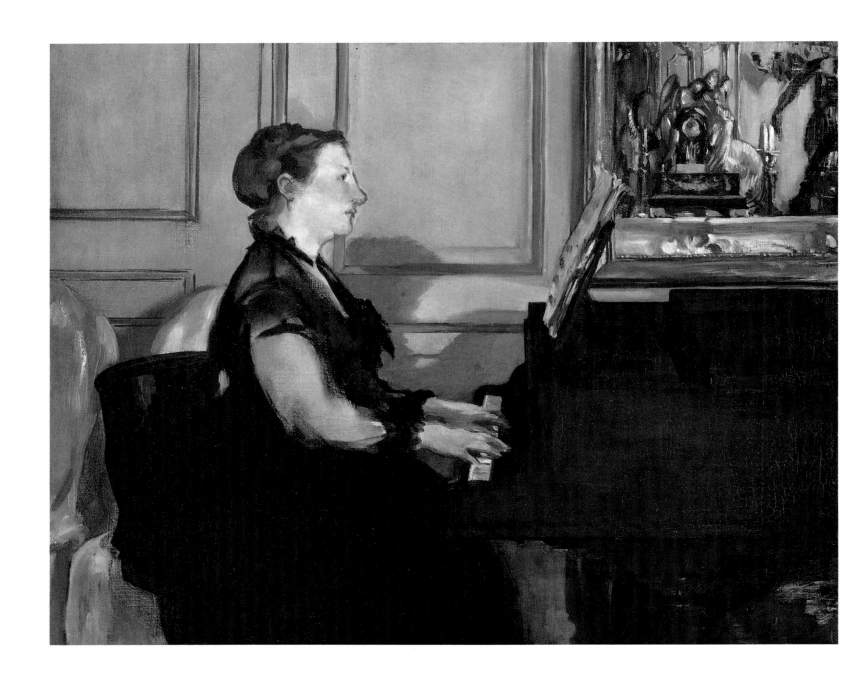

Mme. Manet at the Piano

1867–1868; oil on canvas; 15 x 18 in. (38 x 46 cm.). Paris, Musée d'Orsay.
Manet met Suzanne Leenhoff in 1849, when the young Dutchwoman
gave piano lessons to him and his brother Eugène. By all accounts she
was an accomplished pianist who performed regularly before guests at
the Thursday dinners at their house or at informal soirées. Classical and
modern German music, notably Schumann, were her strengths. The scene
is the salon of Manet's mother, where the couple lived for some months.

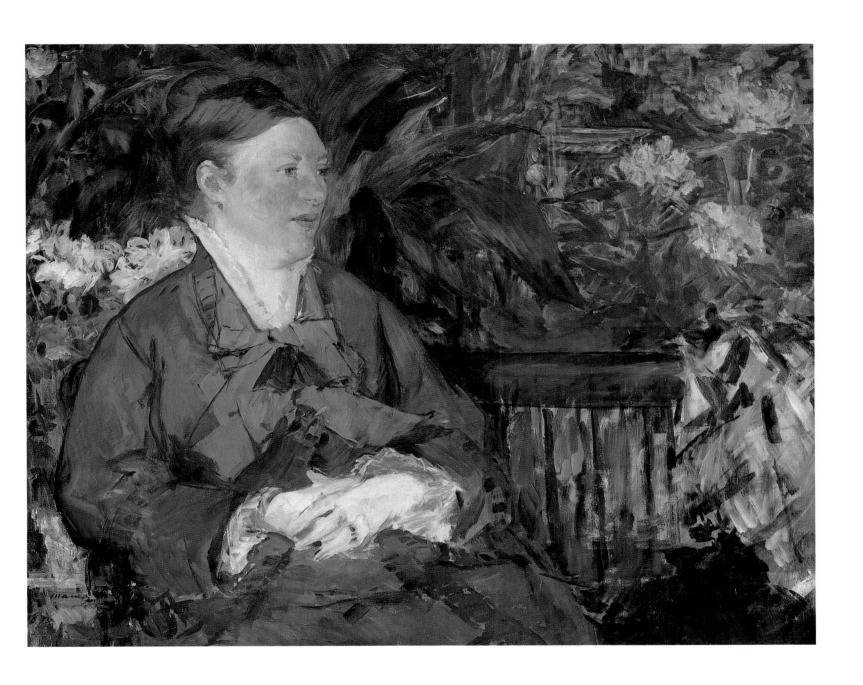

Mme. Manet in the Conservatory

1879; *oil on canvas;* 34 x 39 3/8 in. (81 x 100 cm.). Oslo, Norway, Nasjonalgalleriet.

While painting In the Conservatory, *Manet took the opportunity of
having a greenhouse effect in the studio to do also a portrait of his wife
Suzanne. Her somewhat ruddy, placid features are rendered with
realism and affection. By all accounts, Mme. Manet was an extremely
kind and serene person. The range of grays and blues in her dress
and in the flowers harmonize with her white blouse and her gray eyes.*

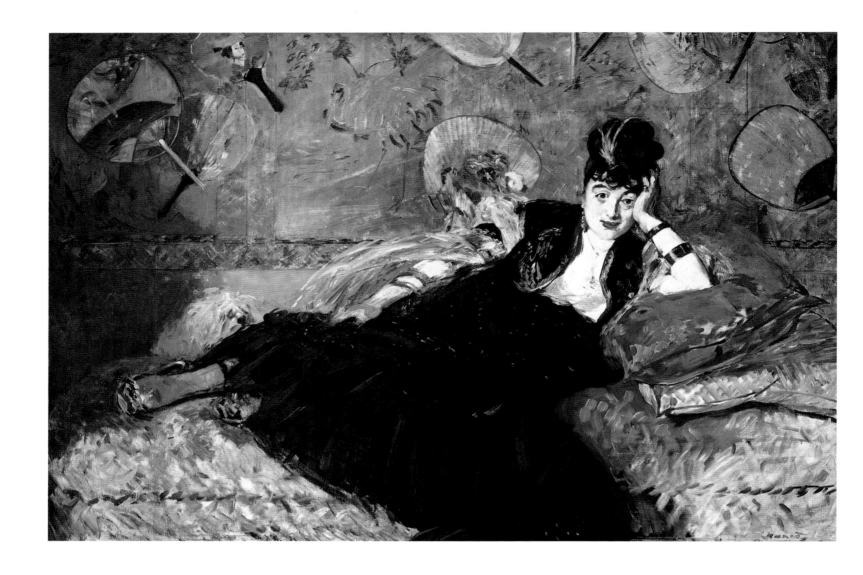

Woman with Fans (Nina de Callias)

1873–1874; *oil on canvas;* 44 1/2 x 65 1/4 in. (113.5 x 166.5 cm.).

Paris, Musée d'Orsay.

Nina de Callias was a "grande dame" of Parisian society in
Manet's time. She headed a salon which comprised writers,
musicians, and artists like Anatole France, Verlaine, Mallarmé,
and of course Manet. Herself a brilliant entertainer and pianist,
she often received distinguished guests, offering them lavish dinners,
poetry readings, and musical performances, as well as intellectual
discussions. Her lively face reveals her sparkling and witty character.

Portrait of Stéphane Mallarmé

1876; *oil on canvas;* 10 5/8 x 14 1/8 in. (27.5 x 36 cm.). Paris, Musée d'Orsay.

Stéphane Mallarmé, who arrived in Paris in 1873, took over to some extent the role in Manet's life played by Charles Baudelaire during the early 1860s. The young poet and the painter became intimate friends, who would see each other almost daily for about ten years, until Manet's death. On several occasions Manet illustrated both Mallarmé's own poems as well as his translations of Edgar Allan Poe. An ardent supporter of the Impressionists, Mallarmé was also on close terms with Degas and Renoir.

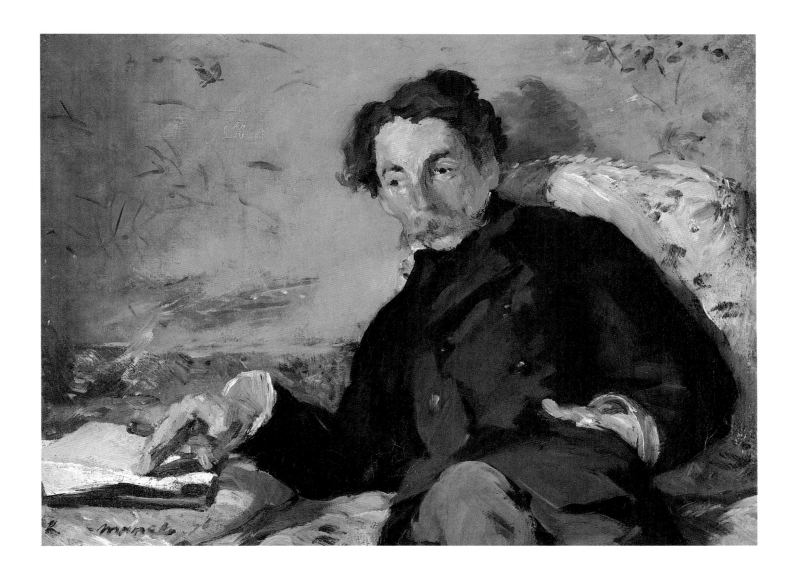

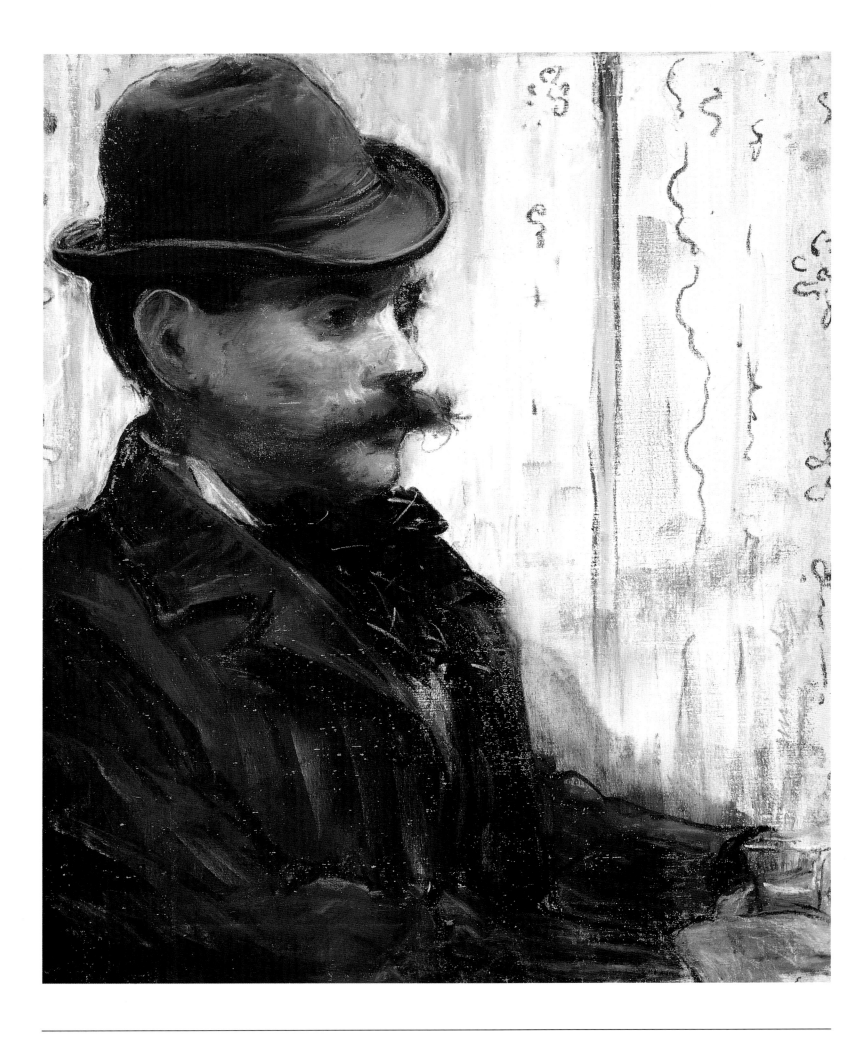

Chez Tortoni

1878; oil on canvas; 10 2/3 x 13 3/4 in. (27 x 35 cm.).
Boston, Isabella Stewart Gardner Museum (stolen).
*The man portrayed here, possibly a writer or journalist,
has not been identified. He is sitting at a table on
the terrace of the fashionable Café Tortoni on the
Boulevard des Italiens, one of Manet's favorite
places in Paris. Gentle, questioning eyes are looking
out at the viewer from underneath a top hat.
The aloofness of his pose and the elegance of his
gesture suggest that he was a distinguished person.*

Alphonse Maureau

c. 1880; *pastel on canvas; 22 x 18 in. (56 x 46 cm.).*
The Art Institute of Chicago.
*The sitter was a painter and friend of Degas's, who
frequented with his Impressionist friends the Café
Nouvelle-Athènes. In 1877, he participated at the third
Impressionist show. As in other portraits from that peri-
od, Manet used pastel rather than oil which allowed for
brighter and more luminous colors. Maureau appears
dressed in the casual outfit of a truly bohemian artist.*

George Moore

1879; *pastel on canvas;* 21 3/4 x 13 7/8 in. (55.3 x 35.3 cm.).
New York, The Metropolitan Museum of Art.
The Irish critic and novelist George Moore was an
enthusiastic young man of somewhat eccentric appear-
ance. Before turning to writing, Moore had studied
painting at the École des Beaux-Arts. He was acquainted
with Mallarmé and met Manet at the Café Nouvelle-
Athènes. The painter did three portraits of Moore, the
most complete one being this pastel, which was executed in
a single sitting, something Manet seldom managed to do.

Pertuiset, The Lion Hunter

1880–1881; *oil on canvas;* 59 x 67 in. (150 x 170 cm.).
São Paulo, Brazil, Museu de Arte.
A strong-willed, popular figure in Paris, Eugène Pertuiset
was a mighty hunter who liked to entertain his listeners at
Chez Tortoni with tales of his adventures and expeditions to
Algeria and South America. Manet posed him at the studio
in hunting costume while the background most likely shows the
sitter's garden in Montmartre. The large head with long side-
whiskers, the powerful modern rifle, and the frontal "photogra-
pher's pose" appear in ironic contrast to the stuffed lion skin.

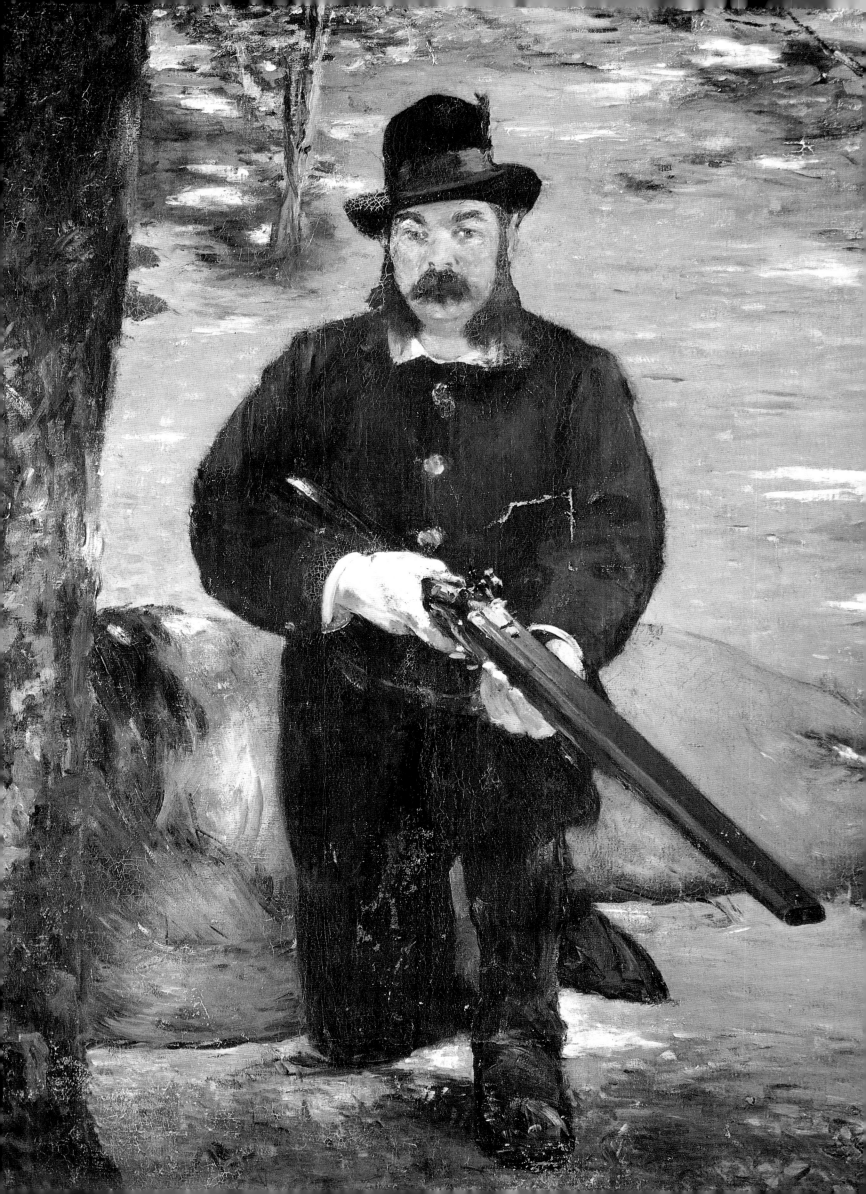

**Portrait of
Antonin Proust**

1880; *oil on canvas;*
51 x 37 3/4 in.
(129.5 x 95.9 cm.).
Toledo, Ohio,
The Toledo Museum of Art.
*Rendering top hats was
one of the hardest things
for a painter to do, according
to Manet who is said to
have made up to twenty
attempts for the present
portrait. Proust's personality
appealed to Manet because
of his style and character,
and also for his striking
appearance. During his brief
tenure as minister of fine
arts from November 1881
to January 1882, Proust
arranged to have Manet
awarded the red ribbon
of the Légion d' honneur.*

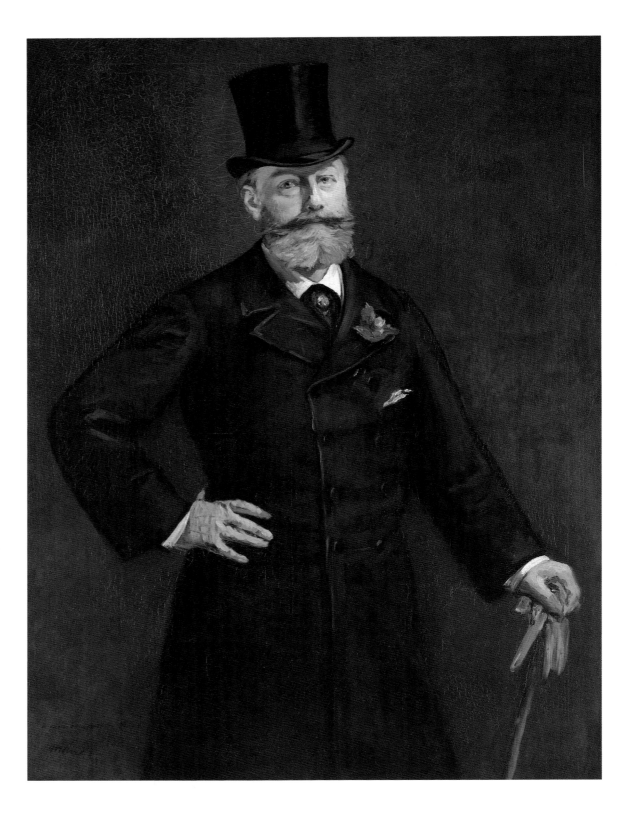

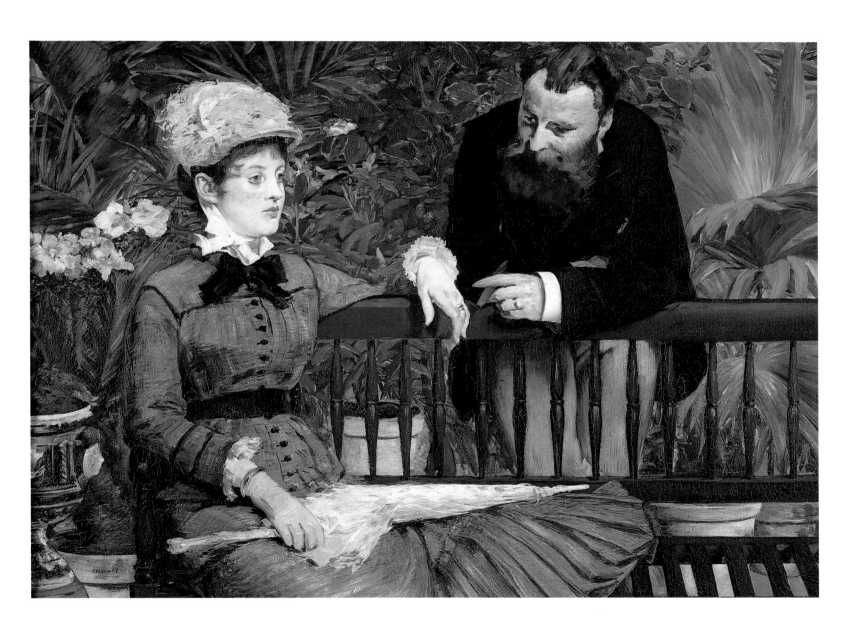

In the Conservatory

1879; *oil on canvas; 45 1/4 x 59 in. (115 x 150 cm.).*
Berlin, Neue Nationalgalerie, Staatliche Museen, Preussischer Kulturbesitz.
*This double portrait of M. and Mme. Jules Guillemet was painted
in the studio of a Swedish painter, which Manet had rented for some
time. If the background with its lush, exotic plants was arranged
by Manet himself or if it reflects a real conservatory cannot be
determined. At any rate, nature is present, although not
"en-plein-air." The green foliage is used as an effective backdrop
for the display of the intimate relationship between the couple.*

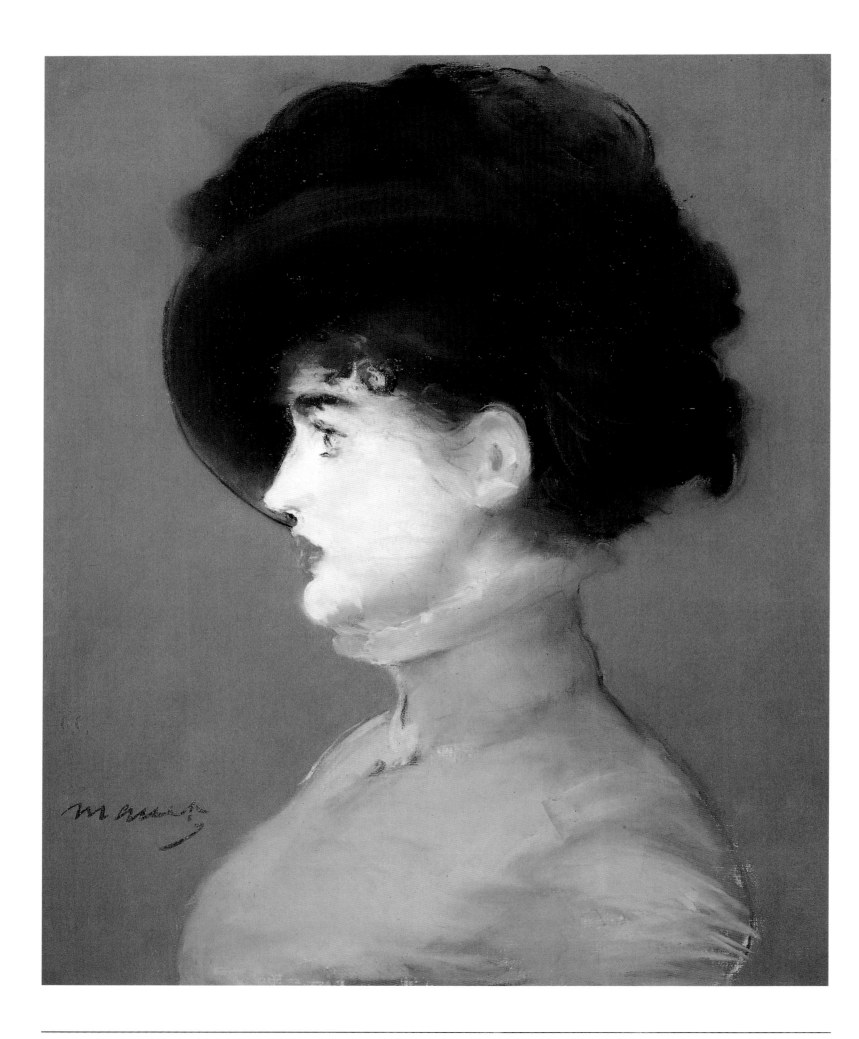

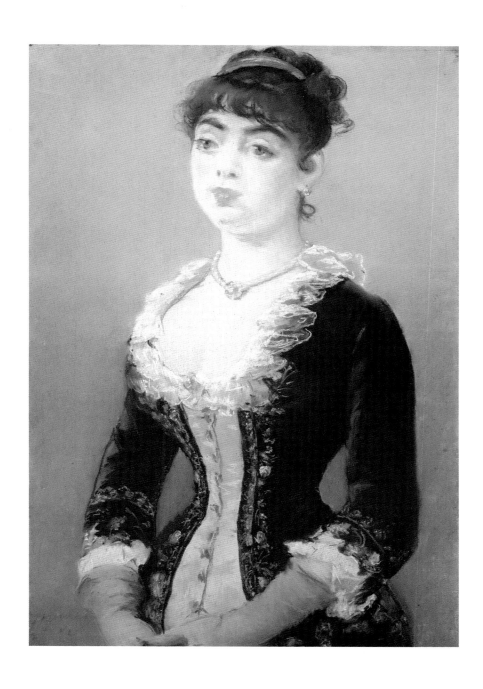

**La Viennoise,
Portrait of Irma Brunner**

1882; *pastel on board;* 21 1/4 x 18 in.
(54 x 46 cm.). Paris, Louvre,
Cabinet des Dessins.
*In his pastels Manet did not shun
the tendency toward the elegant and
beautiful. Irma Brunner, brought to
Manet by Mary Laurent, embodies
the dazzling and exquisite lifestyle of
the demimonde. The profile of her face
is framed by a dark, velvety headdress,
to which responds the pink bodice set
off against the background of gray.*

Madame Michel-Lévy

1882; *pastel on board;* 29 1/3 x 20 in. (74.5 x 51 cm.).
Washington, D.C., National Gallery of Art.
*Manet did numerous half-length portraits of women during
the last two years of his life. For this sitter, who had commissioned
a portrait of herself, Manet prepared two versions, of which
Mme. Lévy chose the present one. The softly modeled face and
the elegant dress are close in spirit to portraits by Renoir.*

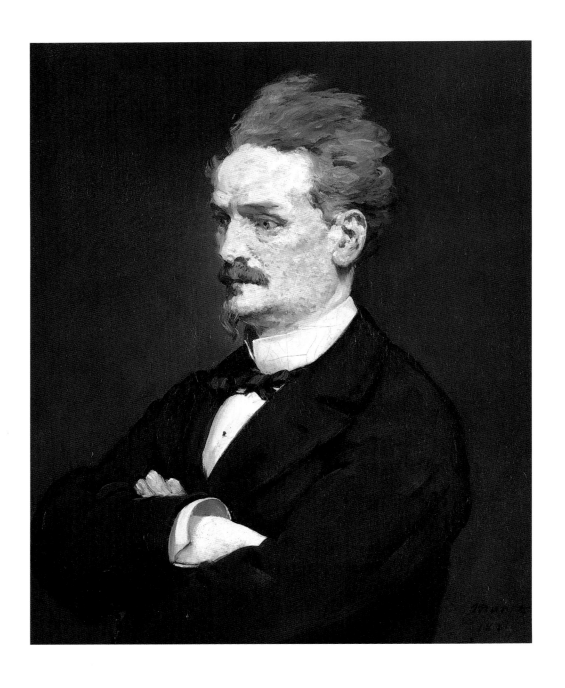

Portrait of M. Henri Rochefort
1881; *oil on canvas;* 32 x 26 1/4 in. (81. 5 x 66.5 cm.).
Hamburg, Germany, Kunsthalle.

Henri Rochefort was a radical and patriotic republican, whose pamphlets against Napoleon III and the imperial regime forced him to live temporarily in exile in Brussels. Rochefort's friend, the writer Alphonse Daudet, remarked about him: "You call that a strange head, aflame like a bowl of punch ..." The slightly pock-marked face shows Impressionist touches under a carefully arranged coiffure expressing an energetic character.

Woman in Fur
(Mme. Jules Guillemet)
1881; *pastel on canvas;*
21 x 17 1/3 in. (53 x 44 cm.).
Vienna, Kunsthistorisches Museum.
Manet had portrayed the Guillemet couple earlier in the Conservatory. Here, he painted the elegant, American-born Mme. Guillemet again, this time alone and only in half-length figure, as in most of his late portraits, especially when working with pastels. The loosely arranged fur around her shoulders picks up the tone of her dark hair, which contrasts with her pale complexion.

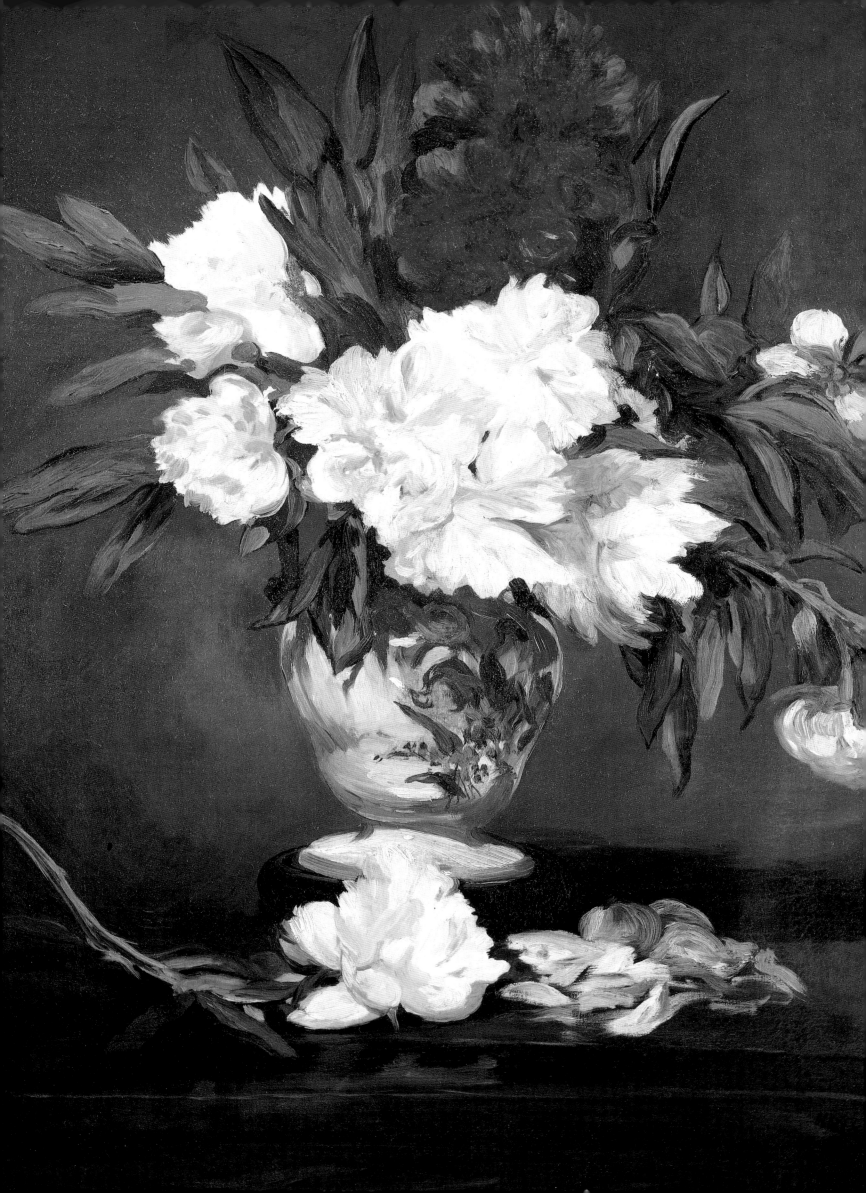

CHAPTER 4

STILL-LIFES AND LANDSCAPES

*I*n terms of quantity, still-life and landscape paintings play a comparatively minor role in Manet's oeuvre. Seen in the context of the artist's relationship with his Impressionist-painter friends, they assume, however, a significant role in addition to offering a delightful and enjoyable diversion from Manet's other works. As has been seen before, Manet's interest in nature was clearly limited to the amenities offered by the culture of his urban class. Other works assume a more documentary character as is the case with the *Battle of the 'Kearsage' and the 'Alabama'*.

Still-lifes of fruit and flowers were quite popular during the Second Empire in France, although this could hardly have been sufficient motivation for an independent-minded artist like Manet. Most likely, he was attracted by the opportunities inherent in the genre to explore techniques of brushwork and to study coloristic values and spatial relationships between the objects on display.

Early Still-Lifes

Presumably, Manet's earliest still-life is the *Plate with Oysters*, which originally decorated the dining room of Suzanne Leenhoff's apartment. It relates to examples of the seventeenth or eighteenth centuries, as did his *Fruit on a Table*, which bears an affinity to works by Jean-Baptiste-Siméon Chardin and Anne Vallayer-Coster. Chardin's simple and realistically rendered still-lifes were especially popular at that time and several artists emulated his style, often enriching their canvases with precious pieces of porcelain or silver. The elegance of Manet's still life derives from its the utter simplicity and the directness of its manner of execution. The objects are presented on the foil of two rectangular fields, the white tablecloth and the dark background. The composition is remarkably spare, and the artist seems to be less interested in the nature of the objects themselves than in the interrelationships of their forms and colors and in their rendering through brushstrokes on a two-dimensional surface.

Theories of Still-Life

Manet explained his ideas about still-life painting years later, when Eva Gonzalès had become his student. He

Plate with Oysters
1862; *oil on canvas;* 15 x 18 in. (38 x 46 cm.).
Washington, D.C., National Gallery of Art.
Manet's early still-lifes are influenced by examples from seventeenth and eighteenth centuries, noticeably the paintings of Chardin, whose simple settings and clear compositions were highly popular. This work was first hung in the dining room of the apartment of Suzanne Leenhoff, Manet's future wife.

Peonies in a Vase on a Pedestal
1864; *oil on canvas;* 36 3/4 x 27 5/8 in. (93.2 x 70.2 cm.).
Paris, Musée d'Orsay.
Between 1864 and 1865 Manet, who painted flower still-lifes only at two periods in his career, worked on a small group of canvases showing peonies, then still regarded a luxury item. The artist grew such flowers himself in the garden at his family's home in Gennevilliers. The exotic exuberance of the flowers are rendered with generous and sensuous brushwork.

gave her rather unorthodox lessons, and in one instance he was teaching her how to approach a still-life. To that end he would pace his studio, "arrange some grapes on the corner of a white tablecloth, a slice of salmon on a silver platter, as well as a knife, and say: 'Do this quickly! Don't pay too much attention to the background Preoccupy yourself mostly with the values. Do you understand? When you look at this [still-life], and especially when you think of representing it as you feel it, that is in such a way that it will make the same impression on the public as it does on you, then you do not perceive the lines on the wallpaper over there. Isn't that so? And when you contemplate the whole thing you wouldn't dream of counting the scales of the salmon, would you? You must see them in the form of small silver pearls

against gray and rose colors! … As to the grapes! Are you going to count those grapes? Of course not. What is striking is their tone of light amber and the dust which models forms while softening them. It is the brightness of the tablecloth as well as the spots which are not directly touched by the light which have to be rendered …The folds will establish themselves if you just put them where they belong. Oh! M. Ingres; he was strong! We are only children. He knew how to paint fabrics.'"

Manet seemed to have applied the same principles to his *Still-Life with Fish* and *Still-Life with Melon and Peaches*. Although somewhat stiff, the tablecloth in the latter work is rendered with an amazing sensitivity for its effects of light and shadow. The round shape of the melon and its green and yellow spots are repeated in the

Fruit on a Table

1864; *oil on canvas;* 17 3/4 x 28 7/8 in. (45 x 73.5 cm.).
Paris, Musée d'Orsay.
The elegance of this still-life derives from its inherent simplicity and the manner of its execution. The white tablecloth and the dark background serve as a foil for the shapes, forms, and colors of the objects displayed. Less interested in the actual presence of these items, Manet is more concerned with composition, relationships of color, picture surface, and brushstrokes.

Pinks and Clematis

detail. 1882c. Paris, Musée d'Orsay.
Deft brushstrokes define the white crystal as well as the green stems of the flowers. The diaphanous quality of the vase is made visible by allowing the purplish background color to be reflected in the glass. Some gilt decoration represented with dabs of yellow adds a complementary note to the green.

pears and wine leaves arranged in the adjacent bowl, while the two peaches in the front with their velvety texture contrast with the smooth surface of the grapes.

Manet's Peonies

Manet painted flower still-lifes at two specific periods in his life. In 1864–1865 he did a series of peonies, as well as a group of smaller bouquets during the last two years of his life, when his illness made ambitious projects impossible.

Peonies were among Manet's preferred flowers, which he grew in his garden at Gennevilliers. Recently introduced to Europe, they were still regarded as a luxury item at the time. Two smaller studies, *Branch of White Peonies with Pruning Shears* and *Stem of Peonies and Pruning Shears* are rendered with an exquisite carelessness Manet knew how to depict so well. The effect of the works lie entirely in the assured, rich brushwork which expresses the unassuming splendor of the cut flowers.

In *Peonies in a Vase on a Pedestal*, the flowers are depicted in their various stages, from the bud on the right to the flowers in full bloom at the top and left to the lower ones which are about to wilt, the last already having lost some petals. Manet may have intended the piece as an allegory of vanitas; this is open to debate. His main concern was the pictorial rendering of the peonies with their lush, thick flowers. Van Gogh was deeply impressed by the painting and mentioned it in a letter at a time when he was himself working on flower still-lifes: "Do you remember that one day we saw a very extraordinary

Manet at the Hôtel Drouot, some huge pink peonies with their green leaves against a light background? As free in the open air and as much a flower as anything could be, and yet painted in a perfectly solid impasto ... That's what I'd call simplicity of technique."

Landscape Paintings

By their nature landscapes have a less intimate character than still-lifes, and some of Manet's were actually intended for the Salon. The *Battle of the 'Kearsage' and the 'Alabama'* depicts a current event, merging reportage with the historical. The union and confederate vessels had fought a battle of the American Civil War off Cherbourg in June 1864, and the event received much public attention in France. Manet, who himself had spent almost a year at sea in his youth, must have been fascinated by the incident. He decided to do a painting of the subject, based on information he was able to gather from newspaper reports and published photographs. The result was quite different from traditional Dutch seascape paintings. The water is depicted from a high vantage point as if seen from a mast of another ship. The sinking *Alabama* and its adversary, the *Kearsage*, appear at the top of the composition, not unlike a Japanese print. A smaller French pilot vessel on the left, with a blue-bordered white flag, comes to rescue the crew. More traditional are the gradations of brilliance and hue which indicate distance, a trait that is completely absent in *Steamboat, Seascape or Sea View, Calm Weather*. Here the ocean is as flat as the paint on the canvas, with no distinction

Race Track in the Bois de Boulogne

1872; *oil on canvas*; 28 3/4 x 36 1/4 in. (73 x 92 cm.). New York, Collection of Mrs. John Hay Whitney.
Manet shared his interest in racetracks with Degas, with whom he must have spent, on at least one occasion, a day watching horse races. While in Races at Longchamp *the viewer was completely involved in the event, here he has become a mere spectator like the two figures in the foreground. Manet never again undertook a painting with a horse-racing theme.*

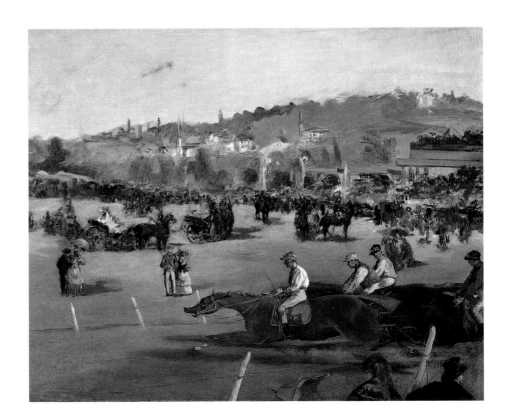

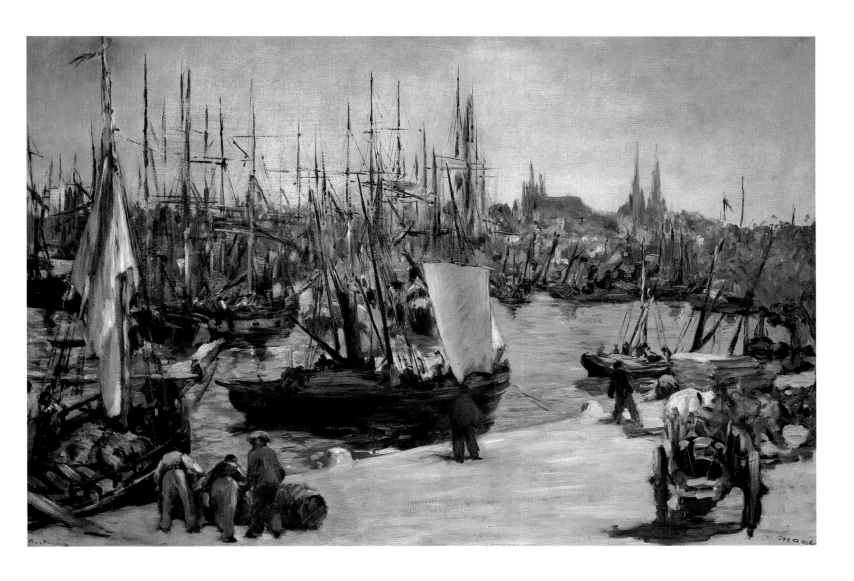

between the foreground and the horizon. Dark sails are set decoratively against the dark blue ground. In its abstraction this canvas is as remote from natural observation as any work by Manet.

Harbors and seascapes make up a good part of Manet's depictions of outdoor scenes. *Moonlight over Boulogne Harbor* was painted from the rooms of the Hôtel Folkestone, where the painter and his family stayed during the summer of 1869. The scene has been transformed into a mysterious, dramatic nocturnal landscape in the Dutch and Flemish tradition. Two years later, after the Franco-Prussian war, Manet spent some time in the south of France, where he painted the bustling activity of *The Harbor of Bordeaux*. It depicts a wharf where workers load barrels of wine onto a small merchant vessel.

At the Beach combines figure painting with outdoor scenes. Painted during the summer of 1873, probably from life since there is sand in the paint, the two figures sitting on the beach represent Suzanne Manet and the painter's brother Eugène. The woman, her face protected from wind and sand by a veil tied over her hat, is reading, while Eugène's attitude recalls his pose in *Le Déjeuner sur l'herbe*. The influence of Japanese works has been noted in the elevated horizon, the stripe of blue at the top, and the gray and black triangular shapes of the figures set against the yellow beach. The result is a monumental composition of two contemplative figures facing the powerful image of the sea. Such an interpretation is far removed from the impressions of sea air which Claude Monet painted at much the same time.

The Harbor of Bordeaux
1871; *oil on canvas;* 26 x 39 1/8 in.
(66 x 99.5 cm.). Zurich, Switzerland,
E.G. Buerhle Foundation.
After the Franco-Prussian War,
Manet went to the south of France,
where his family had fled to escape
the conflict. On their return trip
to Paris they spent a week in
Bordeaux. Intrigued by the bustling
activities at the harbor, Manet
painted workers loading barrels of
wine onto a small merchant vessel.
The lively vertical movement of the
ship masts is balanced by the broad
diagonal quay in the foreground.

Edgar Degas's early depictions of gentlemen's horse races might have motivated Manet to treat the same subject as well. In *Races at Longchamp*, he created the very first image of a racing scene with the horses coming directly toward the viewer. The location is the Longchamp racetrack in the Bois de Boulogne, with the hills of Saint-Cloud in the distance. The viewer is almost frighteningly close to the advancing horses as the illusion of depth between foreground and background is considerably mitigated. *Races in the Bois de Boulogne* is more conventional, insofar as the horses are represented from the side. Crowds of carriages with onlookers fill the central field. It is important to notice that both Manet and Degas considered the racetracks a worthy subject for their paintings about modern life. On at least one occasion the two artists spent a day together at the track. However, *Races in the Bois de Boulogne* was Manet's last painting of this theme.

His Final Illness

The last two years of Manet's life were dominated by the illness which eventually killed him. On the advice of his doctor, he spent the summer months outside of Paris in Bellevue, Versailles, and Rueil. He rented a house there in 1882, which he depicted in *The House at Rueil*. Although almost immobilized with locomotor ataxia, Manet was still able to sit in the garden and paint in the shade of a tree. The painting is full of light and the subject is typically Impressionistic. The scene with its free, vibrant touch is indeed close to works by Monet and Pissarro, but the choice of view and the cruciform composition are clearly Manet's own style.

Back in Paris, Manet painted a series of sixteen flower still-lifes prior to his death, among them *Roses and Tulips* and *White Lilacs*. The flowers were presents from his friends, who incessantly sent bouquets to his home. Clearly the flowers gave him great pleasure and inspired him during his final months of life.

Battle of the 'Kearsage' and the 'Alabama'
detail. 1864;
Philadelphia, Museum of Art,
The Johnson G. Johnson Collection.
The sinking Alabama *is painted with detailed knowledge about a sailing training ship between Le Havre and Rio de Janeiro. But also the subdued chromatic range of the painting and the gray clouds of the steam and the explosion are handled with a great mastery for realism.*

Moonlight over Boulogne Harbor
detail. 1869;
Paris, Musee d'Orsay.
Manet painted at times with a thick impasto leaving the marks of the brushstrokes clearly visible. An encrusted surface, as in the moon shining over the harbor of Boulogne, was occasionally the result of heavy revisions. X-ray analysis revealed that the moon was indeed at first lower, illustrating the painter's care for composition and effect when reworking his canvases in the studio.

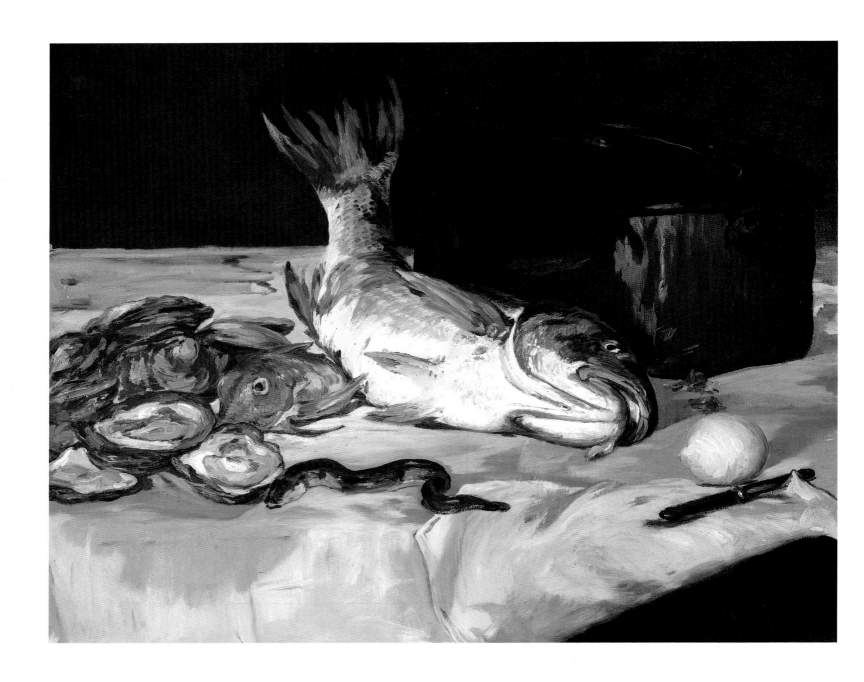

Fish (Still-Life)

1864; oil on canvas; 28 7/8 x 36 1/4 in. (73.4 x 92.1 cm.). The Art Institute of Chicago.
Manet's still-life paintings bear witness to his admiration for the eighteenth-
century artist Jean-Baptiste-Siméon Chardin, whose relatively simple
and realistically rendered still-lifes were very popular during the Second
Empire. Painted at Boulogne-sur-Mer during the summer of 1864,
Manet stressed the diagonal movement running from the lower left
to the upper right by deliberately placing a knife in the right corner.

The Bunch of Violets

1872; *oil on canvas*; 8 3/4 x 10 3/4 in. (22 x 27 cm.).
Paris, Private Collection.
*This small masterpiece was a chivalrous tribute to Berthe
Morisot, to whom the letter in this painting is addressed.
The fan is also a recurrent attribute of hers and the violets refer
to the same flowers worn as a corsage in* Berthe Morisot with
a Bunch of Violets, *although their precise meaning eludes us.*

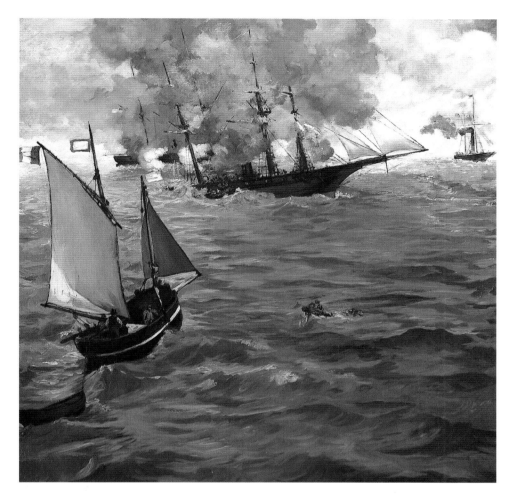

Alabama and Kearsage

c. 1865; *oil on canvas; 52 3/4 x 50 in.*
(134 x 127 cm.). Philadelphia, Pennsylvania,
Philadelphia Museum of Art,
The Johnson G. Johnson Collection.
This painting was prompted by a military action of the American Civil War on June 19, 1864 off Cherbourg, where the Kearsage *attacked and sank the Confederate vessel* Alabama. *Manet based his composition on reports and photographs about the event, which had received much attention in France. The disturbingly unusual viewpoint of the composition— the water is seen from a point high above the sea level—clearly annoyed friends of traditional marine painting.*

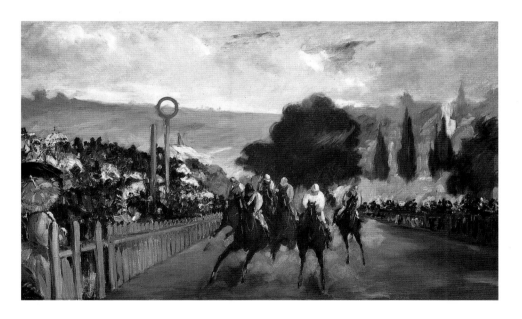

The Races at Longchamp

1864; *oil on canvas; 17 1/4 x 33 1/4 in.*
(43.9 x 84.5 cm.). Chicago, The Art Institute.
The scene depicts the Longchamp racetrack in the Bois de Boulogne with spectators attending a race at the stands on either side of the track. The horses are coming directly toward the viewer, creating an almost claustrophobic effect. There is a strong sense of immediacy and only a mitigated illusion of depth between the foreground and the background with the hills of Saint-Cloud.

The Escape of Rochefort

1880–1881; *oil on canvas; 31 1/2 x 28 3/4 in. (80 x 73 cm.). Paris, Musée d'Orsay.*
The radical politician and pamphleteer Henri Rochefort had been deported to New Caledonia in 1873, only to escape from the prison colony the following year. After his return to Paris in 1880, Manet began to paint The Escape of Rochefort *based on detailed information provided by Rochefort himself. However, the protagonist had embellished his story somewhat. The whaleboat with which he and his four companions had escaped, never reached the high seas but remained in the waters of the sheltered harbor of the island. With this kind of modern history painting, Manet, who himself was a liberal Republican, expressed his admiration for Rochefort's heroic adventures.*

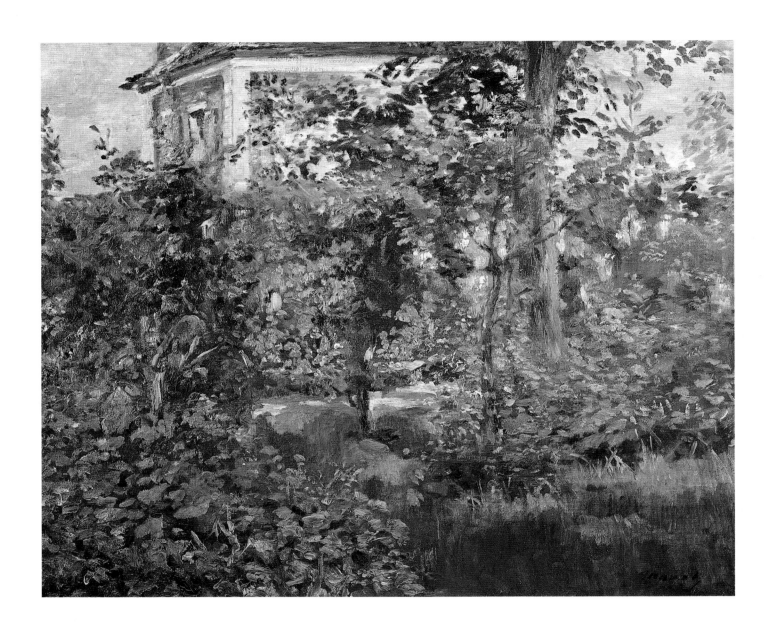

The Bellevue Garden

1880; *oil on canvas;* 21 1/4 x 25 1/2 in. (54 x 65 cm.). Paris, Private Collection.

Manet spent his last summers outside Paris at Bellevue, Versailles, and Rueil, following his doctor's recommendation. Suffering from syphilis and locomotor ataxia, the artist had great difficulty moving and confined his activities to small-scale still-lifes and scenes of his gardens. In paintings like this one Manet came perhaps closest to the Impressionist style of his friends.

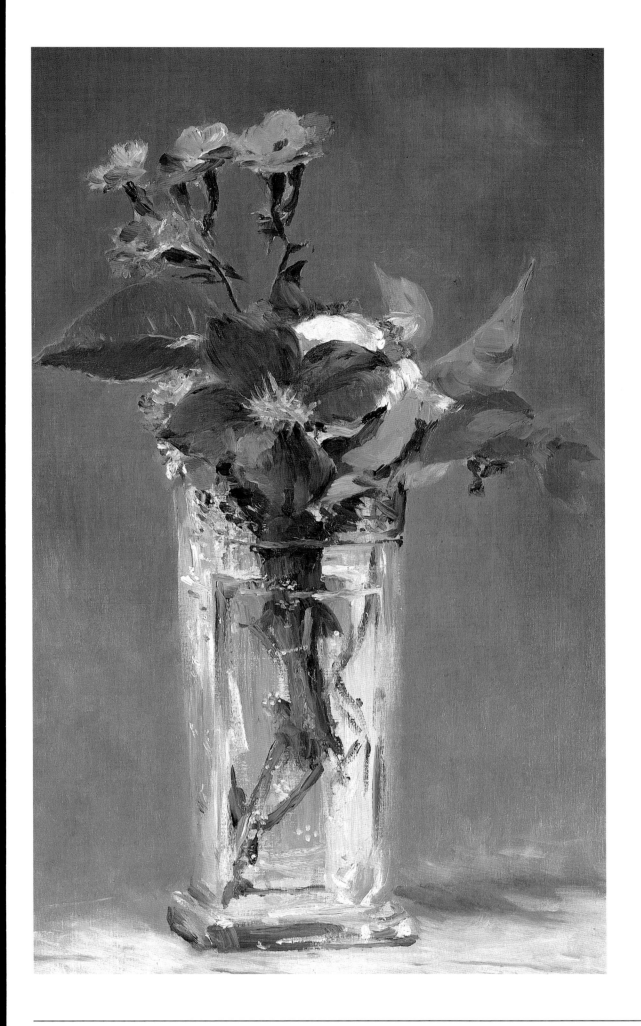

**Pinks and Clematis
in a Crystal Vase**
1882 c.; *oil on canvas;*
22 x 13 3/4 in. (56 x 35.5 cm.).
Paris, Musée d'Orsay.
*The same crystal vase
with square base and gilt
decoration also appears in
other flower still-lifes by
Manet. Here a small bunch
of ordinary garden flowers
has been placed in the vase
as they were, with no
concern for the arrangement.
The blue-gray background
responds to the subtle har-
mony of the violet clematis
set off against the pinks.*

Branch of White Peonies, with Pruning Shears
1864c.; oil on canvas; 12 1/4 x 18 1/4 in. (31 x 46.5 cm.). Paris, Musée d'Orsay.
Manet's virtuosity in still-life and flower painting has never been called into
question, not even by his most adversarial critics. The suggested carelessness
and transitory effect of the abandoned flowers cannot detract from the rich and
splendid brushwork, which expresses the unassuming splendor of cut peonies.

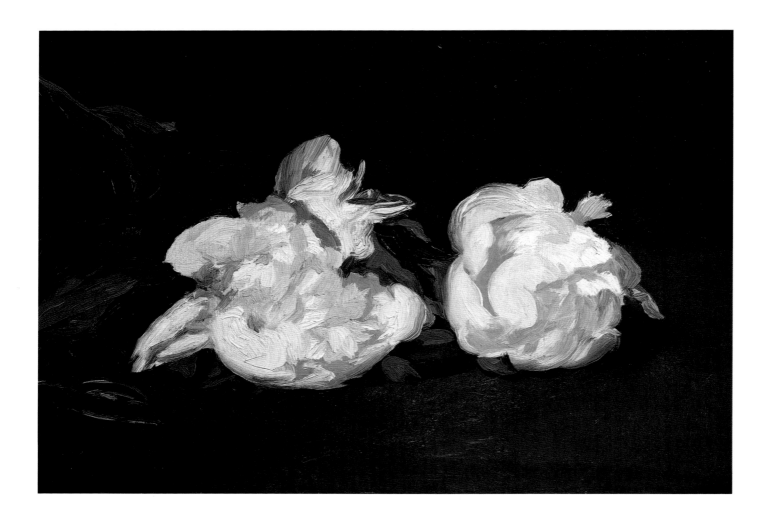

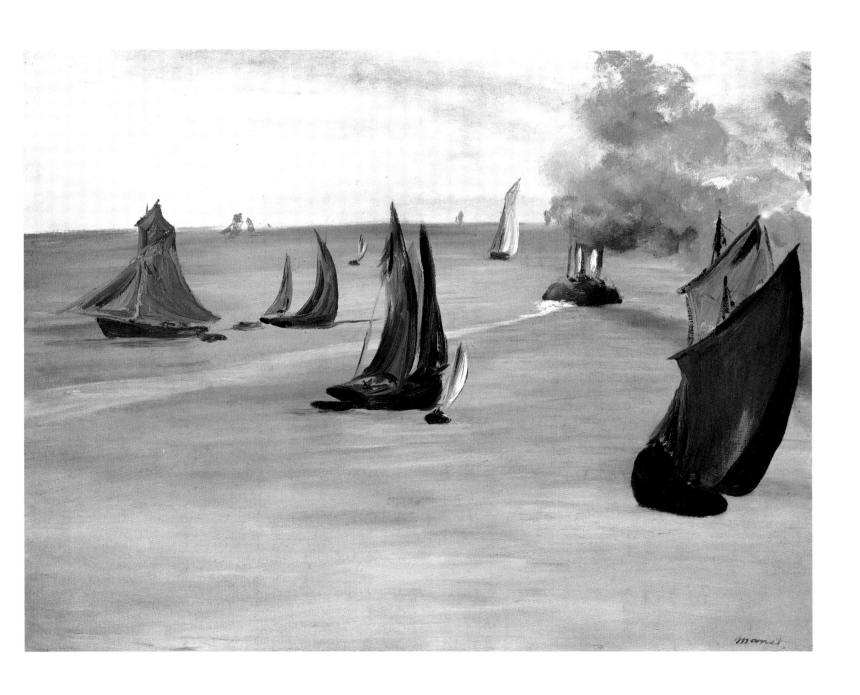

Steamboat, Seascape or Sea View, Calm Weather
1864–1865; *oil on canvas;* 29 1/4 x 36 1/2 in. (74 x 93 cm.).
The Art Institute of Chicago.
*The highly abstract character of this seascape is most likely due
to the influence of Japanese woodblock prints, which circulated in
Paris at the time and of which Manet is known to have owned
several. The elevated horizon, the flatness of the blue color
indicating the ocean, and the unusual black veils distributed
decoratively across the canvas are remote from natural observation.*

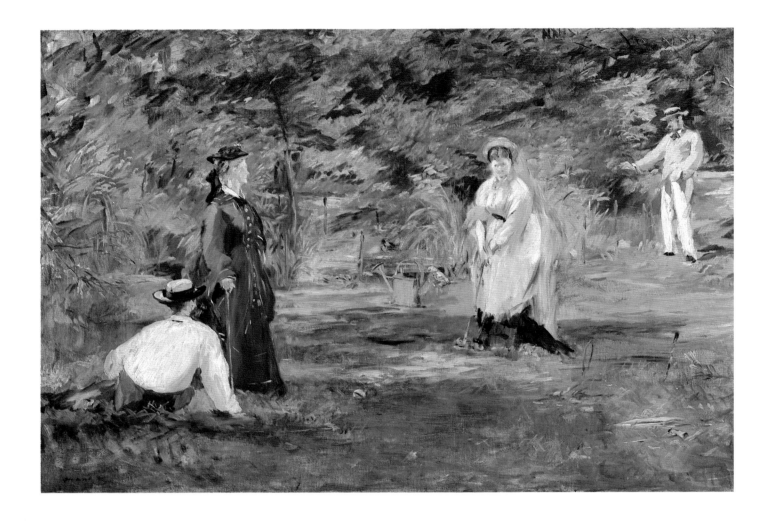

Croquet

1873; *oil on canvas;* 28 1/2 x 41 3/4 in. (72.5 x 106 cm.).

Frankfurt Main., Germany, Staedelsches Kunstinstitut.

*In the garden of the Belgian painter Alfred Stevens people used to play
endless croquet games. The woman to the left is Victorine Meurent, to
the right is Alice Lecouve, a model of Stevens. The man in the
background has been recognized as Manet's friend Paul Roudier, while the
man seen from behind might be Stevens himself. The brushwork is quite
impressionistic, although the forms are firmly modeled with strong colors.*

In the Garden

1870; *oil on canvas*; 17 1/2 x 21 1/4 in. (44.5 x 54 cm.).
Shelburne, Vermont., The Shelburne Museum.
The sitters are Edma and Tiburce Morisot, Berthe's siblings. The baby in the carriage is probably Edma's eldest daughter, who was born only a few months before. The scene might very well represent Manet's first out-of-door painting, reflecting the artist's interest in the interplay of natural light and shadow. The painting's immediacy results largely from the cropping along the picture frame, which allows the viewer to become part of the gathering.

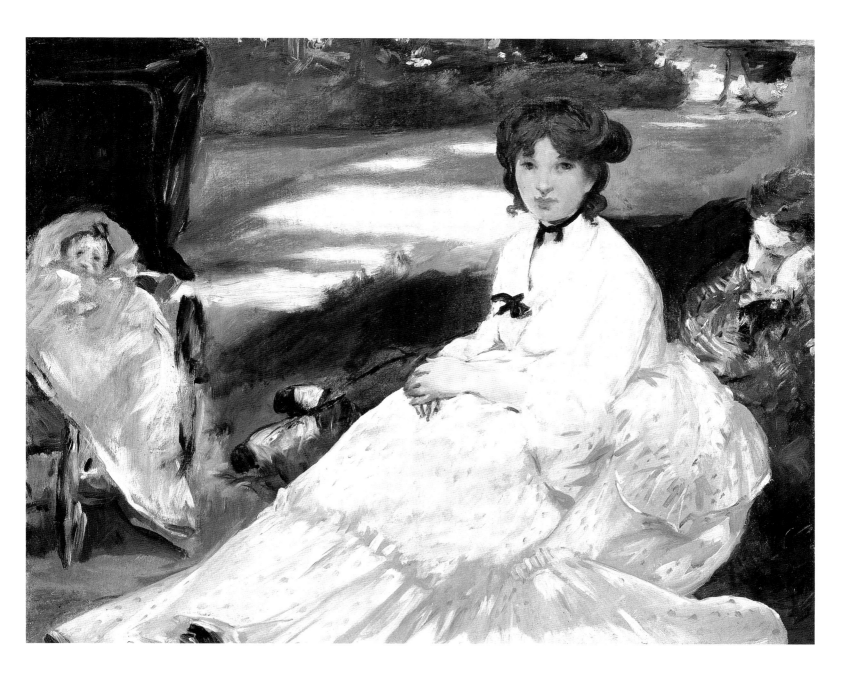

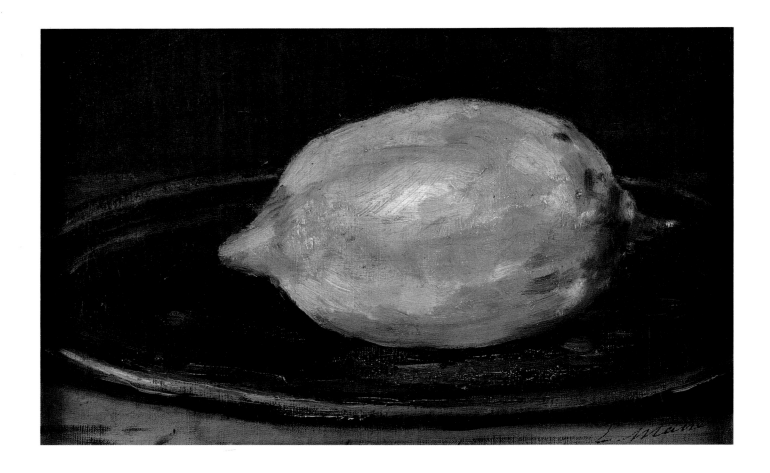

The Lemon

1880–1881; *oil on canvas;* 5 1/2 x 8 1/4 in. (14 x 21 cm.). Paris, Musée d'Orsay.
*Impeded by his illness, Manet painted often small-scale canvases
with still-life subjects. The lemon played an important role in the
artist's painting during the 1860s, and appears in* Portrait of Zacharie
Astruc *and in* Woman with a Parrot, *among others. An abbreviated
symbol for the Spanish and Dutch influence on Manet's art, the lemon
also adds a desired coloristic effect to a work.*

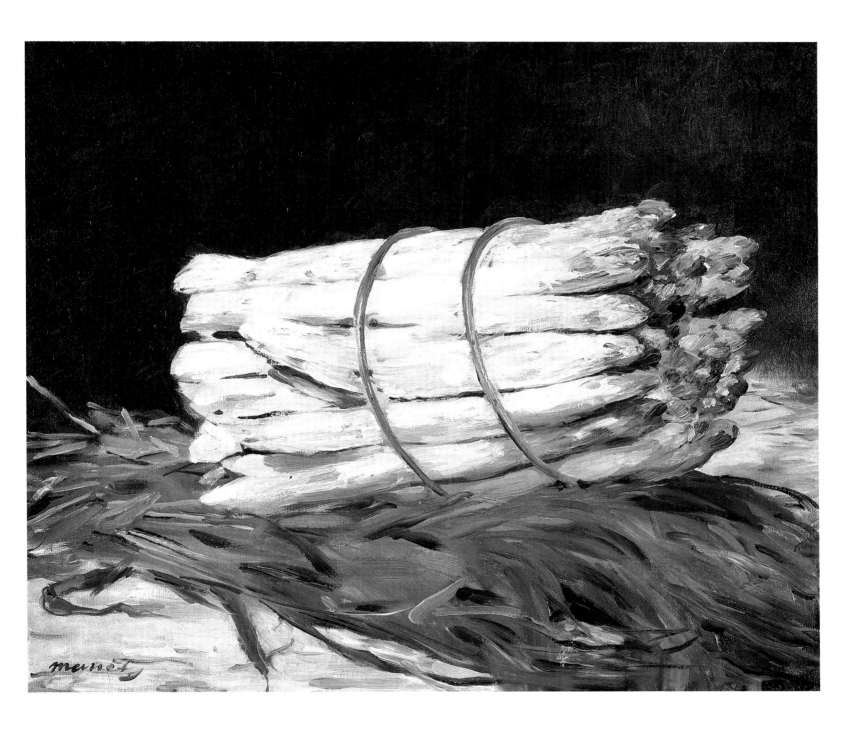

Bunch of Asparagus

1880; *oil on canvas*; 18 x 21 2/3 in. (46 x 55 cm.).

Cologne, Germany, Wallraf-Richartz Museum.

Painted on a dark background in the manner of seventeenth-century
Dutch still-lifes, the bunch of asparagus is bathing in full light falling
in from a source outside the picture. The white stems with their purple
ends contrast beautifully with the green feathery leaves. The painting
was purchased by the collector Charles Ephrussi for one thousand francs.

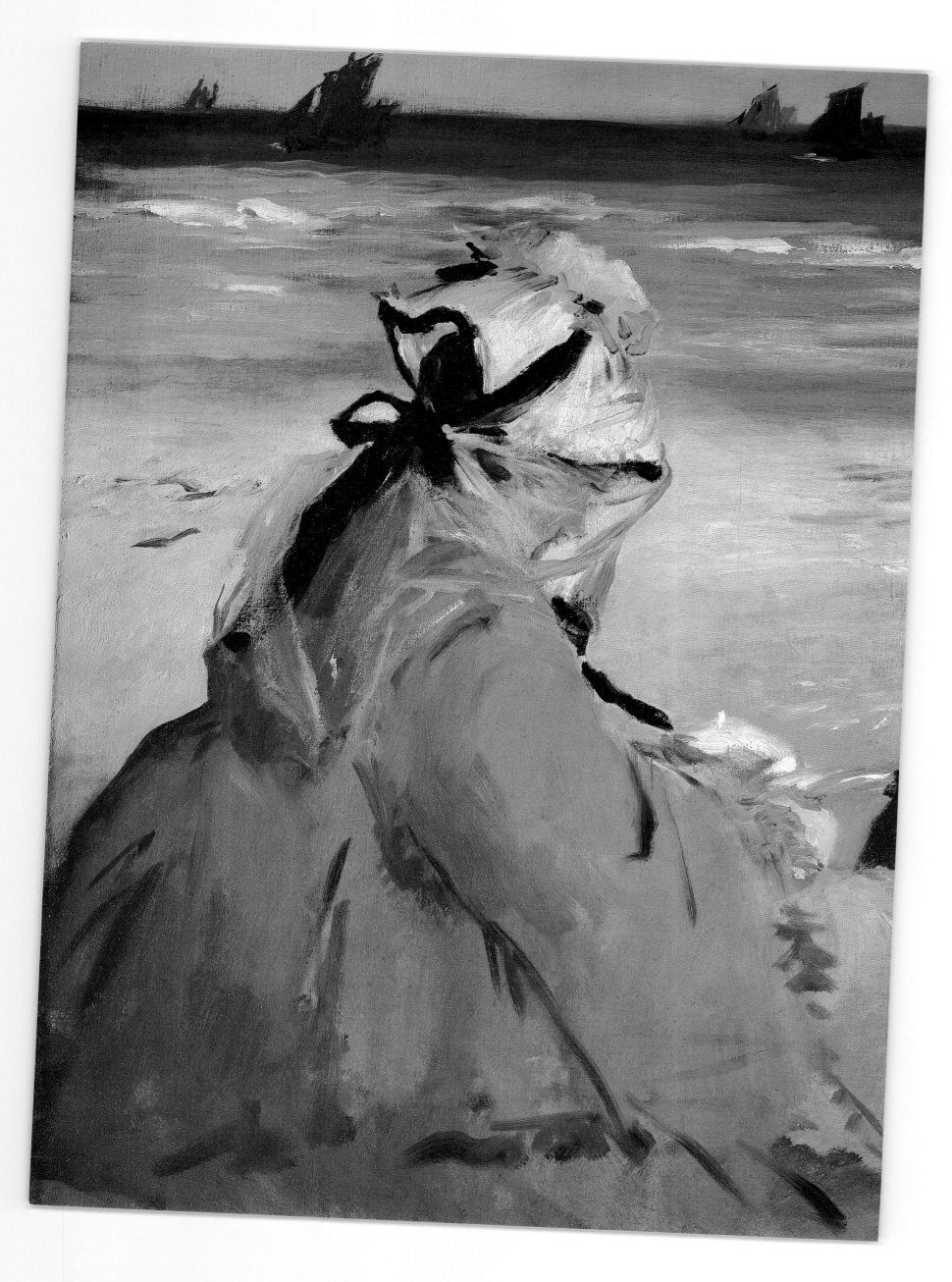

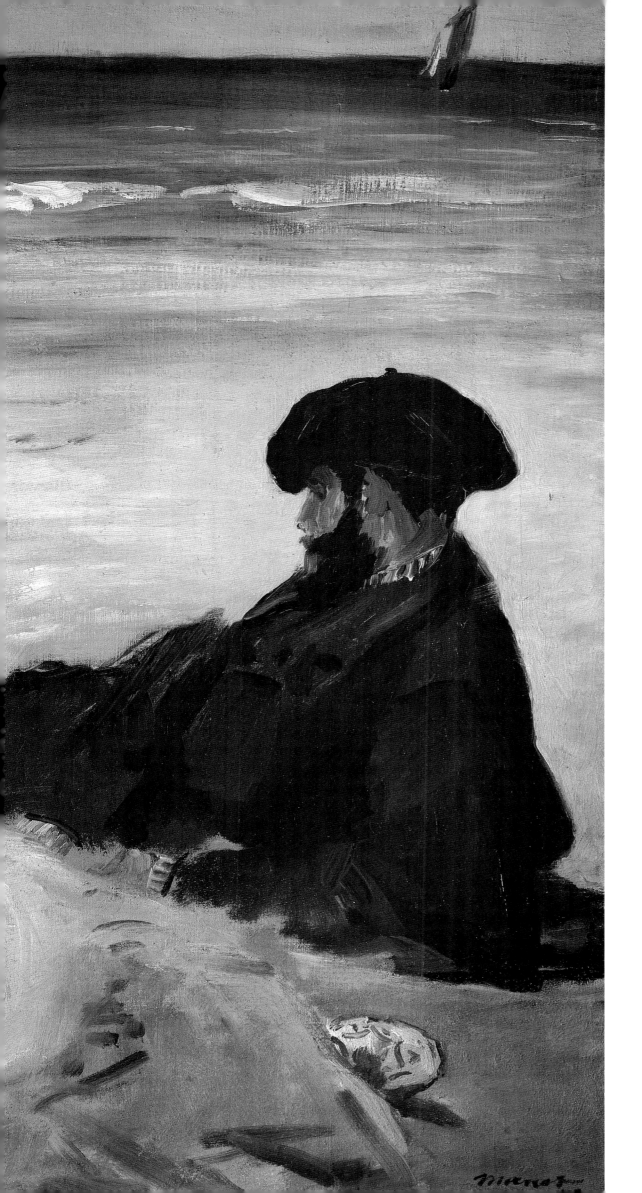

At the Beach

1873; *oil on canvas;*
23 1/2 x 28 7/8 in.
(59.6 x 73.2 cm.).
Paris, Musée d'Orsay.
*During the summer of
1873, Manet spent three
weeks at Berck-sur-Mer
with his family. The sitters
are Suzanne Manet,
reading, and the artist's
brother Eugène, who was
going to marry Berthe
Morisot the following year.
The fact that sand is mixed
into the paint seems to
indicate that the canvas
was actually painted on the
spot. The elevated horizon
with the clearly defined
stripe of blue recalls composi-
tions of Japanese prints.*

The House in Rueil

1882; oil on canvas; 30 3/4 x 36 1/4 in. (78 x 92 cm.).
Berlin, Staatliche Museen,
Preussicher Kulturbisitz Neue Nationalgalerie.
The house Manet rented in Rueil during the summer
of 1882 was a charming building in the Restoration
style. Although almost immobilized by his grave illness,
the artist was able to sit in the shade of a tree, where
he painted this view. The scene is full of light and
a vibrant touch, as can be found in any typically
Impressionist painting by Monet and Pissarro.
The point of view is, however, decidedly Manet's own.

A Path in the Garden at Rueil

1882; oil on canvas; 24 x 19 3/4 in. (61 x 50 cm.).
Dijon, France, Musée des Beaux-Arts.
This landscape was painted in the garden of
the house Manet rented for the summer of
1882 in Rueil. Its feeling of abstraction might
hint at the direction the artist's oeuvre would
possibly have taken had his death not cut
short its development. The subject is the
shimmering color of the foliage in sunlight.

White Lilacs

1883; *oil on canvas*; 21 1/4 x 16 in.
(54 x 41 cm.).
Berlin, Staatliche Museen,
Preussicher Kulturbisitz
Neue Nationalgalerie.
*Placed in a translucent glass
vase like* Pinks and Clematis
in a Crystal Vase, *this time the
flowers, white lilacs, are carefully
arranged. The shimmering
white of the petals harmonizes
with the glass, but it contrasts
with the dark background.*

Roses and Tulips

1882–1883; *oil on canvas*; 21 1/4 x 13 in. (54 x 33 cm.).
Zurich, Switzerland, E.G. Buehrle Collection.
*"There were always lots of flowers in Manet's studios, but never so many
as there were in the rue d'Amsterdam in the early spring of 1883," Adolphe
Tabarant wrote. It is quite possible that the flowers depicted in this work were
a present to the ailing artist from one of his close friends. The sinuous shape
of the dragon etched into the crystal enlivens the clear structure of the vase.*

CREDITS

The Art Institute of Chicago, Chicago, IL; Gift of Kate L. Brewster, 1950.123 p. 102; Gift of James Deering, 1925.703 p. 42 (left); Mr. and Mrs. Lewis Larned Coburn Memorial Collection, 1933.435 p. 79; 1942.311 p. 120; Mr. and Mrs. Potter Palmer collection, 1922.425 pp. 123 (bottom), 131

The Art Museum, Princeton University, Princeton, NJ. Bequest of Archibald S. Alexander p. 38; Lent by the Henry and Rose Pearlman Foundation, Inc. p. 52

The Barnes Foundation, Merion, PA, photographs © 1992. All Rights Reserved p. 69

E.G. Buehrle Collection, Zurich, Switzerland, Erich Lessing/Art Resource, New York pp. 68, 78, 117, 141

Courtauld Institute Galleries, London, England pp. 61, 81

Folkwang Museum, Essen, Germany, Giraudon/Art Resource, New York p. 83

Isabella Stewart Gardner Museum, Boston, MA/Art Resource, New York pp. 27, 103

Collection of the J. Paul Getty Museum, Malibu, CA p. 73 (bottom)

Glasgow Museums, Glasgow, Scottland: The Burrell Collection pp. 16 (top), 59

Solomon R. Guggenheim Museum, New York, NY, Gift, Justin K. Thannhauser, 1978; photo: David Heald © The Solomon R. Guggenheim Foundation p. 50

Calouste Gulbenkian Museum, Lisbon, Portugal, p. 45 (top); Art Resource, New York p. 18

Harvard University Art Museums, Cambridge, MA, Bequest of Collection of Maurice Wertheim, Class of 1906, p. 55

Kunsthalle, Bremen, Germany, p. 97

Kunsthalle, Hamburg, Germany, pp. 60 (bottom), 106, 110

Kunsthaus Zurich, Switzerland, Private Collection; p. 73(top)

Kunsthistorisches Museum, Vienna, Austria/Art Resource, New York p. 111

Metropolitan Museum of Art, New York, NY, ©1993 p. 14, Wolfe Fund, 1909. Catharine Lorillard Wolfe Collection ; ©1987 p. 20, 43, Gift of Erwin Davis, 1889; ©1993 p. 28, Purchase, Mr. and Mrs. Richard J. Bernhard Gift, 1957; ©1982 p. 34, Gift of William Church Osborn, 1949. ©1990 p. 53, Bequest of Joan Whitney Payson, 1975. ©1987 p. 21, ©1993 p. 22, ©1982 p.34, ©1982 p.44, ©1980/92 p.71, ©1990 p. 104 (left), Bequest of Mrs. H.O. Havemeyer, 1929. The Havemeyer Collection.

Musée des Beaux-Arts, Dijon, France p. 138

Musée des Beaux-Arts, Andre Malraux, Le Havre, France p. 130

Musée des Beaux-Arts, Nancy, France p. 93

Musée des Beaux-Arts, Tournai, Belgium, Giraudon/Art Resource, New York pp. 70, 77

Musée d'Orsay, Paris, France, Giraudon/Art Resource, New York pp. 4, 8-9, 24-25, 72 (top), 115 (detail), 122, 125, 126, 134, 144; Erich Lessing/Art Resource, New York pp. 10, 29 (detail), 31 (detail). 35, 37, 39, 40-41, 42 (right), 51 (detail), 54, 56-57 (detail), 62, 65, 74, 82 (detail), 88-89 (detail), 95, 100, 101, 119 (detail), 128, 136-137; Reunion des Musées Nationaux pp. 11, 98, 112, 114, 126

Musée du Petit Palais, Paris, France, Giraucon/Art Resource, New York p. 13

Museu de Arte de Sao Paulo Assis Chateaubriand, Sao Paulo, Brazil, Giraudon/Art Resource, New York pp. 12, 15, 104-105

Museum of Fine Arts, Boston, MA; Presented in Memory of Robert Jordan by his wife. p. 92; Gift of Mr. and Mrs. Frank Gair Macomber p. 49; Gift of Robert C. Paine in Memory of his father, Robert Treat Paine II, p. 23; Bequest of Sarah Choate Sears in Memory of her husband, Joshua Montgomery Sears, p. 26; Courtesy of Museum of Fine Arts, Boston

Národni Galeri, Prague, Czech Republic, Erich Lessing/Art Resource, New York p. 5

Nasjonalgalleriet, Oslo, Norway, photos: J. Lathion pp. 7, 99

The National Gallery, London, England; Reproduced by courtesy of the Trustees pp. 6 (detail), 36, 75, 90

National Gallery of Art, Washington, D.C.; Chester Dale Collection p. 109; Gift of Edith Stuyvesant Gerry p. 85; Gift of Horace Havemeyer in memory of his mother, Louisine W. Havemeyer p. 66; Gift of Mrs. Horace Havemeyer in memory of her mother-in-law, Louisine W. Havemeyer p. 67; Gift of the Adele R. Levy Fund, Inc. p. 113; Collection of Mr. and Mrs. Paul Mellon p. 80; Gift of Eugene and Agnes E. Meyer p. 127; Widener Collection p. 45 (bottom)

Neue Pinakothek, Munich. Germany/Artothek, Peissenberg pp. 47, 72 (bottom)

Norton Simon Art Foundation, Pasadena, CA p. 86

The Norton Simon Foundation, Pasadena, CA p. 46

Ny Carlsberg Glypotek, Copenhagen, Denmark, photo: Ole Haupt p. 19

Philadelphia Museum of Art, Philadelphia, PA The John G. Johnson Collection pp. 118 (detail), 123 (top); Mr. and Mrs. Carroll S. Tyson Collection pp. 64, 87

Private collections: Giraudon/Art Resource, New York pp. 72, 96, 121, 124

Pushkin Museum, Moscow, Russia, Scalla/Art Resource, New York p. 58

Reunion des Musées Nationaux, Paris p. 108

Rhode Island School of Design, Providence RI/Giraudon/Art Resource, New York p. 48

Shelburne Museum, Shelburne, VT pp. 129, 133

Staatliche Kunstammlungen, Dresden, Germany, p. 91

Staatliche Museen zu Berlin Preussischer Kulturbesitz, Neue Nationalgalerie, Berlin, Germany, photos: Jorg P. Anders pp. 94 (detail), 107, 139, 140

Staedtische Kunstalle, Mannheim, Germany, Erich Lessing/Art Resource, New York p. 63

Staedtische Kunstinstitut, Frankfurt, Germany/Artothek, Peissenberg p. 132

Stedelijk Museum, Amsterdam/Art Resource, New York p. 60 (top)

Szépmüéveszeti Múzeum, Budapest, Hungary/Giraudon/Art Resource, New York p. 84

Tate Gallery, London, England/Art Resource, New York p. 16 (bottom)

Thyssen-Bornemisza Colleciton, Madrid, Spain/Art Resource, New York p. 17

The Toledo Museum of Art, Toledo, OH; Purchased with funds from the Libbey Endowment, Gift of Edward Drummond Libbey p. 106

Wallraf-Richartz Museum, Cologne, Germany/Rheinisches Bildarchiv p. 135

The Walters Art Gallery, Baltimore, MD p. 76

Collection of Mrs. John Hay Whitney, New York, NY, photo: Jim Strong, Inc. p. 116

Yale University Art Gallery, New Haven, CT p. 33

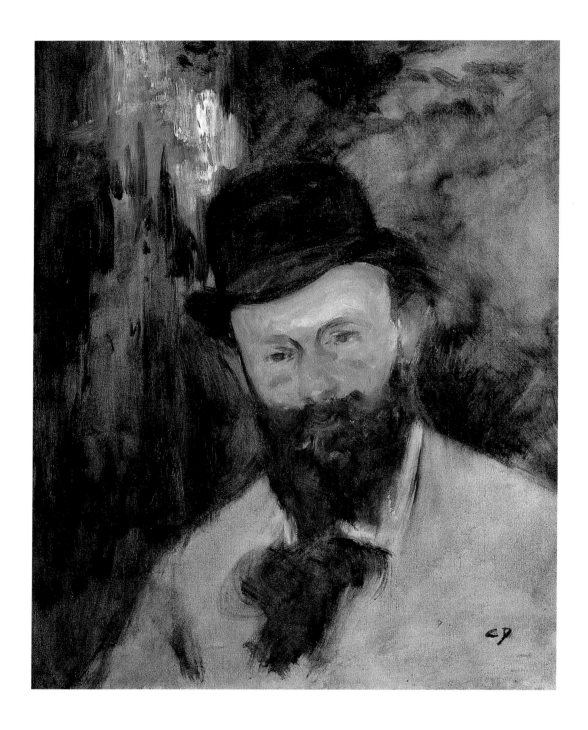

Portrait of Édouard Manet
by Charles Émile Carolus-Duran
1880; *oil on canvas;* 25 1/2 x 21 1/4 in. (65 x 54 cm.).
Paris, Musée d'Orsay.
*The fashionable portrait painter Carolus-Duran did this likeness of Manet
towards the end of his friend's life, when his illness had already set in. A pair
of small, deep-set eyes look straight out at the viewer from a bearded face topped
by a bowler hat. Simplicity, which is one of Manet's characteristic features, is
also to be found in this portrait, where the background is merely sketched in.*